FANTASY CREATURES

The Ultimate Guide to Mastering
Digital Painting Techniques

COLLINS & BROWN

CONTENTS

FANTASY CREATURES

FANTASY & SCI-FI DIGITAL ART
ImagineFX

First published in the United Kingdom in 2011 by
Collins & Brown
10 Southcombe Street
London
W14 0RA

An imprint of Anova Books Company Ltd

Distributed in the United States and Canada by
Sterling Publishing Co, 387 Park Avenue South, New
York, NY 10016-8810, USA

ISBN 9781843406020

A CIP catalogue for this book is available from the
British Library.

10 9 8 7 6 5 4 3 2 1

Reproduction by Rival Colour Ltd, Uk
Printed by 1010 Printing International Ltd, China

This book can be ordered direct from the publisher at
www.anovabooks.com

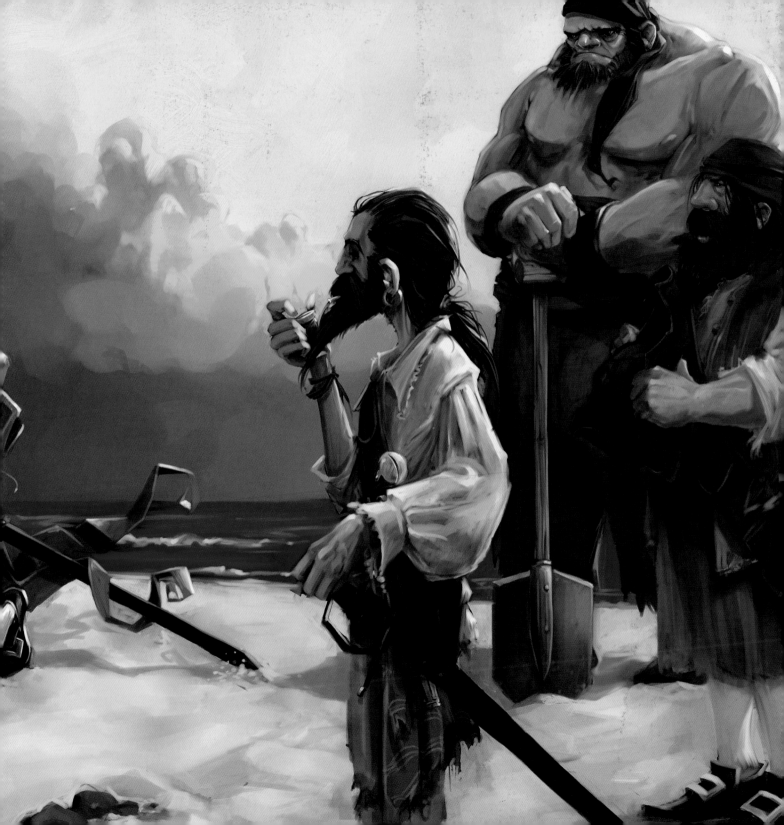

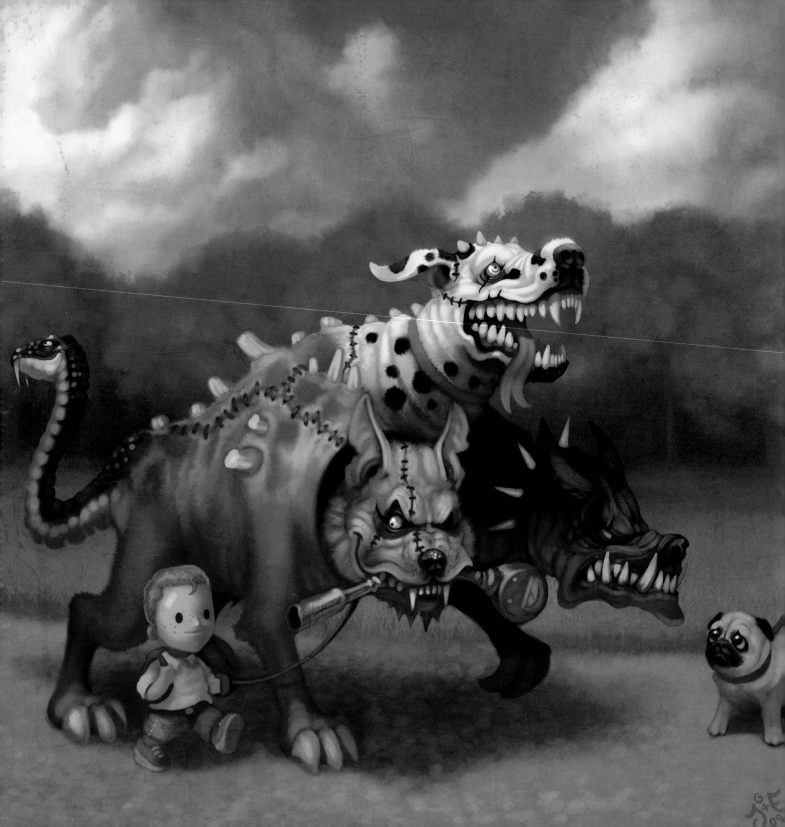

INTRODUCTION

The animal kingdom in fantastical form is a major part of fantasy art's heritage. Inside these pages you'll find all you'll ever need to know to help you learn how to draw and paint your own creature creations. From classic fantasy favourites like faeries, dragons and vampires, to more sinister demons, aliens and helldogs, you'll find out how to concept, sketch and create unique images from start to finish.

On every page you'll find inspiration to help you get started – and the world's leading artists are on hand to take you through each step, dishing out unmissable technical tricks and tips to enable you to produce stunning images in Photoshop, Painter and ZBrush.

Each section is devised to help you effortlessly discover what you next want to paint. Are you a 3D buff? Then Beasts in 3D starting on page 60 is where you'll find techniques galore to help you model beasts and underwater creatures. Need some inspiration? Myths and Monsters on page 120 is a great starting point to get fresh ideas on monster designing. Or you can take an extraterrestrial trip to paint some Alien Races on page 156.

Classic fantasy comes in the form of Faeries, Fables and Friendly Giants on page 24, or you can take a turn to the darker side of fantasy – if you dare – by seeing what's in store in Vampires & Demons on page 96.

Lastly, our section entitled Creature Features delves into the skillets of professional artists. Learn how to speed paint a monster, follow how an artist takes a watercolour image into Photoshop, get help on animal anatomy and discover how artists use thumbnailing techniques to get their image working on a larger scale.

Artists have been imagining and creating new life forms for centuries, now it's your turn to create something special. Happy painting!

Claire Howlett, Editor,
ImagineFX magazine

CREATURE GALLERY

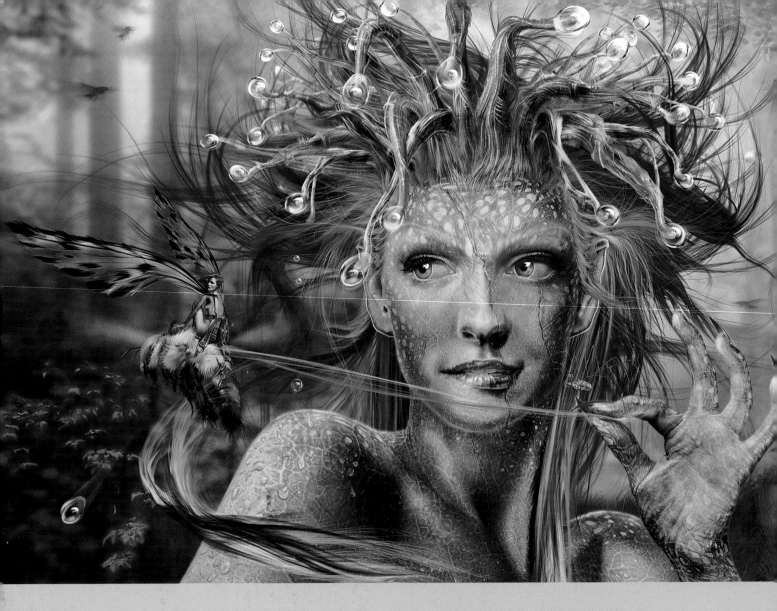

SUNDEW FAIRY

Artist: Emile Noordeloos
Location: The Netherlands
Web: www.digitalpaint.nl

Hair strands group together to form the sundew-like tentacles with sticky fluid drops at the tip. 'This,' Emile explains, 'attracts various insects.' These are caught by throwing a few sticky strings of hair and drops of sundew fluid.

SIREN

The Siren makes herself comfortable with items from a sunken ship, 'and keeps the decaying body of an unfortunate sailor-boy close,' Emile adds.

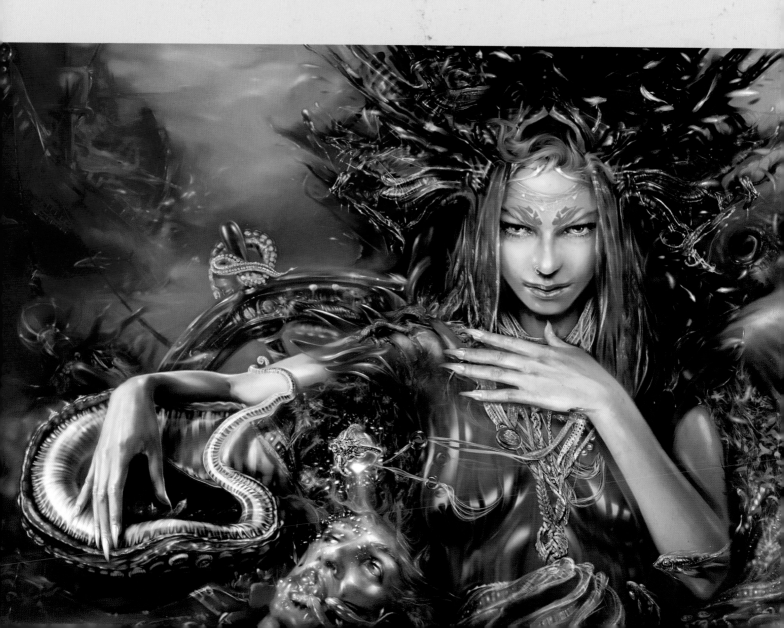

TAUREN

Artist: David Rapoza
Location: USA
Web: www.daverapoza.com

This image is inspired by a World of Warcraft character, the Tauren Shaman. 'I don't have much time for personal work,' admits David, but 'focusing on the atmosphere and mood of the image, I try to give personality to the characters I draw.'

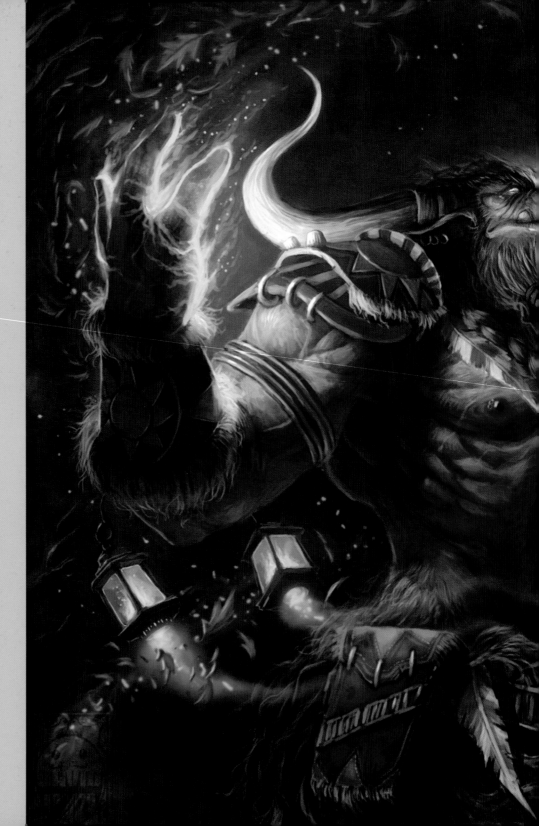

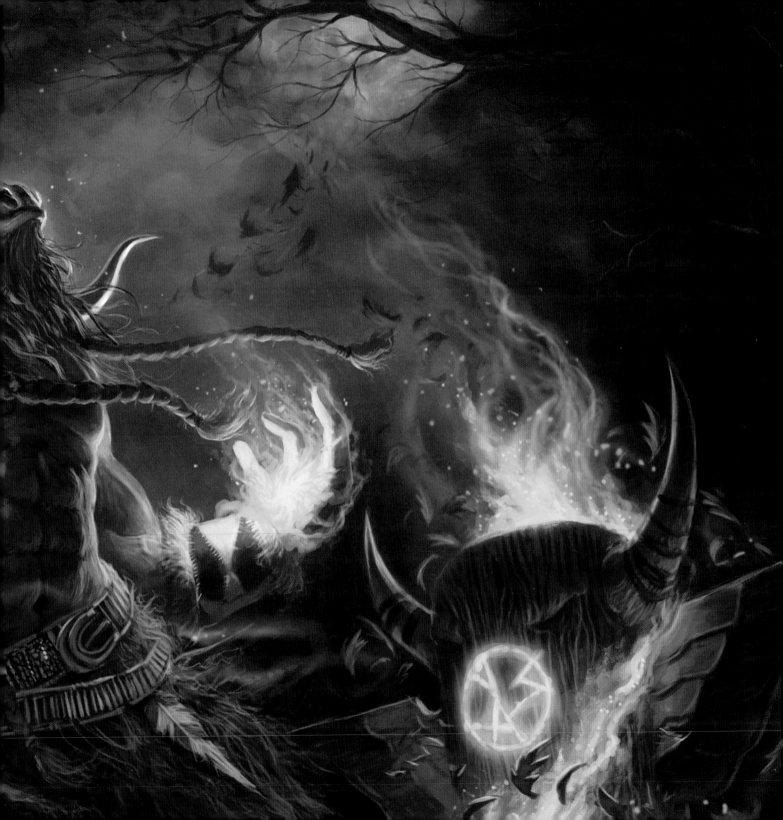

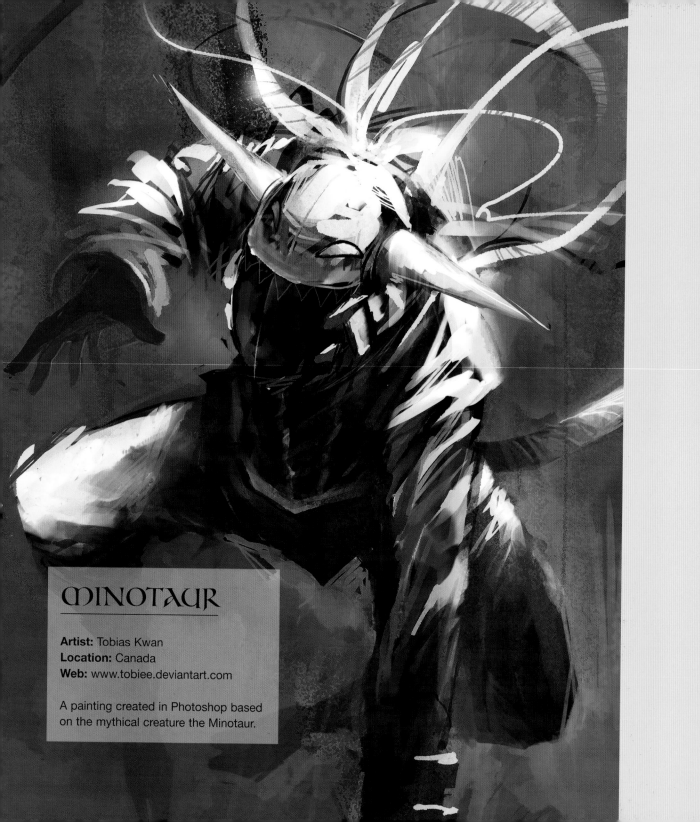

MINOTAUR

Artist: Tobias Kwan
Location: Canada
Web: www.tobiee.deviantart.com

A painting created in Photoshop based
on the mythical creature the Minotaur.

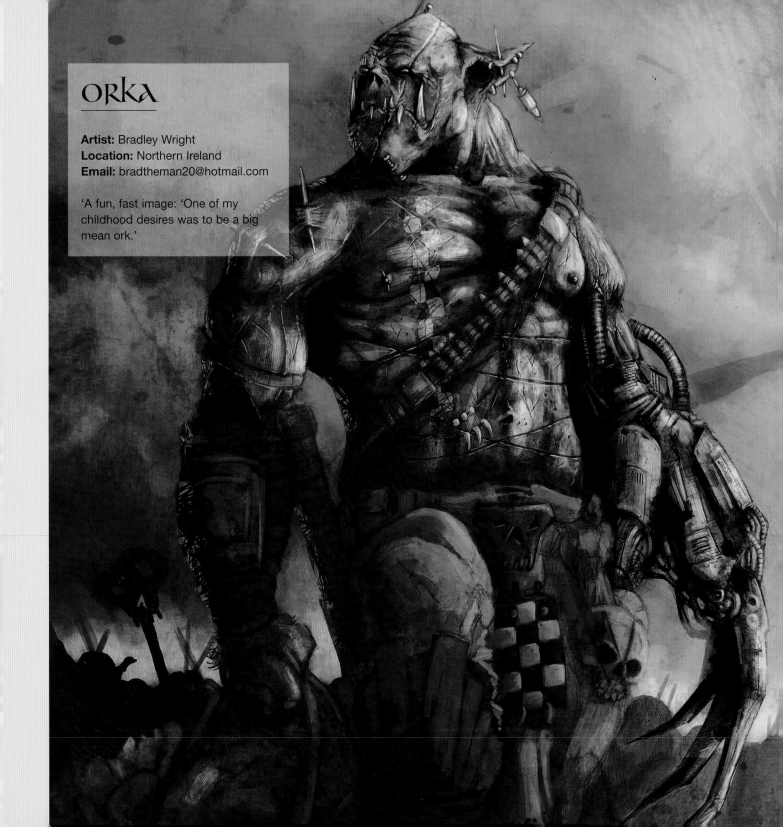

ORKA

Artist: Bradley Wright
Location: Northern Ireland
Email: bradtheman20@hotmail.com

'A fun, fast image: 'One of my childhood desires was to be a big mean ork.'

OLD KNIGHT

Artist: Bradley Wright
Location: Northern Ireland
Email: bradtheman20@hotmail.com

'Although I feel I should be doing more 'arty' and thought-provoking images', muses Bradley, 'sometimes you've got to draw a big old knight on horseback.'

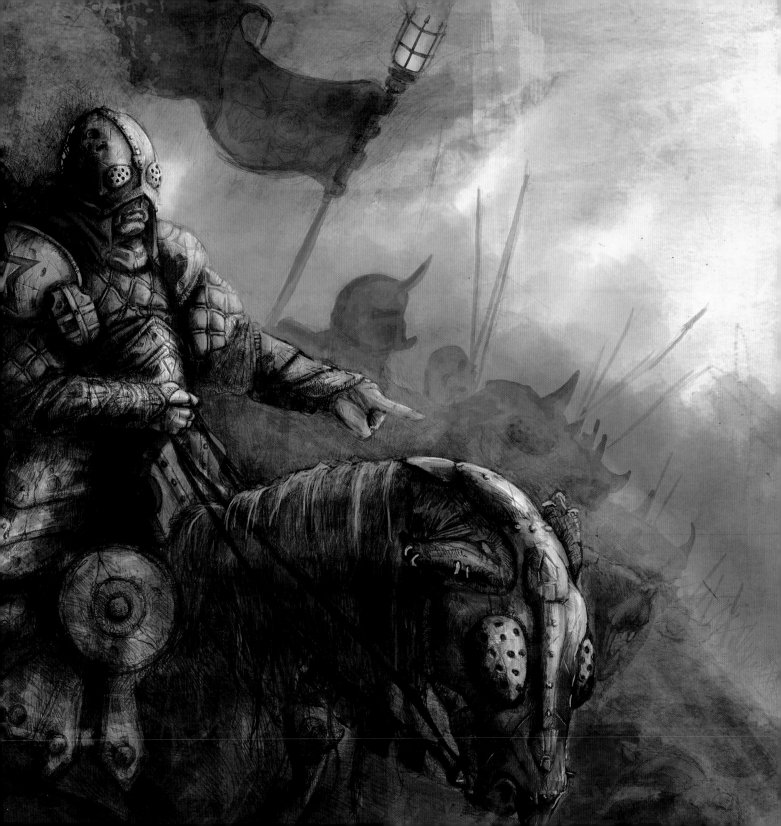

‹KING OF GARUDA

Artist: Jessada Sutthi
Location: Thailand
Web: www.jessada-nuy.deviantart.com

Taken from the ancient epic, Ramayana, 'The King of Garuda has a body mixed between human and bird.'

RED DEMON ›

Artist: Jason Jarava
Location: USA
Web: www.members.cox.net/jaravaj/index/

'A lurking demon high in the atmosphere scouting prey far below in the villages and towns.'

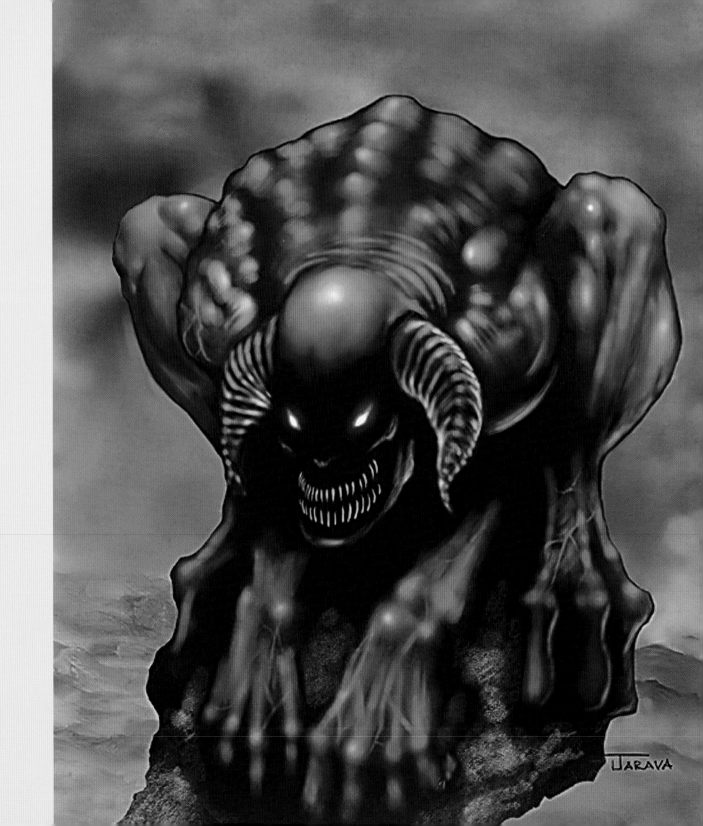

BATTLE

Artist: Tobias Kwan
Location: Canada
Web: www.tobiee.deviantart.com

'A painting inspired by Spartan culture,' Tobias explains.

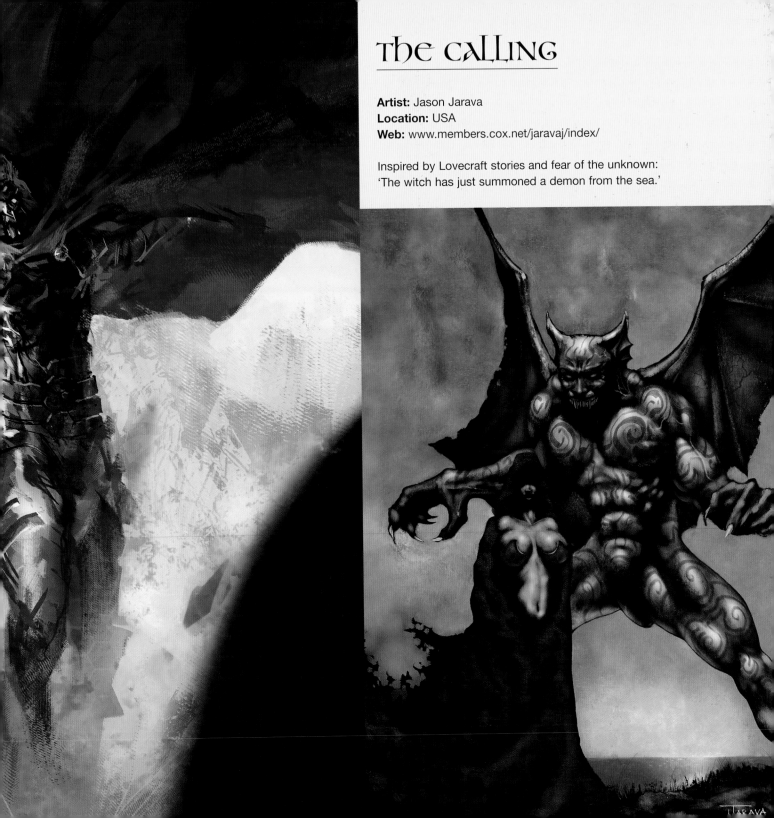

The Calling

Artist: Jason Jarava
Location: USA
Web: www.members.cox.net/jaravaj/index/

Inspired by Lovecraft stories and fear of the unknown:
'The witch has just summoned a demon from the sea.'

‹SABERTOOTh

Artist: Jason Jarava
Location: USA
Web: www.members.cox.net/jaravaj/index/

An ancient struggle between man and
beast. 'An idea that goes back to our
earliest memories. Movement and tension
were the ideas behind this piece.'

PATIENCE›

Artist: Elisabeth Kiss
Location: Austria
Web: www.lizkay.com

'Planned as part of the art book
ArtAviana, this picture is meant to
have an Animation-touch, so I used a
painted background but a comic
shaded character in it.'

Faeries, Fables and Friendly Giants

ARTIST**PROFILE**
BENTE SCHLICK

COUNTRY: Germany
www.creativesoul.de

Bente is a freelance illustrator and concept artist, studying illustration and design in Hamburg. She paints mystical and enchanting images, but also does non-fiction work such as nature illustration, layout and package design.

PHOTOSHOP

PAINTING A FAERIE SCENE

A journey through the painting process of faeries, from sketch to the final painting, by **BENTE SCHLICK**

Faeries, or the Good Folk, have always fascinated humans; they enchant children and adults alike. It's fitting that faeries are often painted as beautiful young women who are the personification of romanticism and everything good. That's what my painting will be about. The main focus of attention will be her face, and I'm aiming at an expression that draws the viewer in.

Another focus will be the faerie's wings, which will be made using a mix of butterfly and dragonfly wings. I'm also going to add in a connection to butterflies.

I want the background to suggest that the faerie emerges from the woods into a softly lit clearing where flowers grow and creatures live. The faerie subtly brings light and life into her surroundings.

For inspiration, I flip through some faerie art books and my sketchbook, building up the scene in my head. I like to have a good concept before I start painting, but sometimes an image can turn out completely different to my original plans, because during the creative process I realise that certain things need to change in order to steer the painting in a particular direction.

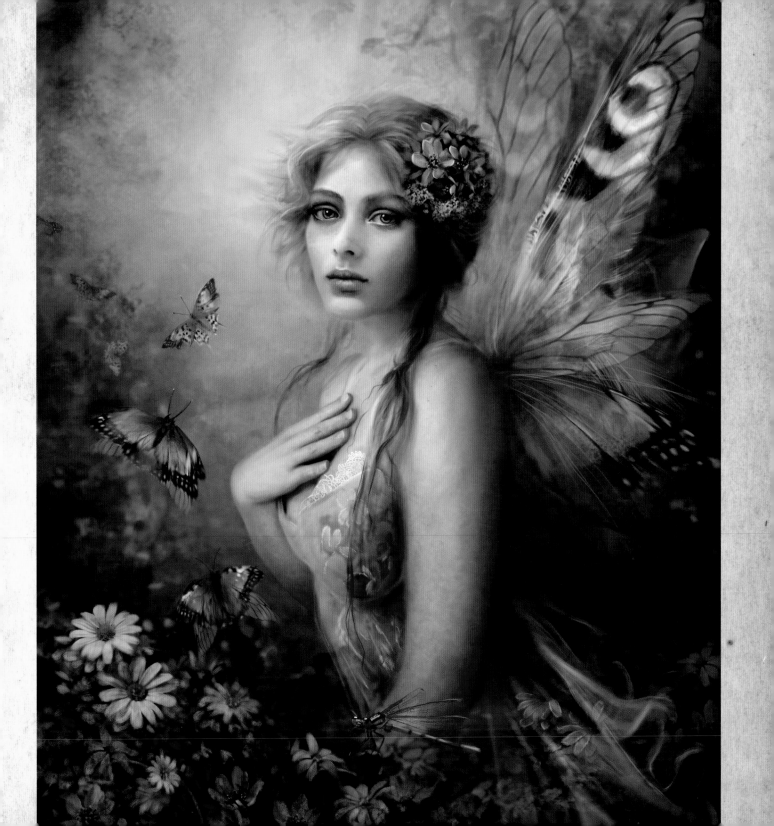

1 The sketch

The sketch is always an important part of my painting process. I like to have a good basis to start working on, maybe because I'm used to doing the same in traditional painting. After trying various poses, I end up with quite a simple one, because we're focusing mainly on the face and wings. For more difficult parts like the wrist or the right posture, I use some references, either from real life or from photographs. This helps to avoid anatomical mistakes right from the beginning, and I highly recommend it when you go for a realistic style, even if it's just to check that you've got things correct.

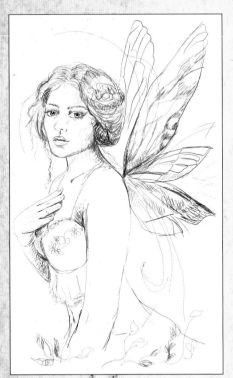

2 Choosing the colour scheme

After completing the sketch, I move on to devising the colour scheme. For this piece I was asked to go for soft ambient lighting, which conveys some kind of summer eve feeling. Because of this, I choose mostly soft yellow, red and green tones for the background and, by way of a contrast, I have selected a bright blue-violet for the flowers and the butterflies. To get a better feeling for the atmosphere and the mood, I mix the basic colours to get middle tones. You can easily make your own ink stripe by using the Gradient tool in Photoshop. The colours for the faerie's face and skin are soft and fresh, mostly red and yellow tones.

3 Colouring

Before I start colouring, I fill the background with a dark colour and set the layer with the sketch to Multiply. I create a new layer above it and fill the figure's shape with another dark tone. This is helpful if you don't want your background colour to compete with the colouring of your character. You can keep this layer over the whole painting process and delete it later. Just make sure you keep it on a separate layer. For the start, I use a simple Hard Round-edged brush with a nice flow. It varies in opacity and is highly sensitive to pen pressure, meaning that I can build up gradually from transparent to full coverage, step-by-step.

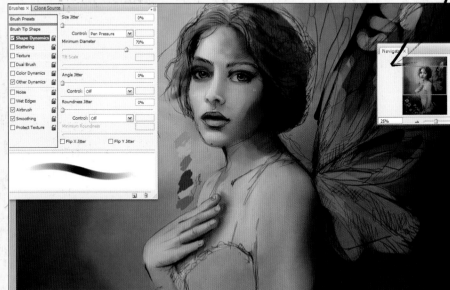

5 Defining the background

The background won't be overly detailed, but it will be very textured. A painting with a lot of detail can be interesting, but too much can also kill the magic of an image. I prefer to give the viewers just a hint and let them decide what they see. It can make a scene much more appealing if you don't explain everything and let the viewer focus on a special highlight – this is especially true with fantasy themes.

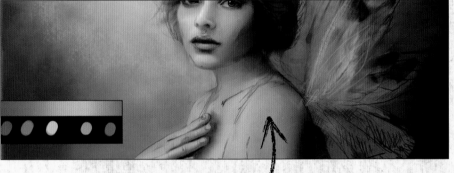

4 The lighting

I set up the basic light sources and highlights right at the start. There won't be a visible source like a sun, so I want the light to appear in a subtle way to give the painting a mystic and romantic touch. The brightest spot will be near her face to turn the attention to her expression. Overall the left part of the painting will be lit, and the right side will be very dark, especially next to the fringe. The gradient I created earlier is now helpful to set down the colours.

6 Foliage brushes

For the background, I use a couple of different brushes starting with simple texture brushes and finishing with leaf-like ones. I paint layer over layer using some layer effects to bring in unique colour spots. I also hint at branches on the right-hand side using a sparkle brush with low opacity and flow.

PROSECRETS

TAKE THE TUBE

It can be helpful to create some tubes for your backgrounds – in this case a simple one implying leaves. Tubes are straightforward dots painted in high resolution, but if you put them into your painting using a layer effect or the Blur tool, they look much livelier than just a brush. Have a couple of different leaf-tube types saved and ready to use.

7 Character

Now it's time to focus closely on the faerie's face. I want her to look strong, but at the same time to show fragility and mystery. I'd like to give the viewer the feeling that she knowingly looks into their heart. I was asked to perhaps paint her with red hair, so I combine it with soft green make-up highlights and yellow-green eyes. In contrast to the red I set some violet flowers into her hair, which also should attract the viewer's eye.

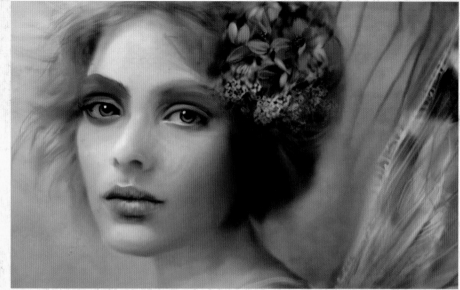

8 Skin textures

I usually prefer to give the skin a natural texture with a more painted look. I want to make sure that my character doesn't look too polished or sterile. When you paint natural beings like a faerie or a human, I feel that the skin and its texture tells part of the character's story.

I have several different skin brushes, and most of them have a huge range of scattering. This means that they're a bit uncontrolled – which is helpful if you're aiming for a realistic look.

9 Layer effects

Remember that skin doesn't look the same everywhere on your character, because it is built up of different layers. It's rough in certain areas, while elsewhere it's translucent, with veins shining through. I find it works well to set your layer with the texture to Overlay or Soft Light, picking a low opacity to achieve unique effects. I also add soft freckles to the faerie's face, setting the opacity to around 50 per cent, because as nice as textures are, they shouldn't be overused.

10 Refining the face

I make her hair a little windswept to imply movement and for a hint of mystery – that's also why I add the plaits. She should look happy and fresh without really smiling. Most parts of the face, and the hair, are painted with the same spackled brush as the branches. Use a Hard Round-edged brush with less flow for small details like iris highlights, the inner part of the eye, eyelashes, hair highlights and crinkles around her lips.

11 Mixing butterfly and dragonfly wings

I like to give faeries a unique character by giving them a special mixture of wings. It's good to draw one or two main wings which are nicely coloured and add some more translucent wings over them so she doesn't look too heavy. When I use butterfly wings, I look at several reference photos and copy different parts to combine them to a new one. My faerie wings will remind you of the peacock butterfly. I like to arouse the viewer's curiosity with the feeling that, although this is fantasy, there are elements they recognise from their everyday life.

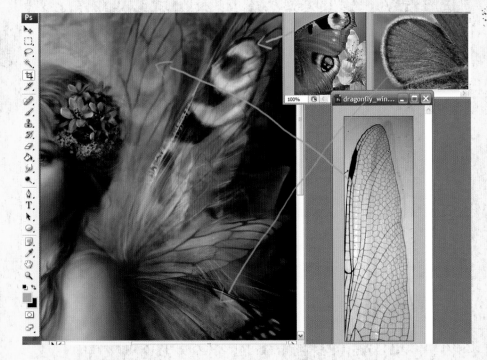

12 Dressing her up

My faerie wears a soft, almost transparent dress that fits with her fragile yet cheeky appearance. It's not the main focus, since faeries often wear much less – if anything – so I give it a violet tone and add flower patterns to the bottom. I pick up the flowers from her hair to add some kind of unity. It's nice if elements from your painting reoccur. They needn't be obvious, and could be merely the tiniest flowers like these – but the viewer will unconsciously notice them.

PROSECRETS

CHOOSE TOOLS WISELY

It's best to use the Adjust Levels rather than the Brightness/Contrast tool, because you can edit your image settings much more precisely using its histograms. You can adjust shadows, middle tones and highlights as well as the keytones. You can switch between the three RGB channels easily.

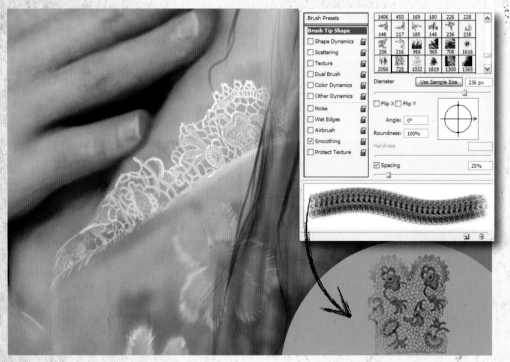

13 Lace and ornaments

I also add some kind of lace to the bottom of the dress. You can paint these little ornaments by hand with a Hard Round-edged brush or you extract textures from photos (finding different types of lace is easy once you start to look) and make special brushes from them. You can use them in a flexible way, perhaps adding some painted ornaments as well. I like to have a combination.

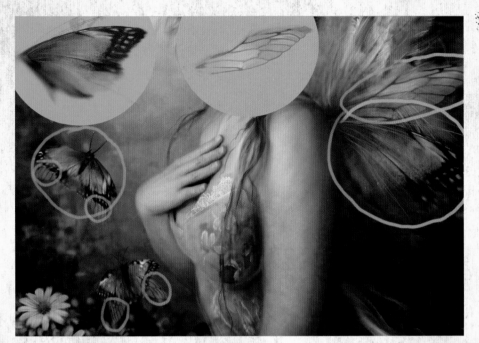

14 The winged creatures

I continue with the idea of repeating elements, and reuse part of the faerie's wings for the butterflies. I want them to look like they're part of the faerie and that they arrived with her in the clearing – almost as if they're some kind of messenger. I don't need to invest too much time into painting them because I have some key elements like the wings already created. I also don't think too much; just play around a little bit and wait until you're happy with the outcome. You can create fascinating creatures this way. Here, they unite the key elements of the painting itself: butterfly, dragonfly and faerie.

15 The flowers

For the flowers, use the same technique as the background – so most parts are just implied brushstrokes and dots and only the foreground flowers are detailed. This way the painting receives a feeling of depth. I choose flowers that announce spring and new life. The main colours are blue and violet again. The marguerites bring their own kind of freshness into the painting.

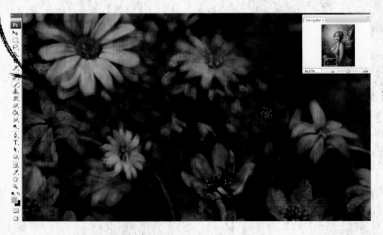

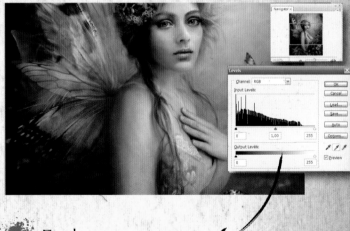

16 Final step

Merge the layers and check the contrast, colour balance and saturation of your painting. Play around with the settings a bit and see what appeals to you most. You should also find time to make any other minor adjustments, and don't forget to flip your image horizontally to see if there are any mistakes you missed.

WORKSHOPS

ARTISTPROFILE
VINOD RAMS

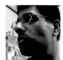

COUNTRY: USA
www.vinodrams.com

Vinod Rams is a concept artist and illustrator with
10 years' experience in publishing and video games.
Character and creature design are his passion and he
finds it very fulfilling when others get enjoyment from
his work. He also thinks he has a big nose.

PHOTOSHOP

PAINT A PLACID TITAN

Concept artist **VINOD RAMS** shows you how to create a character who's large and in charge

he 'Big Guy' character type is a staple of fantasy, sci-fi, and just about every superhero team. He adds an interesting dynamic to stories that have a standard human cast of characters. Here, I'm going to show you how I would go about designing such a character, from thumbnailing body types to painting a final rendered concept. I'll also show how the pose you pick for your concept should highlight the character's personality and I'll discuss ways

of emphasising the character's size and weight, the two most important design aspects for the Big Guy. There's a lot of freedom in creating a character like this; you can really push your proportions and have some fun with anatomy.

Early on I decided I didn't want to concept an evil or gross character, but someone who's a bit more appealing (I hope!) – a kind of loveable sidekick to the protagonist. He should be a gentle giant.

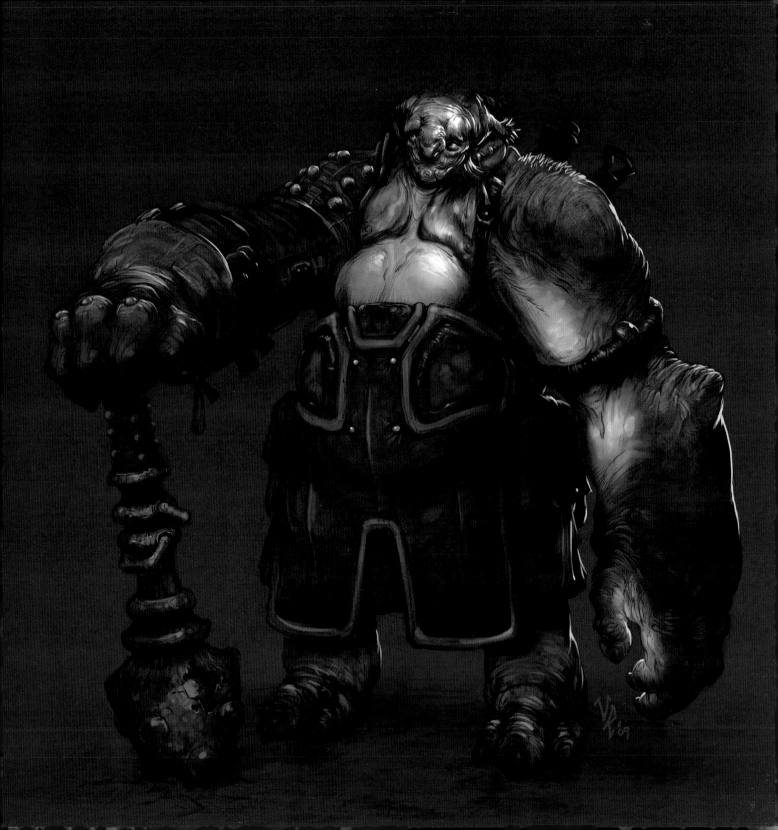

Body type

I have an inkling of what I want to go for with this character. I came up with the idea that maybe he's a blacksmith of some sort. I find some old pictures of blacksmiths on the internet for inspiration. From there, I grab my Sharpies and grey Prismacolor markers and start massing out some body shapes. I want him to have enormous arms, but I need to explore if he's going to be fat, muscular, stand erect, or have a hunchback. At this stage I'm also thinking of poses for the final concept.

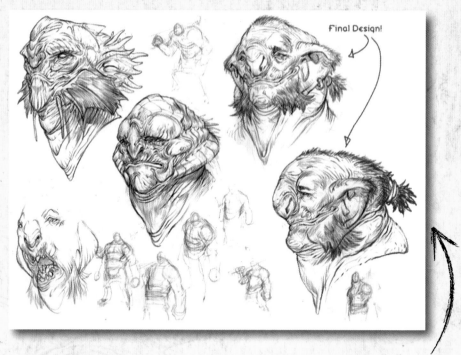

Final Design!

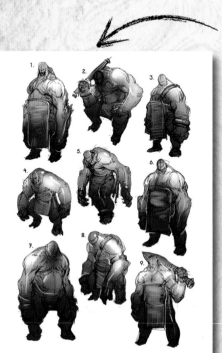

2 Big shapes

After sketching the shapes on paper, I scan the drawings into Photoshop. Whenever you design a large character you can emphasise his weight by making him darker at the bottom. I fill the shapes with a gradient of light and dark grey, placing the darker grey at the feet. This helps to ground the character. I also pull out a few highlights for clarity. Even if you're not going to show this stage to your client, it's always good to fill your shapes with a tone, as it makes the character's silhouette much easier to read. I'm happiest with the overall shape of sketch #1. Notice how his pecs are scrunched up leaving room for a big belly. I also like how his arms are massive and are almost touching the ground. He looks like he's intelligent, and not like the big oaf of the other sketches.

3 Heady goodness

While I'm letting the body shapes simmer, I decide to switch to designing the character's head. For any character design, you want to put a lot of your focus on the face. It's the first thing a person will look at when they see your art. Because I want my Big Guy to be a bit more lovable, I stay away from sharply angled or aggressive shapes. I keep things big, fat, and round. I also don't want to make a completely human character, so I draw upon animals for inspiration. As I block in the character's nose and mouth, I know it's the right design – it just screams friendly to me, a mix of sloth, elephant seal and gorilla.

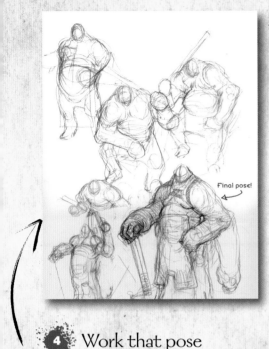

5 Rough drawing

I start my drawing in my sketchbook, using a non-photo blue pencil for my rough drawing. Using the basic body type from the thumbnails, and the pose I selected, I start building my character. At this stage I'm thinking about gesture, big shapes, weight and proportion. It's important when designing any character to keep it looking loose and relaxed. You don't want to start out with a stiff or rigid gesture; a relaxed pose will have more life and show more personality to the viewer.

4 Work that pose

Back in the shape stage I drew a sketch of the character sitting down with one hand on his leg and the other hand holding a weapon up on his shoulder. To me that shows a lot of personality, just from a silhouette. I start exploring that same pose some more. While I still love that idea, I ultimately decide that the concept should show off as much of the character as possible, and having a scrunched up pose with overlapping limbs doesn't convey the design as clearly. Nevertheless, it's good to do these exploratory sketches because they really help to inform the final pose.

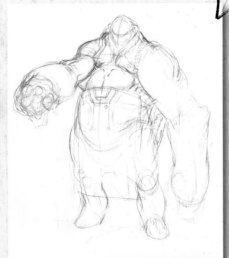

6 Working it out

Note the way I have his head cocked. Ultimately, I want his facial expression and body to be somewhat passive, like he's just happily standing there, waiting his turn to fight. You'll notice in my rough drawings that his right arm is insanely short. This is because I'm running out of room in my sketchbook!

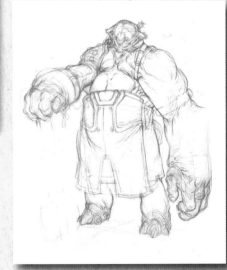

Paint a Placid Titan: Vinod Rams

7 Proportion and anatomy

As I'm finalising, I'm thinking of his body proportions. He's a big character overall, but I still find plenty of opportunities to vary his form – giving him bulky deltoid muscles, wrinkly elbows and fat feet. I also take some liberties; he'd probably need way bigger pectoral muscles to support those massive arms, but I want a contrast between his chest and stomach.

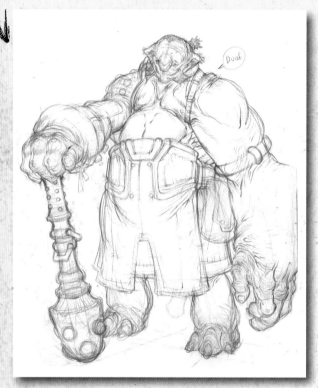

8 Fashion

The blacksmith reference inspired me to give him an apron as his primary article of clothing. I carry the motif of rounded forms which make up his body shape over into his costume design. This helps reinforce his weight and mass. Adding delicate costume details wouldn't make much sense – look at those hands! I was originally going to give him a big hammer as a weapon, but decide to go with a heavy mace. I further reinforce the design motif with his armband and the studs on his shoulder armour.

9 Final details

I switch to my regular graphite pencil to clean up the drawing. I want to emphasise his weathered skin – he's not going to be sharp and sinewy like Bruce Lee. I also pay a lot of attention to his face. I want to make sure the expression, especially in his eyes, is perfect. Since I've already designed the head, all that's left is to pose and 'animate' it. I scan the pencils into Photoshop and fix that right arm and adjust the size of both arms to match, and up the size of his mace.

11 Underpainting

Having separated my line art onto its own layer, I fill the canvas with a basic gradient. I want to stick with mostly earth tones for him, so I pick a deep red and a desaturated brown, which will also serve as the basis for the underpainting. Next I start to block in the local colour: dark brown for his apron and armour, and beige and grey for his skin. I also consult my animal reference for inspiration on colouration and skin detail. I'm using only basic soft and hard round brushes at this point, but it's good to turn the scattering on to get some variation for the skin.

10 Create a mask

Create a clean selection of my line art using the Magic Wand. Next I make a new layer and fill the selection with grey. Any time the selection is needed, I select the layer and Cmd/Alt+click. It's a good way to check the silhouette and create an easy-to-load mask to use as I paint.

12 Don't get ahead of yourself

I spend a lot of time rendering underneath the lines. I keep working until the painting looks almost half complete. I pick a simple overhead light source and block in my shadows using a new multiply layer (placed above the line art layer) after I get my base colour down. I use a basic grey and colour it using Colorize in the Hue/Saturation palette.

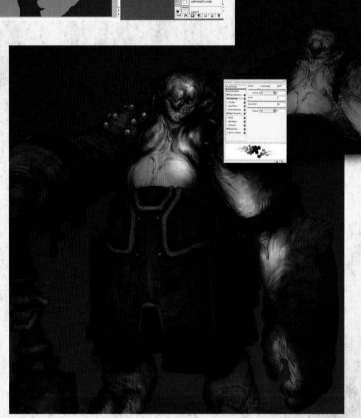

Paint a Placid Titan: Vinod Rams

14 Keep tweaking

As I add detail to the Big Guy, I also tweak his design. I notice his left arm is looking like it's sagging, so I use Edit>Free Transform>Warp to beef it up a bit. I also feel as though his stance needs to be improved, so I make a selection in order to both move and Free Transform his feet into a better position to help his balance. Lastly, I add two more weapons on his back; an easy way to give him more silhouette value.

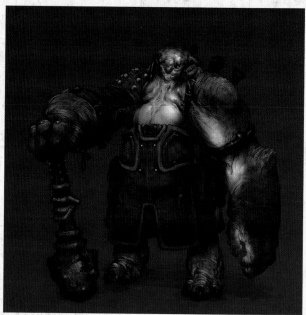

13 Consult the ref

Once my underpainting is complete, I start a new layer above my line work and start detailing the forms. My style combines line work with opaque painting, so I like to leave some lines showing in the final art. I decide not to go fully photo-real with this concept. So rather than overlay photos of elephant or rhino skin onto the image, I just paint it using the reference.

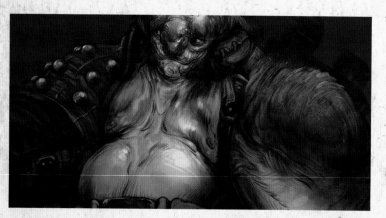

15 Stay on target

I want to create a focal point to draw the viewer's eye. The most important details here are the head and upper body. I use more loosely defined brush strokes on his apron and arms, while tightening up for detail on his head and shoulders. The eye is drawn to the areas with tighter detail. When working on an important area, I make sure not to use too many brush strokes or messy marks, and I watch that my values separate well and help to describe the form. Busy strokes confuse the eye and cause the viewer to look for focus in the wrong place.

17 Bells and whistles

One concept art trick is to add a bold rim light on a character to pop out their shape from the background. It's not always realistic but it does help sell the design. I rough this in to see if it works and then refine the edges. I also use an Overlay layer and a soft round brush with some pink hues to warm up the skin tone on his chest and left arm. Finally, I copy his chest and head onto a new layer and hit them both with the Dodge tool – just another trick to pop out important highlights and focus the viewer's eye.

16 Supersized

To emphasise how big and bulky this guy is, I make his musculature react to his clothes. To do this, I overlap his skin on his armband and squish it around his shoulder strap. To increase the size of his belly, I use Filter>Liquify to make his apron look even rounder.

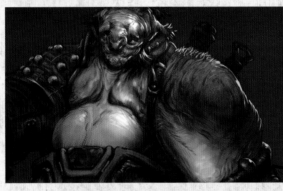

18 Finished!

I think in the end he looks heavy, strong, and friendly. I think I'll name him Marvin. I'd want him on my side for sure!

shortcuts
SELECT THE BRUSH'S OPACITY
Number keys 1 to 0
Hit the number keys to change the brush's opacity – so 4 would be 40 per cent.

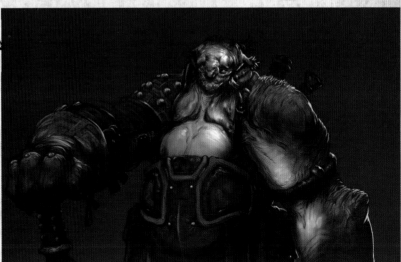

Paint a Placid Titan: Vinod Rams

ARTISTPROFILE
BOBBY CHIU

COUNTRY: Canada
www.imaginismstudios.com

Bobby Chiu is an artist from Toronto, Canada. He started his career at the age of 17, designing licensed toys for Disney and Pixar. As the head of Imaginism Studios, Bobby's clients now include TV and movie production companies.

PHOTOSHOP

The Big, Bad Bunny Eater

Discover how **BOBBY CHIU** can turn a simple 15-second sketch into the biggest threat the bunny world has ever known, and then try out the same techniques for yourself

As an independent artist, clients often ask me to help them come up with interesting and innovative designs for creatures or characters. There are almost as many theories on how to create a successful original character as there are artists in the industry, but this isn't a character design workshop, so I won't dwell on the design process I go through each time. Instead I'll take you through my own specific thought processes as I generate a creature that I find interesting. My main focus here, and on the following pages, will be on how to paint life into your chosen creature.

Before my client can sell my idea to their audience, I need to sell my idea to my client. This brings up my first and most important principle: when designing a character, I must install into it a broader idea, something that can potentially be built into a global, multimedia, marketing phenomenon.

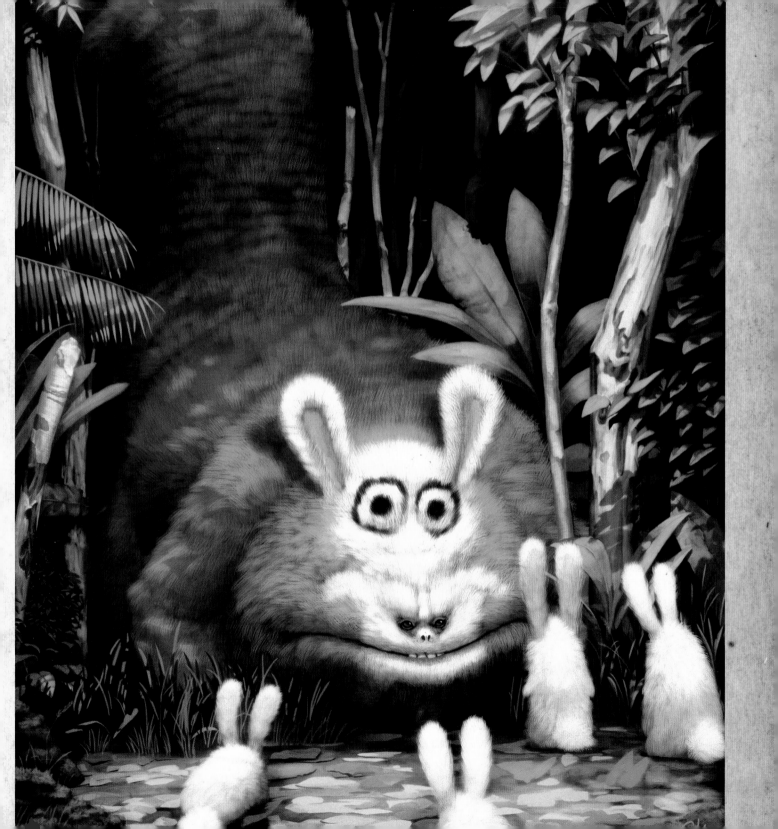

1 The initial idea

When brainstorming your initial creature idea, remember that animals have a reason for looking and acting the way they do. So imagine that your creature is something that's normally found in the wild. Where does it live? What does it eat? How has it evolved in order to survive in its particular niche? Think of as many details as you can because it will be these that make your creature compelling.

My initial idea was for a creature with a large eye pattern on its face. But how can this be an adaptive feature? Maybe its facial markings help it hunt or attract prey, such as rabbits. This sounds interesting, so I decide to work with it.

2 The initial sketch

So now I have an idea, it's time to get it down on paper… er, computer screen. As you can see, the first visual of my creature is a very loose drawing that I did in about 15 seconds. Your initial sketches shouldn't take longer than this at the experimental stage. You might end up developing dozens of different initial images before you settle on your final image, so conserve your energy.

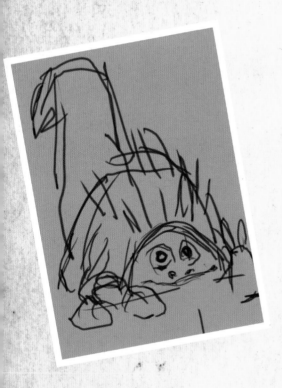

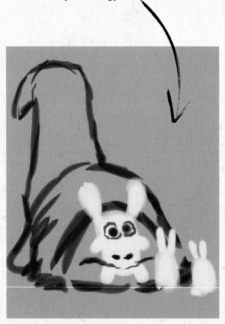

3 From bones to a skeleton

When I like what I have in my bare bones doodles, it's time to piece them together into the skeleton of my painting. I turn down the Opacity of my initial drawing and work out a second sketch that better explains my idea. At this stage, the concept of a camouflaged predator becomes clearer. You can see how its facial markings resemble a bunny, including its bunny-like ears, the large anime-ish eyes that started this picture, along with its actual beady and evil-looking eyes and the wide mouth to gulp down real bunnies. For good measure, I've also incorporated my creature's prey into this sketch because without them my creature would be just a bizarre monster that inexplicably has a white bunny on its face. It has to make sense.

4 A little clean up

I turn down the Opacity of my skeleton image and sketch over it with finer lines, adding more detail. Two more bunnies have joined the party. Oh boy, it's going to be a bloodbath.

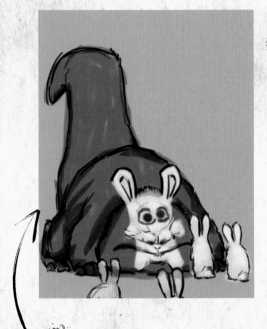

6 Refining light with a mask

This is a key technique that I highly recommend. I add colours and simple environmental structures to my rough painting. Once I have a rough worked out, I refine the lighting effects by making a mask of it. To do this, I first bring out my base colours and add some general lighting from the top. Until this point, the major layers for my rough should be in one folder. I make a copy of this folder, and flatten it into a layer. Now I have a duplicate of my rough, which I brighten and put into a mask. I lay my brightened rough mask over my original, darker rough and paint the whole mask black. This hides everything on that layer and allows me to add lighting quickly and easily by simply painting white into spots where I want to expose my brighter mask. This technique saves me from picking out lighter colours and painting them on to my rough individually. (I use this masking technique several times over the course of a painting. Again, this is an invaluable trick to know!

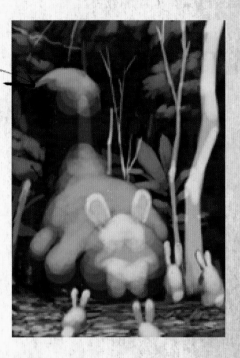

5 Adding tones and lighting

I add tone to address what the rest of my creature looks like. To maximise contrast, I make the body of my creature dark while keeping the bunny face very light. Composition-wise, this gives the image a duality: you can view the painting from the bunnies' perspective by focusing only on the face of the creature, or you can take the National Geographic-style macro view and see the painting as a whole.

After the tones, I add some lighting. I decide that such a large creature must have an equally large background to camouflage itself against. It would have a hard time blending into flat prairies or bare grasslands, so my creature must be a forest-dweller and whatever light hits the ground must come straight down through the canopy.

7 Textured layer

I take images of scanned leaves and mesh them together to create a textured layer, which I place over my rough and set to Soft Light. This will leave a hint of texture all over the painting and give it a more life-like feel.

PROSECRETS

ZOOMED IN, ZOOMED OUT
When sketching, I like to work with a zoomed-in window and a duplicated, zoomed-out one simultaneously. I use the zoomed-out window for large shapes and the zoomed-in one for details. This mimics the painting technique of stepping back from the canvas to view the image, and helps to ensure that my sketch has good composition and balance throughout.

8 Detailing the background

Now I sharpen the edges of background structures, such as leaves and tree trunks. I use colours that are local to the part of the painting that I'm detailing, using high Opacity and high Flow but close enough to the original colour that the contrast is subtle. One by one, I carve out a solid silhouette for each structure in my painting. Then I add in light and shadows, and finally colour variations. This is painstaking but vital. I start at one corner of the page and work my way across until all the leaves, vines and trees in the background are fully represented.

9 Redefining the creature

The first thing I do when I start to paint my actual creature is block in its silhouette using a solid-edged brush with the Opacity turned down to about 80 per cent, so I can see what I'm painting on top of. Once I have the silhouette clearly defined, I apply a simple lighting scheme to my creature using colours very close to those I'd blocked in with, followed by a redefining of the creature's musculature. At this stage, I try to alternate passes of light and shadow in order to maintain a balance between light and dark.

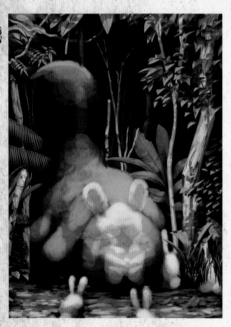

10 Custom brushes

For body covering, I want to make a Custom Brush to fill in my creature's fur. First, I open a new document. I want to make a size 80 brush, so I set the dimensions of my document to 80x80 pixels. On this new document, I paint in 8–12 dots of varying shapes and sizes, all small. Next I go to Edit>Define Brush Preset, and name my new brush. I'm calling it Fur Brush. I click on the Toggle the Brushes palette button and open the Options menu. Under Brush Presets>Brush Tip Shape I turn the spacing of my brush down to one per cent. This will ensure when I paint with my custom brush, I produce a series well-defined lines instead of lines of dots everywhere.

11 From dark to light

Now that I have fur on my creature, the last thing to do before I get to the tweaking phase is adjust the lighting. Putting together all the layers I've developed for my creature at this point, I'm able to use the masking technique from Step 6 to quickly adjust lighting on my creature.

When choosing colours for this, I prefer to imagine what the creature would look like in the shade and use that as my base colour. And then I brighten it where the body catches the light, going from dark to light.

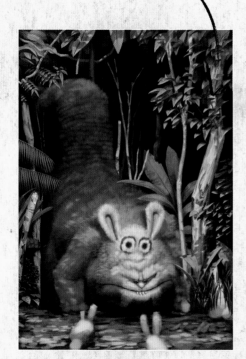

PROSECRETS

PICKING COLOURS

We normally determine how light or dark a colour appears to be by comparing it with the colours surrounding it. This is why, when selecting colours, I Eyedrop a colour locally from my painting to use as a reference point and only use my Colour Picker to adjust its hue and tone. This way, I can ensure the colour I select will fit in well.

12 Detailing the foreground

I've completed the background and the middle ground, so I now need to finish off the foreground. The technique for doing this is the same as Step 8. I paint using colours sampled from the locality of my image I'm detailing. I carve out shapes for grass and fallen leaves – structures in the foreground – before applying light to each individually. I add the bunnies last because they're the closest to the point of view and therefore in the fore-foreground. Going from dark to light again, I consider what colour the bunnies would be if they were sitting in the shade and I use that as my base colour. Then I apply fur using my custom brush followed by lighting using the mask technique.

13 Finishing touches

The painting is almost complete. All that's left to do is make minor adjustments and enhance the details.

I want to use another mask to cast a filtered, hazy type of glow to warm up my image, so I duplicate my image and open the Filter>Blur>Gaussian Blur, which controls how much blur I get. In this case, I go for a radius of 4.9 pixels.

Then I change the Layer Mode from Normal to Screen. This brightens the entire image. Now my Warm Light Mask is complete. Using the steps outlined in Step 6, I lay my mask over my original painting and paint over the spots that I want to introduce additional sunlight to.

Now the image is 99 per cent complete. The last thing I have to do is flatten the image and add some Noise (just 2.5 per cent) and that's it. Break out the champagne, I'm done!

shortcuts
INCREASE/DECREASE
[and]
Use the square brackets to quickly increase and decrease your brush size in Photoshop.

ARTISTPROFILE
JONNY DUDDLE

COUNTRY: UK
www.duddlebug.com

After many jobs, Jonny somehow ended up in the games industry where he worked as a concept artist for seven years. In 2006, he left his 'day job' to freelance as an illustrator for children's book publishers and as a concept artist in the entertainment industry.

PAINTER AND PHOTOSHOP

SEXY SIREN

JONNY DUDDLE combines humour with the faintly erotic and a group of painterly pirates

I've not done any illustration work that could be considered erotic. So when I was asked to produce a piece of erotic art, I was initially flummoxed. I thought about painting a saucy space vixen, a flirtatious fairy or a Barbarian babe in a furry bikini. I even tried a few sketches, but none of them seemed to hit the mark and I was getting frustrated.

Until I found an old sketch that I'd done of a mermaid. This started off as a small doodle in Photoshop while I was working on something else. There was something about the mermaid scribble that I liked, so I saved it for possible future development. I've got folders full of doodles that never become anything more, but as I was browsing through them for some hidden nugget of inspiration, she popped out immediately. I love drawing pirates and I've always wanted to paint a mermaid, so a sinister siren tempting a few bedraggled pirates into range of her bloodstained axe seemed like a good idea!

I often try to tell a story in my illustrations, and my art style has an unavoidable humorous bent, even if everyone in the painting has a frown on their faces. So I'll attempt to create an interesting illustration that contains both humour and eroticism. Whenever I've tried to be even remotely erotic in real life, I'm usually laughed at, so it shouldn't be too difficult to get some humour into my painting, but how about the 'erotic'? Let's see...

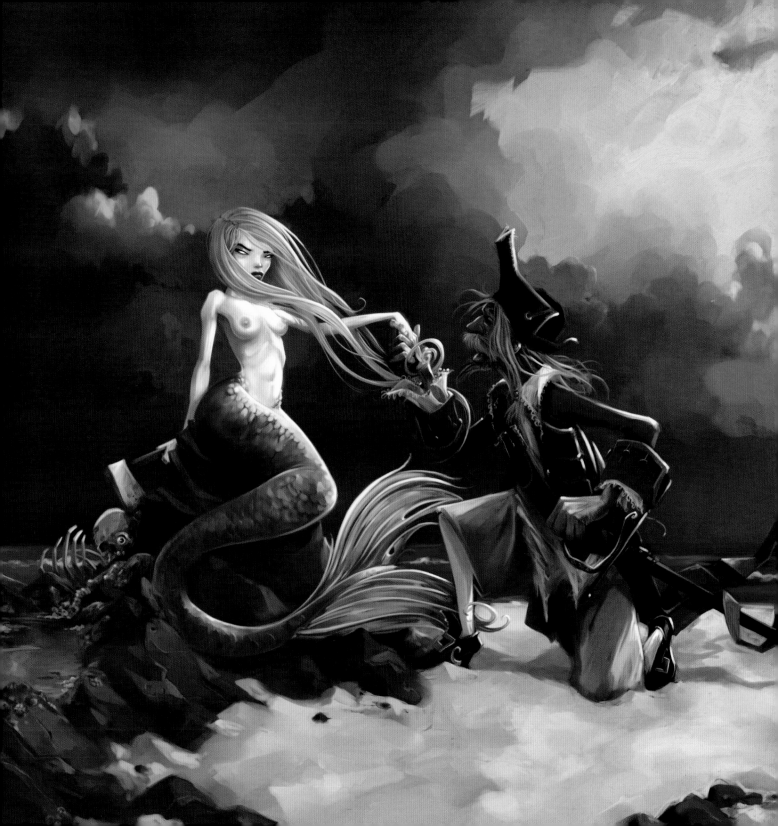

1 The concept

I start developing the existing mermaid sketch by adding pirates. The gangly pirate captain comes first, followed by a small contingent from his crew. I want the pirates to be a ramshackle bunch that will contrast nicely against the siren. I use a Divine Proportion template that I've screen-grabbed from Painter X to firm up the composition, more for a bit of fun than any serious attempt to nail the layout at this stage.

2 Monkey or no monkey?

The drawing stage is dragged out over a couple of weeks, with 20 minutes here and there, and the pirates move around the canvas in a compositional jig. I keep each element of the sketch on a separate Photoshop layer, which helps me arrange the layout until I'm happy.

At one point a monkey appears, which I think might add to the comedy, but I decide it's a bit much (and not particularly erotic) and that I should probably try to do some paintings that don't include monkeys, so he doesn't make it into the final line art.

3 Laying down some colour

The scene is a desert island, so my initial approach is to paint in a bright blue sky and some golden sand. At this stage I'm not too worried about getting the colours right, but aim to fill in the canvas with paint. I always find it easier to get stuck into a painting once there's some colour to play with and I've got something to evaluate, rather than when I'm faced with line art on a white or grey background.

4 Re-splitting into layers!

At some point between arranging the composition and painting in some base colours, I'd flattened the line-art into one layer. I now realise that this will cause me problems in the early stages of the painting's development, so I bite the bullet and go through the tedious process of splitting the composition into its three main elements: the background, the siren together with the pirate captain, and the three observers. This will make it easier to work on the environment in particular.

SHORTCUTS
GROUP LAYERS
Ctrl/Cmd+G
During the initial sketching stage of this image, I grouped some character drawings to keep things organised.

5 Adjusting colours

The sky seems a bit garish, so I create an Adjustment Layer and fiddle with the hue and saturation. I mask out the sand (which I'm relatively happy with) during this process, so that the Adjustment Layer doesn't affect it. I also start blocking in some suggestion of colour on to the pirates. I create a layer with the blend mode set to Soft Light, and paint in some dark colours to pick out the clothing and form of the three figures. I like to work from a dark base colour, building up lighter the lighter tones, so at this point in the painting everything's pretty muted.

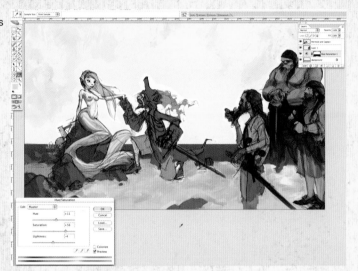

6 The siren's face

I've been putting off developing the drawing of the Siren's face. The initial sketch had a surprised look that seemed a bit too innocent and cute. I want this siren to be more sinister than that. I scrub out the cute eyes, and go for a more vampish look that should be warning enough to put off any pirate.

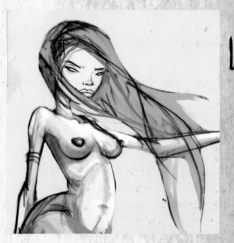

PROSECRETS

APPROPRIATE LEVELS OF DETAIL
I got a bit carried away with the detail in the siren's tail and it was becoming a magnet for the viewer's attention, so I drastically reduced the sharpness of the scales and fins so that her upper body, face and hair would be more prominent. It's important to use appropriate levels of detail in the different areas of a painting. Generally speaking, the focal points of a painting should contain the most amount of detail.

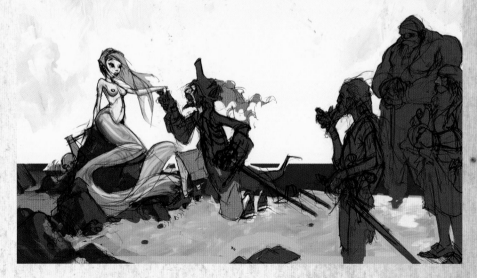

⑦ Painting the sky

I decide to bring in some menacing-looking clouds to match the sinister looking siren. I move from Photoshop to Painter, and work from a few different reference photos using chunky brushes from Painter X's Artists' Oils and a great blending brush (courtesy of Don Seegmiller), aiming to keep a loosely painted sky with bold marks and big swathes of dark cloud. These pirates really should have twigged that something fishy is going on. I enjoy trying to develop the narrative within my illustrations, and any visual clues to what's about to happen can help the viewer to interpret the story. In this case, the calm before the storm...

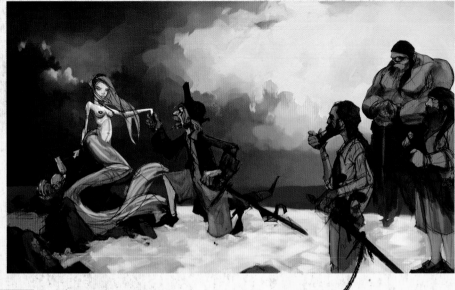

⑧ Thinking about lighting

With the sky painted in and more work done on the background; I get a better idea of where I should be heading with the characters. By using the reference photos, I've ended up with a light source off to the right of my canvas and this needs to be taken into account when I begin painting the pirates. The faces of the pirates will be in shadow and this suits the composition, because the focal point needs to be the siren, who will be face on to the sunlight. She can be much more brightly lit, almost glowing in fact, which should contrast nicely against the dishevelled look of the pirates.

⑨ The big fella

I get stuck into the chunky pirate. He's a big fella, and I want to give him a brooding sense of power, but he doesn't need to look particularly clever. I start by picking colours from the base I painted earlier and eradicating most of the scruffy line art. His musculature starts to appear more convincing and he feels more solid as the lines disappear. I possibly get a bit 'tight' while painting his face, but this painting has five distinct characters, and I'm going to work them up to an almost finished level one by one.

10 Developing the other pirates

The other two pirates follow the same procedure. I paint them one at a time and work them up to an 'almost finished' level. The skinny sea dog puffing on the pipe gets more attention than the bearded buccaneer on the far right, because he's more prominent in the composition. He also gets a little more light across his white shirt, to make him really stand out from the other two crew members. I'd like the viewer to look at him after the siren and the captain, and wonder if he might notice the axe, or the remains of previous victims because of his position on the sand.

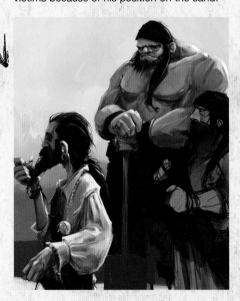

11 Get your rocks on

I want to get some detail into the rocks and sand, but I don't want the foreground to compete with the characters for the viewer's attention. The rock pool is important to the story, because it will contain some remains from previous victims, but this shouldn't be too blatant on first glance. I do another search online, and find some good rock reference to work from. I also want the rocks to works as a compositional aid to help frame the siren.

PROSECRETS

ADJUSTMENT LAYERS
An Adjustment Layer is a wonderful tool for making all sorts of changes to a Photoshop document. What makes Adjustment Layers particularly useful is that they remain editable and can be applied to certain layers. You can also mask out areas that you don't want to be affected. You can use Adjustment Layers with a range of palettes including my favourites, Levels, Curves and Hue/Saturation. Create an Adjustment Layer by going to Layer>NewAdjustment Layer>Levels, for example.

12 The sea

The sea takes up much less of the canvas than I originally envisaged, but is an important element that cuts across the whole canvas and separates the beach from the ominous clouds in the background. It's simply painted in varying shades of blue, green and turquoise. I then pick out a few lines of incoming surf. One of the great things about the pale sand and the viewing angle is that the eye happily sees quite a distance of beach in just a few millimetres of paint.

Sexy Siren: Jonny Duddle

13 The pirate captain

This pirate captain is no extroverted dandy of wealth and means, but is instead a scruffy old timer who is a few decades past his prime. He needs to obviously be the captain, so I paint a coat that may once have been rather grand in days gone by, a gold-trimmed tri-horn, and some stockings and shoes that hopefully suggest his status. I want his clothes to accentuate his gangly gait, so keep them baggy and tatty and swirling in the sea breeze.

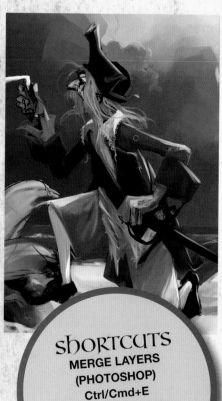

14 The siren

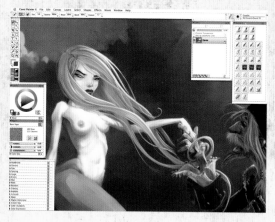

I usually pile into the most interesting, and fun, part of a painting very early on; but in this case I've left the best bit until last. It might be fear of painting a semi-naked female, which is something that I've done a lot of in various life classes over the years, but very little of in my illustrative work. I spend a lot of time on the torso, trying to get a skin tone that I'm happy with. I want the siren to glow so keep to a pale complexion, and end up with blue hair, rather than the black mane I was planning from the start. This is an attempt to emphasise the mythical nature of the siren and I think it looks good against the captain's coat and the orange tint to the lighting. As a finishing touch, I paint a few strands of hair encircling his wrist and arm, as though the siren has already got him trapped.

15 Fish tails

The siren's tail is the trickiest part of the painting. I didn't foresee any problems with this and had lots of fish reference at the ready, but when I get to work on it, it always looks too detailed next to the rest of the painting and some of the strong hues from the fish reference stand out too boldly in the composition. I also have a battle with the saturation of the colours in the tail. They keep coming out too vibrant, so I take the artwork into Photoshop and calm it down a bit

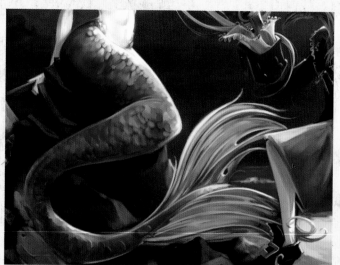

with another adjustment layer which I merge down. And then I go mad with a grainy blender (in Painter) wiping out most of the detail I've spent an hour or so painstakingly painting. I've gone full circle and it looks almost 'rough' compared to where it was heading, but the finished tail seems to sit happily in the painting and that's what's important.

shortcuts
MERGE LAYERS (PHOTOSHOP)
Ctrl/Cmd+E
Once I'm happy with a new layer, I'll collapse everything to a flat canvas.

16 Blood and guts

To hint at her wicked intent, I decide the siren should have the remains of previous victims lying on the rocks behind her. I don't get too absorbed in detail with the bones, blood and guts on the edge of her pool. All that is required is the suggestion of the pirates that have gone before. A few brush marks should do the trick.

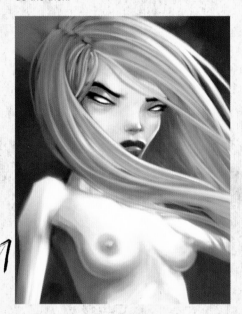

shortcuts
LEVELS (PHOTOSHOP)
Cmd/Ctrl+L
The Levels palette is incredibly useful for cleaning up scanned drawings.

18 Final adjustments

And that's pretty much it… Out of curiosity I take the painting back into Photoshop and try a few Adjustment Layers. Some tweaking of the Levels seems to bring out the colours and emphasise the important areas of the painting, so I leave the Adjustment Layer in place and see its effects by painting with black on to its mask.

17 More details

I'd worked each of the characters up to an almost-finished standard on the first pass, so this stage of the painting doesn't take long. I try adding an iris and pupil into each of her eyes, but it detracts from her appearance, so revert to the empty white eyes.

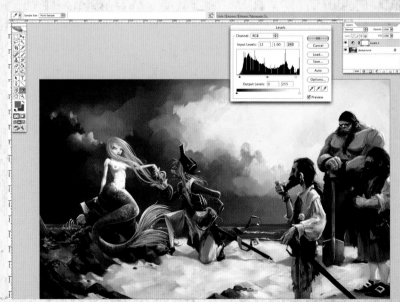

Sexy Siren: Jonny Duddle

ARTIST**PROFILE**
MARC POTTS

COUNTRY: UK
www.marcpotts.com

Marc is a UK based folklorist, occasional author and faerie artist, best known for his darker, pagan twist on faerie art. The elementals, nature-spirits, gods and goddesses of myth and the imagination are his main subjects.

The NATURE OF FAERIE ART

Folklorist and faerie artist **MARC POTTS** reveals his top 20 tips to get inspired

 kay, so this isn't a workshop on how to paint faeries and it's certainly not a bunch of tips on artistic technique. I paint art based on folklore and mythology – witches, dragons, gods and goddesses – but I am mainly known as a painter of faeries. A bit of a girly subject? Not at all. Faerie folklore is steeped in pagan mythology, and if you look into it you soon realise that you could be reading about the pre-Christian deities. You'd also realise that faeries aren't all lovely; in fact, more often than not, faeries can be dark, sinister and plain nasty. I personally find it much more fun to paint the dark, the wicked and the downright bizarre.

The advice that follows is more about my inspiration, sources of ideas and how I approach my faerie art.

1 Do Faeries wear stripy tights?

There's definitely a market for the pretty Victorian image of a faerie in a wispy, flowing dress, or even the modern punky-looking faeries in stripy tights, giving off a bit of an attitude. It's a convention and there's nothing wrong with following it.

2 Not all faeries are girls

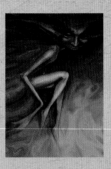

Don't forget the male of the species and the plain weird. A hedgehog could be an urchin – a faerie in disguise. Imps, goblins, brownies, pixies and elves are often considered to be male faeries. Titania is a popular subject, but Oberon and Puck shouldn't be forgotten. There's lots of scope for being unconventional.

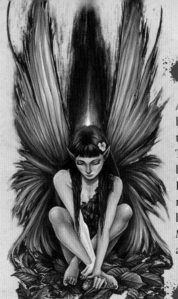

3 Scene it

Think about the backdrop – where would faeries be most likely to lurk? Hedgerows are good; they're boundaries, which are an important aspect of faerie lore. Faeries could be found in gnarled old trees, or anywhere tangled with nature and inaccessible to humans.

4 Folklore

Get hold of some books on faerie folklore, then read and assimilate. A *Dictionary of Fairies* by Katherine Briggs is a great source of ideas, as is her *Fairies in Tradition and Literature*. *The Fairy Mythology* by Thomas Keightley is also a good resource. There are a lot of faerie A-Zs available, but one that must feature on your list is *Faeries* by Brian Froud and Alan Lee.

5 Faerie Types

Here are just a few of the many faeries that can be found in ancient folklore: Asrai, Apple Tree Man, Banshee, Barguest, Bogie, Bwca, Changeling, Coblynau, Derrick, Dwarf, Elf, Ellyllon, Fir Darrig, Faun, Firbolg, Ganconer, Gnome, Hag, Hedley Kow, Henkie, Hinky-Punk, Imp, Jenny Greenteeth, Killmoulis, Knocker, Leanan Sidhe, Lepracaun, Mermaid, Muryan, Ogre, Pwca, Phenodyree, Puck, Selkie, Skriker, Troll, Will O' the Wisp, Woodwose. Look 'em up!

6 Mythology

A bit grander in scale than folktales. Poring over books of world mythologies will soon pay off, throwing up ideas for the weird and wonderful. This can be applied to all forms of fantasy art, but there are faeries here, too. Think of the Elves, Orcs and Trolls in *Lord of the Rings* – all mythologically-inspired versions of the genre, but faerie art nonetheless. The Irish Mythological Cycle and the Welsh Mabinogion are good local examples.

7 Faeries ain't pretty

Faeries can be sinister beings. Use this notion when developing a character – combine beauty with something odd, like a hare's foot in place of a hand, or twigs for hair. A faerie doesn't have to have wings, either. Simply making the eyes odd can set it apart from humans. Faeries often appear beautiful, but there will be something that gives them away.

8 Think Nature

I see faeries as nature spirits or elemental beings, so look to the natural world for inspiration. Leaves, twigs, feathers and bits of plants could all be incorporated into a faerie character. I often do this as part of the faerie itself – organic growths sprouting from the back or head, or from an arm or leg. And if you must clothe your faeries, apply the same approach to elements of clothing – a dress made out of leaves or a mask of twigs and feathers. I'm always collecting stuff for reference when I'm out and about.

9 Do your research

This is an important one – it will make your character more believable and give it substance. I'm not suggesting that you hide yourself away for years and eventually emerge as an authority on mythology. Simply putting in a few hours' research is perfectly adequate.

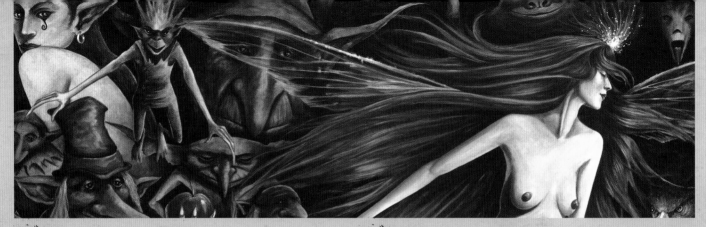

 ## 10 Simulacra

Look with an artist's eye. Gnarled goblin faces could peer out from the bark or roots of a tree. Dragon heads could form in the shape of a weathered rock. If the morning light is just right, faerie creatures leer out at me from the pattern in my bedroom curtains. If you really want to see them, they'll appear.

 ## 11 Colour

Faeries are the shades of nature – the greens and browns of autumn leaves and the delicate hues of flowers. The greencoaties and Green Lady are denizens of the faerie world, as are the brownies and brown men. The names all suggest their colours. Adding a splash of bright colour to the subdued tones can create a glow.
I use mucky colours and build up translucent layers. Don't be afraid to experiment.

12 Get them to pose

Try meditation or path-working to see them in your mind's eye – visit a wild beautiful place, somewhere that faeries might lurk, to spark the imagination. Try to connect with the spirit of a place and you never know, a faerie might just pop out and pose for you. It does help to be a bit nuts as well...

 ## 13 Animal bits

Faeries are said to be shape-shifters, so try incorporating animal parts that give this away. Faeries with gossamer insect wings are the obvious choice, but how about using moth wings instead of a butterfly wings? Get a field guide and study the patterns. Paint faerie characters with frog legs or rabbit ears, horns or antlers. Some faeries could appear very insect-like – who's to say that a mayfly isn't a faerie?

14 Make them glow

Faeries can be considered manifestations of supernatural energy, pulsing with light. You could suggest this energy with the flow of a painting, using sinuous lines to guide the eye. For instance, faeries don't need wings to fly, so they don't need to be structurally perfect. Instead of giving them solid wings, try wings made of light and colour.

 ## 15 Suggest a narrative

This approach lends itself well to faerie art. Has something just happened? Or might it be just about to happen? Suggest a narrative and let the viewer's imagination do the rest. Allow the viewer to involve themselves and create a story in their mind. This can really inspire, and make a picture magical. I sometimes have a half-formed story in my head when I start a painting, and at other times a story might come later. Either way, you're creating folklore.

16 Elemental symbolism

Faeries can be classified according to their elemental nature, and this can be followed in character development. What might a fire sprite look like? Or a dark earthy Trow? An air spirit would probably appear slight and ethereal, and although a mermaid is an obvious choice for water, why not think outside the box and paint an Asrai or even a Jenny Greenteeth? Faeries themselves could be connected to the elusive fifth element of spirit.

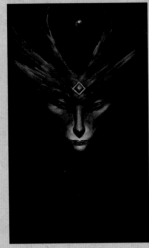

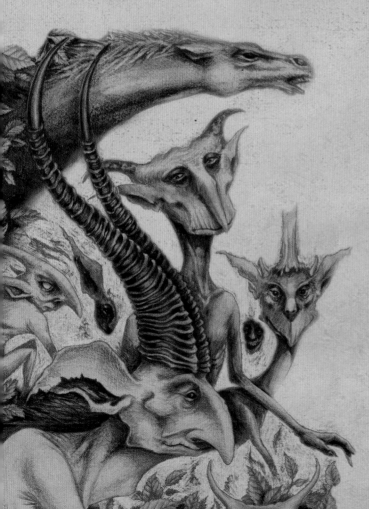

17 Sketching and doodling

It sounds obvious and every artist does it – but I'm constantly doodling faerie faces, wing ideas, goblins and dragon heads. I also sketch interesting bits of nature, leaf shapes, feathers – anything that catches my eye and imagination. Build up sketchbooks full of reference material that you could incorporate into a painting.

18 The Goddess and the Green Man

Are they the king and queen of faeries? I often incorporate a green or brown-man foliate face in a faerie painting, sometimes with antlers or horns to represent the Lord of the Woods. The Green Lady or the twiggy haired hedgewitch archetypes represent, to me, a form of the faerie queen or a forest goddess.

19 Faerie art masters

Be inspired by those who have gone before: Rackham and Dulac, John Bauer or Richard Dadd. John Anster Fitzgerald and Joseph Noel Paton took inspiration from folklore and Shakespeare. Also, look at the masters of natural history art.

20 There are no rules

You can ignore all of the above and paint what you like. It's not that there are no rules, more that, as with the world of faeries itself, the rules are weird and the possibilities of your imagination really are endless.

BEASTS IN 3D

2

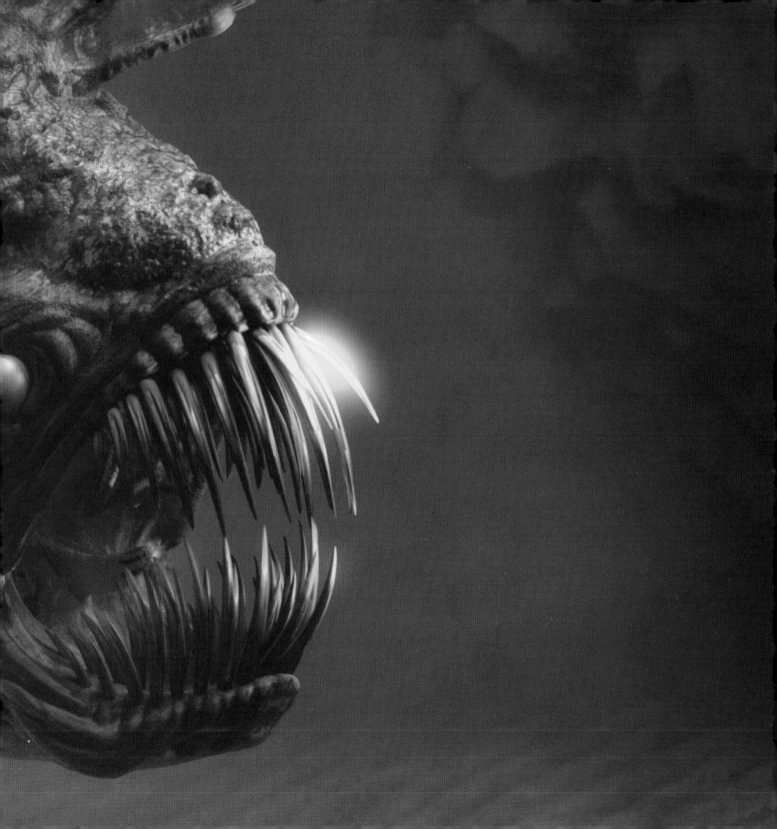

ARTISTPROFILE
SCOTT SPENCER

COUNTRY: New Zealand

Scott Spencer is a creature and character designer at the Weta Workshop in Wellington, New Zealand. He's worked on a variety of projects, from supplying make-up effects and design for film to sculpting characters for the collectables market.

ZBRUSH

CREATING A BEAST 1

SCOTT SPENCER breathes life into a creature using ZBrush, a handful of brushes and a simple sphere

ver the past few years, ZBrush has revolutionised creature design for films and games. Using conventional painting, sculpting and illustration techniques, the concept designer can generate three-dimensional artwork with brush-based tools that can be confidently labelled 'artist friendly'. Any ZBrush artwork can then be painted to define the creature's skin texture, and finished in Photoshop to create a compelling illustration that's guaranteed to capture the viewer's imagination.

In the first instalment of this two-part workshop, I'll show you how to use ZBrush to create an other-worldly beast from scratch. I'll use just a few brushes and a simple sphere to help make the process straightforward – even if you've never touched

ZBrush before. Part one looks at how to sculpt in ZBrush, focusing on design considerations such as the relationship between shapes and forms. You'll find out how to see your creature in abstract terms and work in silhouette. Trust me – it's just like drawing thumbnails using a marker pen.

In part two I'll assemble and paint the beast using ZBrush and Photoshop to create a compelling final image that's ready to go on show. Note that the final sculpted head you see here was created entirely from a simple ZBrush sphere – no complex modelling software was involved in the process. In all these steps I'll use the basic ZBrush tools to their full advantage, proving that the software is not only user-friendly, but easy to master because of its intuitive approach to design.

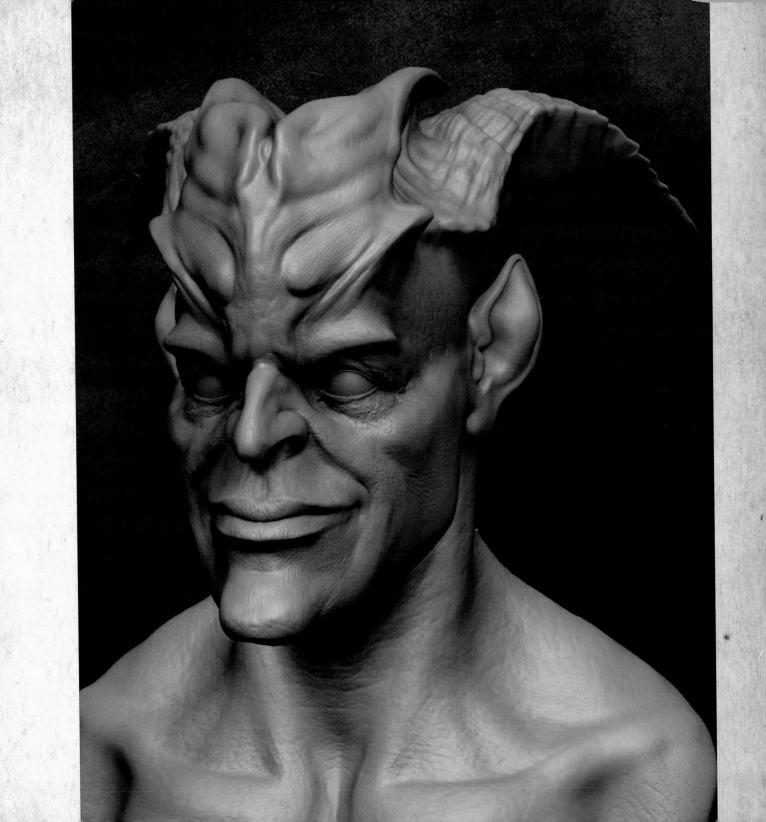

2 Get a move on

I use the Move brush to change the shape into something resembling a head. To speed things up, I press [X] to activate X symmetry. This duplicates any changes on one side of the object on the other side. I adjust the ZIntensity and Draw Size sliders to control the brush. You may want to add subdivision levels with the Divide button. These increase the sphere's resolution, so you can create more complex shapes. Save your work as a Tool.

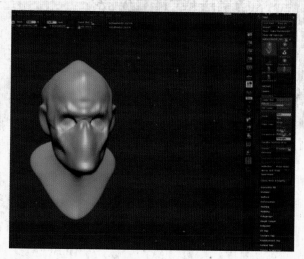

3 Create a head shape

I establish the shape of the skull with the Move brush. I also pull the neck and shoulders down from the bottom of the sphere – simply adjust the Draw Size to pull the neck down and out. I vary the subdivision levels using the slider under Tool>Geometry. Lower values work better for overall shape changes, while higher ones suit more subtle alterations and adjustments. You can see the sculpture in perspective by pressing [P].

1 Take a ball of clay

I begin by selecting an object to sculpt. In ZBrush you can sculpt models imported from other 3D programs, or work on a ball of clay generated by ZBrush itself. There are several ways to create a base object in ZBrush that's ready for sculpting; for character heads, I prefer to use a simple sphere. When you start the software, the Polysphere is the default object. It's the simplest basic form, and with just a few brushes it can be turned into a dynamic creature bust.

SHORTCUTS
MOVE BETWEEN SUBDIVISION LEVELS
To step down to a lower level, press **Shift+D**. To step back up, press **D**. **Ctrl+D (PC)** or **Cmd+D (Mac)** adds divisions.

4 Control your brushes

At the top of the screen are sliders to control Brush Size, ZIntensity (or strength) and Brush Modes. To access these, right-click the tablet pen to bring up the Quick menu. Press Alt to add or subtract matter with the brush. If I keep ZAdd activated for my brushes, holding down Alt switches the brush into subtract mode. Releasing Alt returns it to normal. To smooth my sculpture as I go along, I press Shift to activate the Smooth brush.

5 Material world

Sometimes it's useful to change to a more neutral-looking material. I prefer to use either Matcap Gray or Basic Material. To change materials, click the Material palette on the left of the screen; Matcap Gray is under Matcap Materials. The Basic Material is under Standard Materials. Unlike the Matcap Gray, the Basic Material has a noticeable shine, which can be helpful for seeing objects accurately. Both of these materials are preferable to the default red shader, which is slightly translucent and can make it difficult to view your work properly.

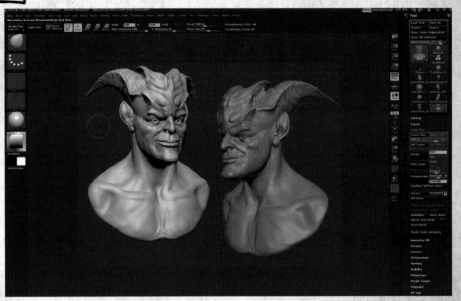

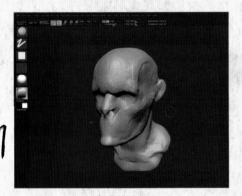

6 Get blocking

The Claytubes brush adds form to the surface, much like scooping into soft clay. I use it to add the secondary forms of the head, such as the cheekbones and muzzle. When using a brush, I can hold down Alt to switch from building out to pressing in on the sculpture. Here, I press Alt to carve out the eye sockets. This is like changing from ZAdd mode to ZSub.

7 Get a more rounded view

As I establish the shape of the head, I regularly rotate the bust to check on my progress. The danger of working too long in one viewpoint is that the finished sculpture can look flat and lack definition. At this early stage I try to see the sculpture simply in terms of broad strokes and general shapes. I can see that the face looks acceptable from the front, but from the side it's far too flat.

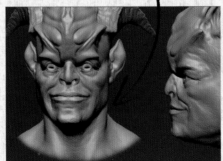

PROSECRETS

SAVING FILE FORMATS
ZBrush enables you to save your work as Tools or Documents. Documents are just images and can't be moved around. When you save in ZBrush, always save as a Tool: go to Tool>Save as or press Ctrl+S and press the Save The Tool button.

8 Add eyeballs

I select Tool>Subtool and click Append to sculpt the eyes around a spherical shape. The Polysphere tool, found in the Subtool menu, attaches it to the head. When I press Transparency on the right side of the screen, the sphere sits inside the head, although it's too large to be an eyeball. I need to change its size and position, then mirror it.

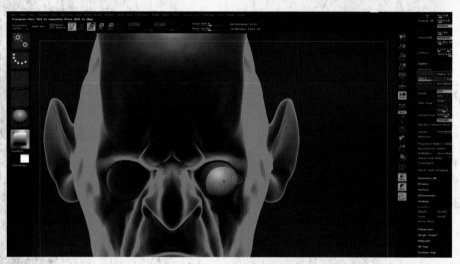

9 Transpose and mirror the eyes

I use the Transpose tools to move the eyes in relation to the head. You can access these tools via the Transpose, Move and Scale buttons at the top of the screen. I press Move, then click and drag to create a Transpose line. It's possible to move the sphere by clicking inside the centre circle, and once I'm in Scale mode I use the outer edge of the Transpose line to scale the eyeball down. When I'm happy that it's the right size and in the correct position, I can mirror it by clicking ZPlugin> SubtoolMaster>Mirror. This creates a new Subtool with both eyes combined.

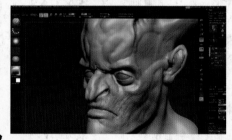

10 Make the eyelids

I use masks to create the eyelids. Masking helps to create more specific shapes by isolating some areas from the effect of your brush. When I select the Standard brush and hold down Ctrl, the brush goes into Masking mode (indicated by a yellow cursor). I can now paint the shape of the eye on the mesh with a mask.

11 Sketch wrinkles

The Standard brush is particularly effective when sketching in wrinkles. I keep the ZIntensity value low so the shapes don't become overstated. Using the Standard brush and holding down Alt in ZSub mode, I add wrinkles radiating from the mouth area. I also begin to build wrinkles in the brow. Note the direction of the arrows and how the wrinkles flow from the cheekbone down to the mouth.

Use masks to sculpt the lips

The upper lip typically overhangs the lower one, so I need to mask the lower lip to work the shape of the top lip. First, I hold down Ctrl and paint a mask on the lower lip and chin. Next, using the Move brush, I shift the upper lip out slightly. I then set the Standard brush to a small draw size and create a sharp edge where the lips join the face.

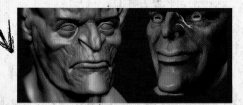

Apply gravity to the flesh

It's important to create the impression of gravity acting on the flesh when sculpting the fleshy bits of the face, such as the nasolabial folds at the sides of the mouth, otherwise the face ends up looking somewhat plastic and unnatural. Gravity is constantly pulling on all aspects of the face, and its effects are most obvious in these loose, fatty tissues.

I use a mask to isolate the area for the nasolabial fold and then build up the shape with the Claytubes or Inflate brushes, keeping the ZIntensity setting on a low value. Once the form is built up, I use the Move brush to tug it over the masked area slightly.

Extract the horns

I decide to give the creature a pair of horns. I start by simply masking the area they will grow from. I invert this mask by holding Ctrl and clicking, then use the Move brush to pull the horns from the head. I base the shape on buffalo horns – they need to have a discernible step down from the front view and a majestic sweep back from the sides. I sharpen the edges using the Pinch brush.

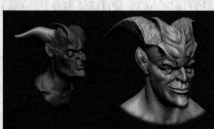

PROSECRETS

MASKING IN ZBRUSH

You can help make more precise shapes by using masks. Masks will isolate some areas of the sculpture from your strokes. To paint a mask in ZBrush, hold down Ctrl and your cursor will turn yellow. This means any strokes will apply a dark mask to the surface. If you click and drag from outside the model you'll draw a marquee that will mask anything inside the rectangle. Hold down Alt as well to subtract from your mask.

Create balance

Whenever you add a new feature to a character model, it's vital to consider the effects this has on the rest of your design. Here, I feel that the two sets of horns are both strong statements that don't compete with each other. A third statement, such as antenna, might cause the design to feel cluttered. Note how the lines of the head and horns sweep through each other and are mutually supportive. This helps to create unity across the creature's head and makes it more pleasing to look at.

Sculpt in silhouette

I remove the shading by changing to the Flat Colour material, which creates a silhouette of the creature – just like drawing with marker pens on paper. Click the Material Palette icon on the left-hand side of the screen, then select the Flat Colour shader. I use this technique to ensure that the character's profiles are working. By using the Move brush to make changes while in flat shade mode, I can make bold design decisions without having too much information and choice.

Creating a Beast I: Scott Spencer

17 Sculpt the ear

The creature's ears need masking to finish them off. I make sure I've added several subdivision levels before sculpting the ears, beginning at level five. Once I've pulled the general shape of the ear out from the head, I isolate the inner ear with a mask and use the Claytubes brush to define the shape of the inner ear. I then invert the mask and use the Move brush to shift the outer ear (or helix) out and around the inner ear. This creates the ear's complex overlapping of forms.

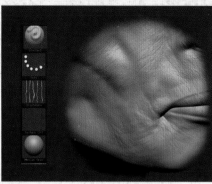

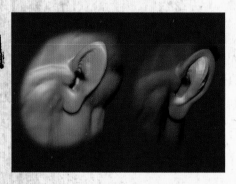

18 Work with alphas

I use the standard ZBrush brushes and Alphas to spruce up my creature. Alphas are simply images used as brush tips. For the underlying skin texture, I select the Standard brush, open the Alpha palette and select Alpha 58. I hold down Alt and stroke the brush over the skin in circular motions. I then drop the Brush Draw Size to 60 and the ZIntensity to 10 to create a fine, crosshatched skin pattern.

19 Work between levels

It's important to move between the brush subdivision levels regularly. A good rule of thumb is to always work at the lowest possible level that supports your design. If you try to sculpt all your forms at the higher levels, the brushes have too much material to work into and they tend to generate soft, blobby results. It's like trying to paint a portrait without first establishing the large-value shapes. The end result becomes unfocused because there was no broad base to start with.

20 Use texture stamps

When adding skin details, you can take the texture stamp approach by changing a few brush settings. First, I click the Lightbox button, select Alpha and pick Leathery Skin 15. I then close the Lightbox and change the Stroke type to Drag Rect. I click and drag the character's head to generate the texture on the surface. You can also use the Inflate brush with a ZIntensity setting of 5 over the finer details. This puckers the small, crosshatched wrinkles together in a manner similar to the bunching of fine wrinkles found on human skin.

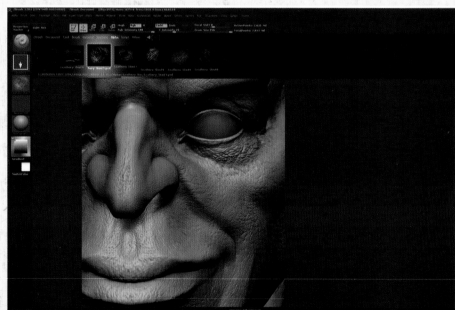

21 Create the neck

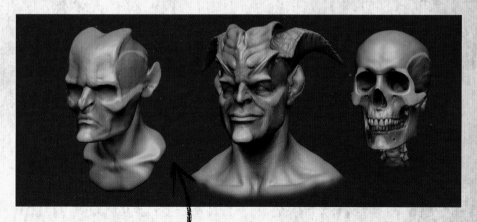

Using the Standard brush, I add the muscular and skeletal landmarks of the neck. With a combination of ZSub and ZAdd, I etch the clavicle bones and the tensed heads of the sternomastoid muscle into the clay. I create the muscles not so much by building them up, but by carving away some of the negative spaces between them. This helps make the forms more subtle, as if there really is a layer of flesh over the bone and muscle. I smooth as I sculpt to refine the skin's surface.

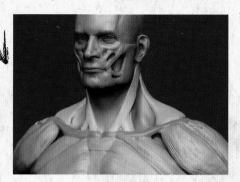

22 Establish bone landmarks

It helps to establish the bony landmarks of the face at the start of the sculpting process. These help me gauge anatomy and proportion, as well as give the character a sense of structure and form. Visual appeal is created when soft, fleshy areas are contrasted and compressed against bony forms, such as here in the cheekbone. By maintaining a sense of where the skull is while I sculpt, there's always a roadmap to the facial features that I can refer to while I'm working.

23 Export a render

To create a portrait render of this head, click Document and deselect the Pro option, then set Width to 1,680 and Height to 2,240 and click Resize. Ctrl+N clears any images from the canvas, which is now blank. Now click and drag the stylus pen to 'draw' a new copy of the head on this blank canvas. I press the Edit button, rotate the head into place and press the AA Half button at the right of the screen to anti-alias the image. Once I'm happy, I select the MatCap Gray material and press Render>Best. I export this by going to Document>Export and save it as a TIF or PSD.

PROSECRETS

NAVIGATION IN ZBRUSH
To navigate in ZBrush you can either use the Move Scale Rotate buttons on the right-hand side of the screen or rely on the following hotkeys. To rotate simply click and drag your stylus anywhere in the window off the model. To Move hold Alt then click and drag. To zoom, hold Alt, press your stylus down on the screen area off the model, release the Alt key and move the stylus up and down – this tricky combination will zoom the model. It takes a little practice but you should master it in an hour or so.

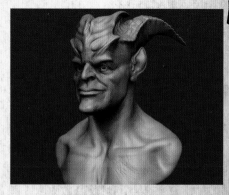

ZBRUSH AND PHOTOSHOP

CREATING A BEAST II

In part 2 of his ZBrush workshop, **SCOTT SPENCER** designs a colour scheme and creates a Photoshop painting of his creature

I'm going to use a few simple brushes to design the creature's skin in ZBrush. My techniques are based on real-world airbrush strokes that are used by make-up artists to paint animatronics and prosthetics. By laying down colour in passes of random dots, I'll create a skin texture that's both vibrant and realistic. What's even better, is that this is a loose and fast process.

This particular approach is successful because there are several layers of colour that have been generated in a non-ordered manner. These layers combine to give the appearance of skin. Once the paint scheme is designed, I'll pose and finish the illustration in Photoshop, creating a compelling image of the horned beast.

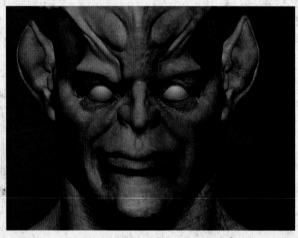

1 Optical mixing

I start by designing a skin texture for my creature using a technique that's based on optical mixing. This is the term used when you place two colours close to each other so that they mix in the eye of the viewer – for example, dots of red and blue located together appear as a violet shade. This approach helps to create a skin tone that feels more interesting and 'alive' to the viewer.

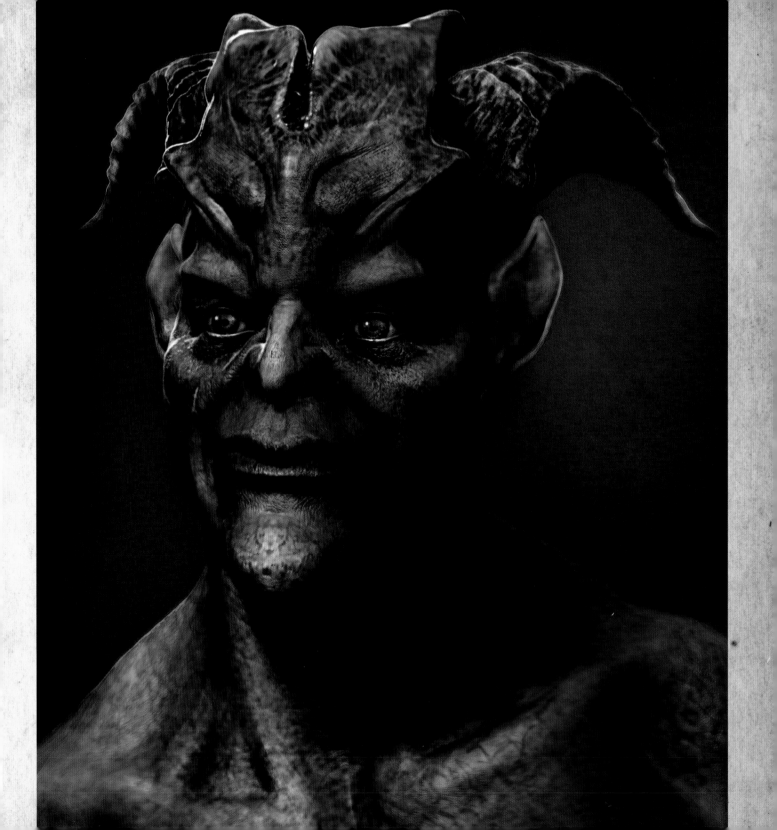

② Customise ZBrush

I move two buttons to within easy reach to make things easier. Click Preferences >Custom UI and select Enable Customize. Next, click the Color menu, hold down Ctrl and drag the SysPalette button down to just beneath the Color palette. I do the same for the Fill Object button. With these in place, turn off Enable Customize again and save the changes by clicking Preferences> Config>Store Config.

③ Prime the creature

I need to prime it with a base colour. I load the ZTool in the Tool menu, and from the Color palette I choose a suitable base hue for the skin – a sickly pale purple will work well here. I then coat the head with this colour by clicking Fill Object.

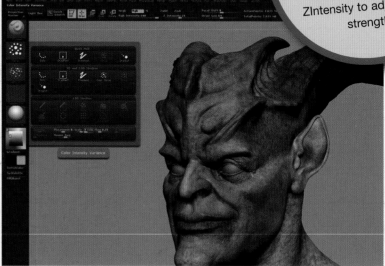

④ Create a Spatter brush

ZBrush uses the same brushes for both sculpting and painting, so I need to customise a brush to make it behave like an airbrush. To do this, I select the Standard brush and turn off ZAdd at the top of the screen. Now that Only RGB is selected, the brush will just add colour. From the Stroke menu, I then select Spray and alter the Color Modifier value to 0. The final step here is to pick Alpha 07 from the Alpha menu.

SHORTCUTS
BLEND AS YOU GO
Press **Shift** while painting to turn on Smooth mode. Ensure ZAdd is off and Only RGB is on. Use ZIntensity to adjust blend strength.

5 Temperature regions

My initial pass of colour is an overstated temperature pass. Using the Spray brush, I apply blocks of red, blue and yellow to specific areas of the head. I use blue for the recessed areas and the beard line. I apply red to the cheeks, nose, ears and chest, with yellow for the forehead, cheekbones and collarbones. These colours start to suggest secondary hues where they overlap with each other.

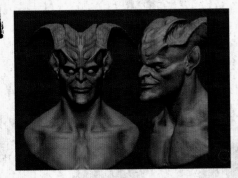

6 Mottling pass

Next, I select the Freehand Stroke and change it to Alpha 01. The following pass is called mottling, a term that simply means little squiggly lines. I cover the head with a single mottling pass, so that when I put on thin washes of the base skin tone later, the squiggles help modulate the intensity of the temperature pass as it shows through. Mottling can be done at any stage during the paint job.

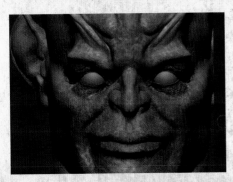

7 Create realistic flesh

Here's where the layers of colour begin to merge and become more realistic. I select the original base colour and lower the RGB Intensity to 12 or 15. After making sure that the Spray Stroke is active, as well as Alpha 07, I lay in passes of the base colour over the mottled layers. As the colours sink into the skin, they give the flesh depth. It's a difficult technique to grasp until you try it out. You'll get the best results when the mottling pass is as tight and light as possible.

8 Adding contours

This is the process of painting in shadows and highlights on a 3D surface. It's a technique often used by make-up artists to change the appearance of an actor's features, and here I'm using it to accentuate the sculpture of the creature's head. After choosing a raw umber hue, I begin to spatter dots into the recesses around the bone structure with the Spray Stroke. I build up the colour slowly with a low RGB intensity setting. This helps strengthen the forms of the head that could otherwise become obscured by the painting process. It can also be used to add character, by shading into eye sockets or hollows of the cheeks to create a sense of menace, for example.

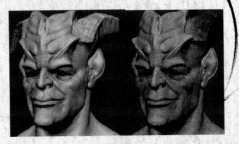

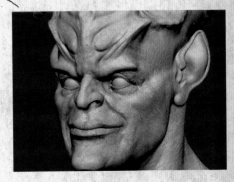

9 Cavity masking

To accentuate skin texture and head forms, I select a yellow ochre hue and click Tool > Masking > Mask By Cavity to mask the recesses. I turn off View Mask and paint over the bone structure, inverting the mask to paint only in the recesses (Tool> Masking> Invert). I add a light layer of veins on the cheeks, nostrils and eyelids, and do another Spray Brush pass in raw umber, to age the character.

10 Sculpting and painting the eyes

I use the Standard brush to sculpt a recess in the sphere of the eyeball for the pupil and iris. By having a sphere with the accurate indentation of the iris along with the pit of the pupil, it'll be easier to paint the iris of the creature in Photoshop. It's also helpful to have the pupils indicated so that the creature's gaze is obvious when it's posed for the final illustration. A lot can be implied about the character by the direction of his gaze.

11 Posing the head

To prepare the model for posing, I select Zplugin>Transpose Master, click T Pose Mesh and press Move to access Transpose move mode. I mask the head as explained in part one of the workshop, then draw a transpose line by clicking and dragging from the base of the skull to the bottom of the shoulders. Now I click and drag inside the middle circle to rotate the head on its shoulders. To offset the creature's posture slightly, I click and drag in the centre of the bottom circle to rotate the shoulders. Once I'm happy with the pose, I click Transpose Master>TPose SubT.

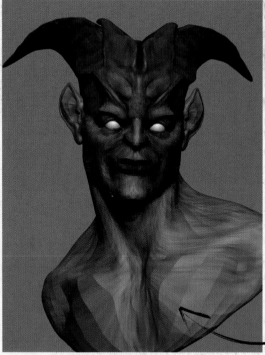

12 Prepare for export

I click Document and turn off Pro, then resize the image to 1,680x2,240. Ctrl+N clears the canvas, and I redraw the bust by clicking and dragging the Tablet pen. I press [T] to enter Edit mode. Next, I click AAHalf on the right to activate anti-aliasing. This setting must be on for every image that I export.

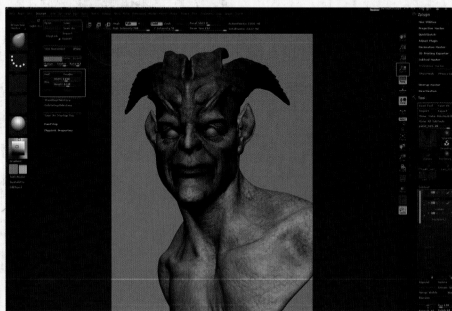

13 Store position with ZApplink

With the position stored, I can export multiple versions of the same view without worrying about accidently moving the sculpture. I can also come back later, make changes and export a new image to drop into the Photoshop file, knowing it'll line up perfectly. I turn the head to a dramatic angle and check that I'm in Perspective mode by pressing [P]. Clicking Document>ZApplink Properties>Cust1 stores this position in the Cust1 button for quick recall. I save this by clicking Save Views.

14 Multiple exports

I want to export different versions of the ZBrush sculpture. By taking advantage of ZBrush's materials, I can create Blending layers to combine in Photoshop, producing interesting effects. I select the Matcap Gray material from the Material menu, then click Render>Best. When the render is complete and with AAHalf on, I click Document> Export to save it as a PSD file. I repeat this for Basic Material, Flat Color and Skin 4.

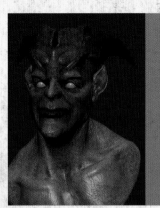

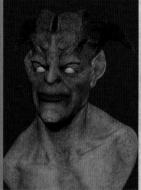

15 Produce shiny skin

A special Blending mode image will help make the skin shiny. When I take this image and add a Screen Blending mode to it in Photoshop, the skin will get a sheen that's tricky to achieve otherwise. I choose a black colour and press Fill Object. Now, I select the basic material and click Render. This renders an image with only the shiny highlights of the character, which I export as specular.psd.

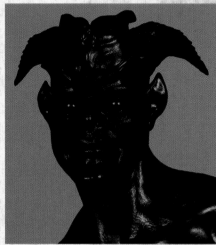

PROSECRETS

SAVE YOUR BRUSHES
When you find a brush setting that works well, save it by going to Brush>Export. Save it in the \Pixologic\ZBrush 3.5 R3\ZBrushes folder so it'll be in the Lightbox menu each time you launch ZBrush.

16 Create a depth pass

Before moving to Photoshop, I save a depth image from ZBrush. This is a greyscale file that represents the distance of the character from the camera. I'll use this as an Alpha mask in Photoshop on several Adjustment Layers. This depth image will make it simple to create depth of field and atmospheric perspective effects. I click Alpha>GrabDoc and press the Export button, saving it as depth.psd.

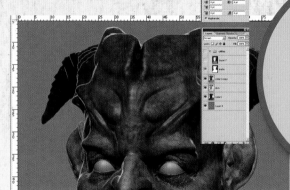

SHORTCUTS
SWITCH COLOURS AS YOU WORK
Press **V** to swap quickly between the primary and secondary colour swatches while you work.

17 Photoshop layers

In Photoshop, I open depth.psd, and under Image>Mode, convert the file to 8-bit RGB. I also drop it down to half its size so that it's the same resolution as the other images I exported earlier. Then I save the file, close it and click File> Automate>Load Files Into Stack. From the resulting window, I load all my exported images into a single layered file. If you're using Photoshop CS3 or earlier, you'll need to copy and paste each image into a layer manually. Once the layers are in place, I save the file as a PSD. I'm now ready to begin the finishing touches.

18 Photoshop blending modes

I place the Flat Color image over the Basic Material one and set Flat Color Blending mode to Overlay, pushing up the contrast and saturation in the skin. Depending on how intense an effect I want, I can desaturate the colour in the Overlay layer. Pressing Ctrl+U brings up the Hue/Saturation menu, where I reduce the Saturation. I use the specular.psd image with the Screen Blending mode.

19 Overlays for texture

Adding a layer of noise can make things feel less digital. Photoshop's noise filter tends to weaken your blacks by lowering the image's overall contrast, so a better approach is to add an image of a noisy random pattern as an Overlay layer at the top of your stack. I've used a shot of a concrete wall, but most stock photos of a noisy texture will work. I reduce the Opacity to between 30 and 50 per cent.

20 Depth image

I use the depth image as a mask in an Adjustment Layer for atmospheric perspective, then collapse the current layers into a single composite layer. Then I add an Adjustment Layer, paste the depth image into the Alpha channel and adjust the sliders to see how the effect is scaled for distance from the camera. I can reverse the effect by inverting the Alpha channel (Ctrl+I).

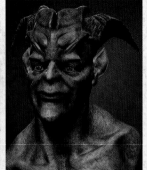

 When I render my image in ZBrush, it ends up looking plastic and dull. How can I light my image in a more dramatic way?

ANTONIS PAPANTONIOU REPLIES

The default lights in ZBrush are there to enable you to see your 3D models clearly while you sculpt them. The problem is that these lights are too revealing, and arguably, the more you reveal in your image, the less drama you will achieve.

You can observe this in nature. The most dramatic lighting occurs at sunrise and sunset, especially when the sunlight is partly obstructed by clouds. During those times, shadows lengthen and objects are fused together in lit outlines. Details on the objects are not fully described, but the outlines and the shape of the shadows imply them.

To set up this kind of dramatic lighting in ZBrush, go to the Light menu and click once on the first light. This will place the light behind your objects. Click and drag this light to the side.

Add a second Sun-type light and activate the Radial button so that only the outlines of your objects are lit. Add one more Sun-type light and place it in a position that's opposite to your main light source.

Now pick some colours for your lights. If you make your main light a warm colour, pick cool colours for the other two or vice versa.

It is time to add Spot-type lights to selectively reveal details in your image. Click on P in the Placement submenu and drag in your image to place it. Use the Radius dial to increase or decrease the lighting range. Pick colours for your spots. Remember that coloured lights are visible only when using Best render mode.

This image is lit by the default ZBrush lighting. This light set-up is too revealing, and removes any sense of drama from the image.

This is the same image lit with a dramatic light set up. Apart from the lights, everything else (material, colours and textures) remains the same.

WORKSHOPS

ARTISTPROFILE
KHALID AL MUHARRAQI

COUNTRY: Bahrain
www.muharraqi-studios.com

Khalid Al Muharraqi is the son of Abdulla Al Muharraqi, one of Bahrain's pre-eminent artists. He studied a wide variety of artistic subjects before setting up an advertising company, then founding Muharraqi Studios.

3D SKILLS

hunter of the deep

Create detailed sculpts in ZBrush that can be used in other 3D applications with expert **KHALID AL MUHARRAQI**

A lot of people think it's strange that I use so many different applications. Many 3D artists tend to stick to one or two programs but, coming from the background of a traditional artist, I have no problems with mixing media to get the result I want. In 3D, I use whatever tool helps me get the result I need.

Today, applications are talking to each other better than ever before, and that enables someone like me to get the best of all worlds 'mix' different technologies in order to get the results I want. This is something I hope to share in this workshop.

For Hunter of the Deep I've used three main applications: ZBrush, Modo and LightWave. I'll be going back and forth between them to show how a detailed sculpted model, created in ZBrush, can be exported and used in other applications. Read on to find out how.

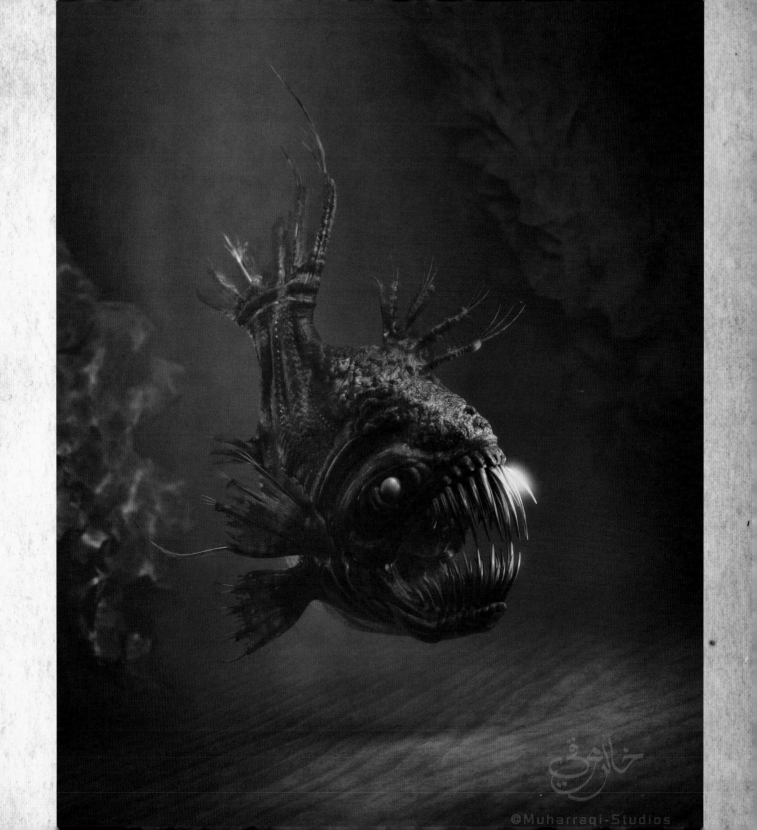

1 Concept sketch

Artists begin to conceptualise and put together their ideas by sketching, and this applies to everything from graphic design to illustration to architecture. I've always started with a sketch, as my background is in traditional art and I learned from my father that this is always the best way to start every project you do.

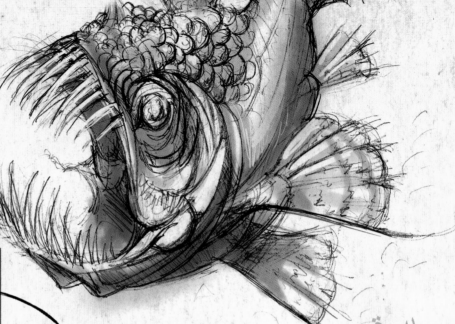

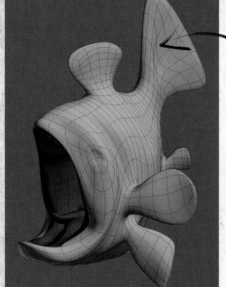

2 Modelling

Generally, I use LightWave and Modo for modelling. The basic model geometry that I created for this project is 1,182 polys, which is very low, and the whole purpose of having a low polygon mesh on this exercise is to simplify the modelling element for the artist. In this way, you start from a basic canvas, which can be done with ZSpheres on ZBrush or in any other 3D application. You can sculpt in the detail later on.

3 Sculpting mesh in Modo

Once the basic mesh is ready, make the general shape of the model closer to what you're looking for. In Modo, go to the Tool palette, choose the Centre Selected drop-down list and go to All. This enables you to centre the object for symmetry sculpting. Click on the Symmetry tool and switch it to X. Make sure that in the Sculpt and Paint palette, you have the Paint mode on Mesh.

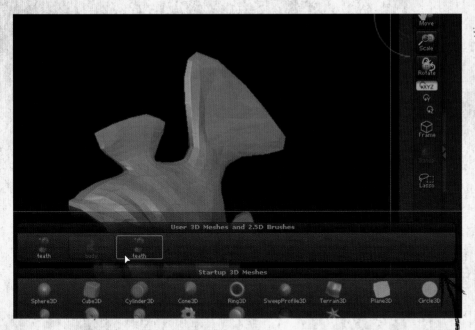

6 Pre-sculpting

In order to be ready for sculpting in ZBrush, you'll need to have at least two levels of subdivision. Click on the Geometry palette and subdivide the geometry to a level that you like. On this project I've gone to level seven, which takes the poly count to 4.8 million. The shortcut for SubDivide is Ctrl/Cmd+D. Press X to switch on Symmetry mode and you're now ready to sculpt.

4 Exporting the basic model to ZBrush

Open the model in your 3D application (in my case it's Modo) and export it into two files. One file will be the body geometry and the other, the teeth, fin bones and eyes. The reason for this is to make things easier later, when you're importing it back for normal maps usage.

5 Loading into ZBrush using Subtools

You'll want to keep the fin bones and teeth on another workable layer. In order to do this, go into the Tool panel and click on Import 3D Mesh. Import the body geometry, and once you see it in the Tool palette, repeat the process for the other file. In order to use the Subtools, click on the body object once and drag it into your viewport so that it's visible on screen, and make sure you switch on Edit Object in order to work on it. In the Subtool panel, click on Append and select the teeth layer, and it will appear in the top panel.

PROSECRETS

IMPROVE YOUR BAKE QUALITY
The higher the level of geometry subdivision, the better the quality of your bake will be. As it gets lower, your bake will seem more pixelated.

I usually start with the Z intensity, under ZAdd, at about 11. Now you can start sculpting artistically and go between the lower and higher subdivisional levels as you're working, depending on how much detail you need on screen in order to push and pull the geometry.

Imagine that your image is a bit of clay that you can add to by clicking ZAdd, or take away from by clicking ZSub. Of course, you'll always need to use the Smooth tool to smooth out and blend the results of some of the above actions. I usually look at some reference images of muscles, skin and so on while I work, and doing that enables me to visualise things much better.

In order to be efficient with the memory usage of your screen, select the area that you wish to work on using Shift+Ctrl/Cmd. This hides the rest of the geometry and enables you to work in the area you want to focus on – it also makes your computer faster.

You can always create your own textures in other applications, but ZBrush enables you to do it directly and easily with fast feedback. An example of that is if you start on ZBrush on a clean layout, using the simple Brush tool, draw the pattern that you like on the canvas. In order to make it repeatable, click on the [~] key and drag the image you have created and then fill up the gaps that are around the pattern. Once you're finished with the tile-able bump texture, go to the Tool palette and click on the MRGB ZGrabber. Once selected, drag a box around your viewport. You will see that there is an Alpha and a texture that are available in your Texture and Alpha palette. You can save them for future use and texture away as much as you like.

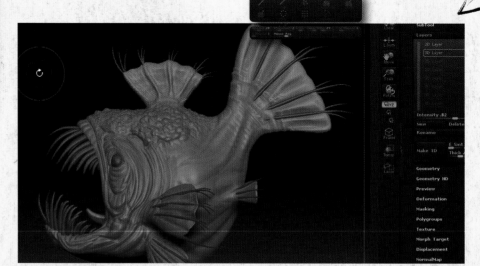

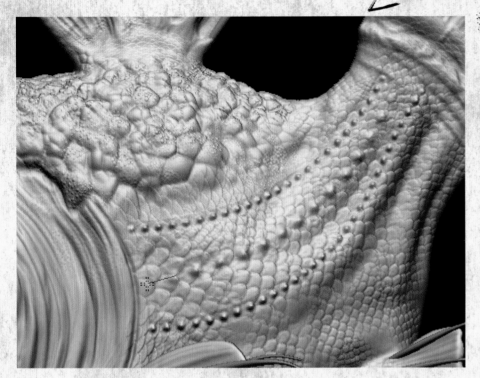

10 LazyMouse

LazyMouse gives you a constant flow of pressure, which eliminates variation when sculpting. A good area to use it in is when creating a repeated stroke texture, for example in a design pattern, stitching, buttons and so on. In this case, I used it for the beading pattern on the back of the fish. In the Brush palette, you will find a couple of brushes that have been already set up for LazyMouse (the Stitch brushes and Track brushes). Select the one that you like and change the Alpha to the pattern you wish to use. If you want to adjust distances of the repeated patterns, go to your Stroke menu and in the bottom, you will find the LazyMouse control panel that enables you to adjust it to your taste.

9 Texturing scales

ZBrush enables you to have layers of different details on your object. Go to the Layers palette and click on New, and that will create a 3D layer that you can name whatever suits you. ZBrush gives you the option to have multiple layers (you could have separate layers for skin, horns and muscles, for example) with multiple sculpted details distributed over them. I use it for putting in the scales onto the character and to try different types to see which one works best. The scale Alpha gets distributed using the Dragdot brush, which is under the Current Stroke menu. You now have control over size and rotation of the texture.

11 Modelling details

When putting the details on to your sculpt, it is usually the final step of a project. You'll be working on the highest level of geometry subdivision and it'll correctly project the Alpha textures. I usually do most of my detailed skin texturing at this level.

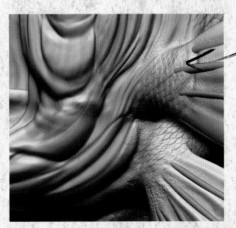

PROSECRETS

FEWER UNDOS
When you work with files where the poly count exceeds four million, avoid crashes and lag by reducing the number of undos.

12 Paint

ZBrush painting is different than other applications because you paint directly on to your polygons. Get the object on screen and select the shade of colour you want using the Current Colour Selector. Go to the Current Material window and select something light in Colour, such as White Cavity. This'll enable you to see colours when you're painting. Fill the object by going into the Colour palette and clicking on Fill Object. Make sure that the ZAdd is switched off and the RGB Intensity is on. Now you can switch between colours to brighten up the areas that you need to enhance.

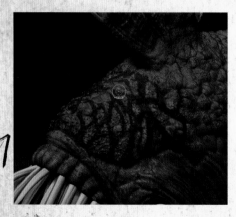

13 Masking

In order to start masking, select the brush you wish to use, and mask the area by pressing Ctrl/Cmd with the left mouse button. Once you're happy with the mask, use your normal brush to spray the colours that you wish to use and that'll project the colour onto that specific area. To clear the mask selection, click on Ctrl/Cmd+Shift+A.

14 Loading a colour texture

In order to load a texture on ZBrush to use for colouring, go to your Texture palette, click on import and select the image you like. That image will then appear in your Texture palette and you can switch to it for any colour usage that requires a photo reference as a base.

15 Fast UVs

Make sure your final object is on screen, then go to your Texture palette and click on Enable UVs. Make sure that the geometry of the character is at its first level, then click on the GUV tiles and that will create UV coordinates directly in ZBrush. To check on the UV coordinates, click on the UV Check button to create a basic colour texture, enabling you to understand how the UVs look.

16 Colour to texture

Keeping your object at the highest subdivision level, click on the Colour to Texture button under the Texture palette. An image will appear on the Texture palette on the left, which will usually be 1,000x1,000px as a default. That's not a very large file and you can increase the size in the texture panel by creating a larger size (I used 3,000x3,000) and click on New. This'll create a blank texture in your current texture area. Now you're ready to bake the texture again from the Texture palette under Tools and convert it from Colour to Texture again. Once you are done, you can select the image and export it to the format you need.

17 Displacement

Displacement maps are 16-bit greyscale images that can be read by other 3D software to reflect bumps and details that are on a UV map. This enables you to create highly detailed geometry. Have your object open in ZBrush and push the subdivision level back to the lowest point. Switch the Morph Targets back to base morph. Then open the Displacement menu and put in the level of pixels you would like (in my case, 2,000x2,000) and click on the Create Displacement Map button. After a short wait, a file will appear under the Alpha Panel, select it and use the DE Exporter button. This will export a TIFF file. This image can then easily be used for displacement in other 3D applications.

18 Fast Normal Maps

ZBrush has a built-in plug-in called ZMapper. Push the subdivision level back to the lowest and switch the Morph Targets back to its base morph. Open the Normal Map panel, and hit the Tangent button. Then select the size in pixels of the file you want to create and click on the Create Normal Map button. It now bakes the map, and you'll see a progress bar on the top panel. Once done, an image appears in your current texture palette. You'll need to flip the V and export it to the format you like.

19 Exporting the ZBrush object to other software

Since I've done the UVs in ZBrush, I'll have to export the object from ZBrush with its UV maps. Have your object open on screen and push the Subdivision level back to the lowest and switch the Morph Targets back to its base morph. Then in the tools panel, go to export and export it to an .OBJ file. And that's it! You're now ready to use your sculpted model in any way you like!

Current Texture
fish7

Width=1024
Height=1024
Depth=32

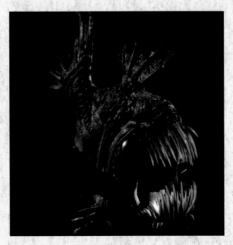

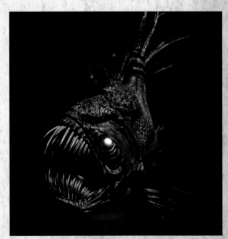

WORKSHOPS

ARTISTPROFILE
ALVARO BUENDIA

COUNTRY: Canada
www.buendiacg.com

Alvaro recently graduated in 3D animation from the Vancouver Film School.

ZBRUSH AND PHOTOSHOP

Feto Lives!

Create a creepy-looking 3D alien foetus in ZBrush with **ALVARO BUENDIA**

I n the process of trying to come up with ideas for an original creature design, I sat down and started thinking and sketching concepts. It always creeped me out seeing pictures of certain foetuses, both human and animal, so I came up with the concept of a foetus of some strange monster-creature.

In this workshop, I'll explain how I created this image from concept to preparation to execution; starting modelling in XSI (but you can use any 3D app) re-sculpting in ZBrush, texturing in Photoshop and ZBrush, re-touching textures in Photoshop, rendering, and composing the final image in Photoshop, to bring the creature Feto terrifyingly to life.

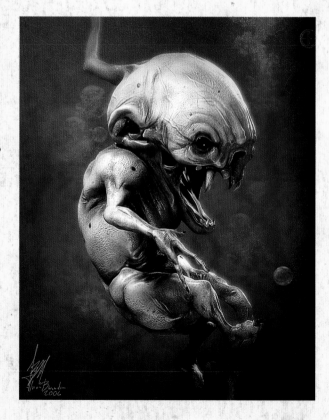

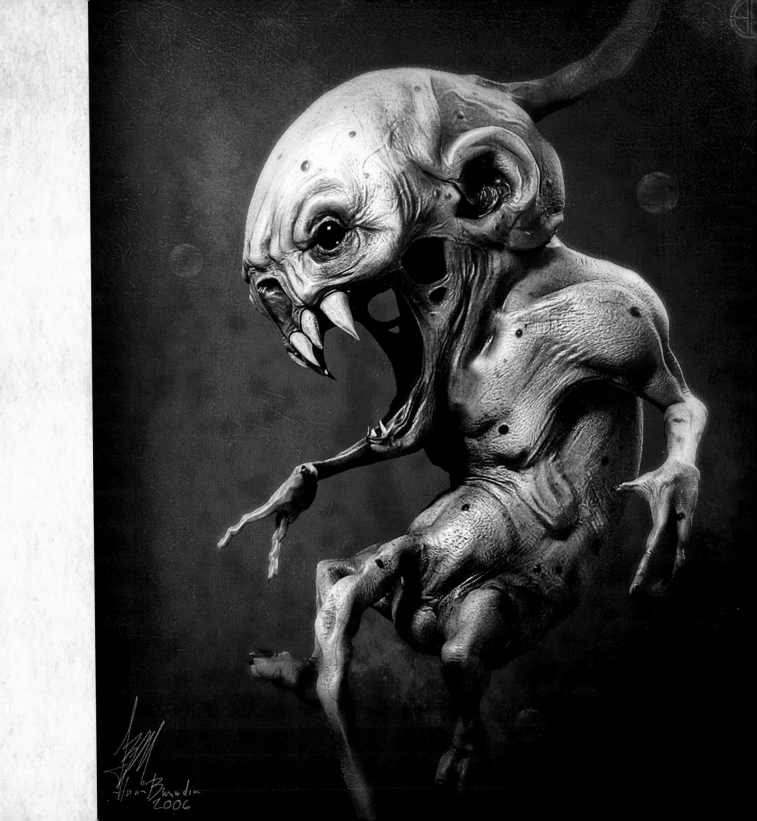

1 The concept

Behind any piece of art lies a concept. I make several sketches and try out lots of different shapes. First I play with the proportions, trying to come up with features that inspire horror and creepiness. I figure that one of the most horrific creatures known to man is the T-Rex, with its round eyes, sharp teeth, three fingers on each hand and three toes on each foot. Keeping the shape as a sapien, though, will make my creature look more like a human predator.

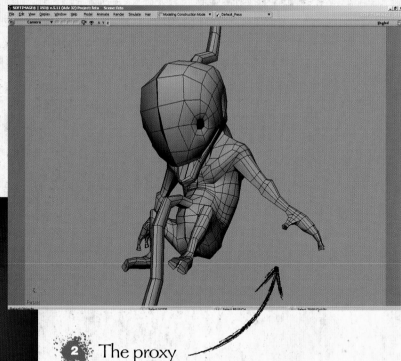

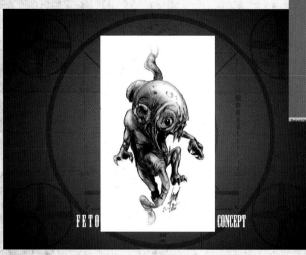

2 The proxy

After nailing my concept, I start with a proxy of the model in Softimage|XSI (but you can use any 3D app), only modelling one side and duplicating it as a clone, so that side will change if I modify the original. I merge both the original and clone sides. I make sure it's simple and all in quads, so ZBrush can open it properly.

3 Exporting the proxy

I export the model as an OBJ), and open it in ZBrush as a tool. Edit mode must be turned on.

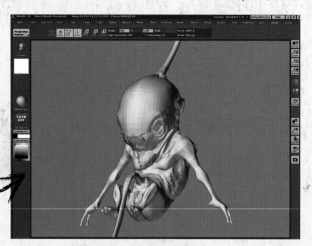

PRO SECRETS

CREATE A GOOD CONTRAST
On an image always try to be contrasty and moody; be certain that your audience knows where to look. Make sure your image is not flat, and also not confusing – put the information where you need it to be, and the rest just to lift your eyes to that point of interest.

 ## ZBrush sculpting

In order to have enough geometry to tweak, I bring the subdivision level to 2 or 3 and start sculpting. I like to use the Inflate and Layer tool to pull detail, and to carve detail I simply hold down Alt/Option. To define I use Pinch, and the Smooth tool to smooth areas I think are too pronounced and exaggerated. Before adding detail it's good to have enough references to make the model believable.

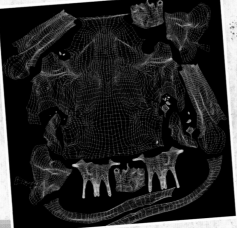

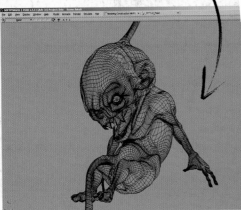

Retopologize

For this particular model I decide to bring the geometry only to level 2, and bring it to XSI to retopologize it, guided by the sculpting I did in ZBrush.

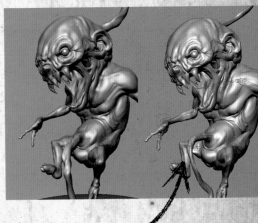

shortcuts
PROJECTION MASTER
G (Mac and PC)
Press G whenever you want to drop or pick up the Projection Master in ZBrush.

Unwrap

After the geometry is done, I separate the head and the body and unwrap the UVs of each object separately on the Texture Editor. After the unwrap I merge both of the objects, creating a cluster. You select one cluster and go to the Texture Editor>Edit>StampUVmesh, then select the second cluster and do the same again. This helps as a guide to texture for the character.

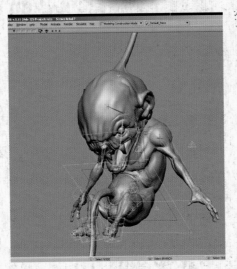

Posing

The posing in this character is made in XSI. I just grab the XSI Biped rig, under Primitive>Model>Biped-rig, which is a premade rig with default controls – good enough for posing. You have to make sure that your character is symmetrical. After adjusting it to the proportions, to envelope it, go to Animation>Skeleton>Envelope. Notice that the more time you spend painting the weights, the less you have to resculpt.

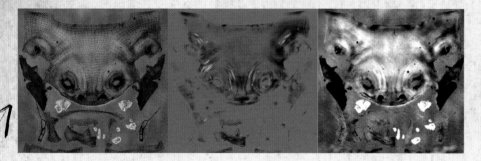

⑧ Textures

After the character is posed and resculpted, I export the head and the body separately to ZBrush to do the Bump map. I recommend using actual pictures to create Alpha brushes; just grab one piece of skin that has some wrinkle or other specific detail, desaturate it and crank up the levels in Photoshop. Make sure the corners of the Alpha brushes are completely faded, as this will save you having to clean up the bump. Make sure you have the bump material only in ZBrush, so you're able to see the bump while doing it. Go to the Projection Master, and make sure you have everything but Colour off, then press Drop, and start painting the bump. Bear in mind you can only paint from one perspective while in the Projection Master, so you'll have to do this several times. Once you're happy with the bump, save the images as a PSD.

For the Colour map, I first paint everything in Photoshop, using the stamp I did in XSI and the bump from ZBrush as guides. After painting the overall piece by hand, I look for high-resolution pictures of people, grab a big chunk of skin, and patch it with the Clone tool in Photoshop. Then I put it on top of the texture, Auto level it, put it on Overlay, and play with the Opacity.

For the specular colour I just combine the bump with the Colour map, desaturate it, and play with the levels. After doing this I make some areas lighter, such as the forehead and the lips, and others darker, such as the armpits.

Then I apply all the textures on the model. Normally I apply a subsurface scattering or Fast Skin Shader, as it's called in XSI, to give the impression of having different layers of colour in the skin.

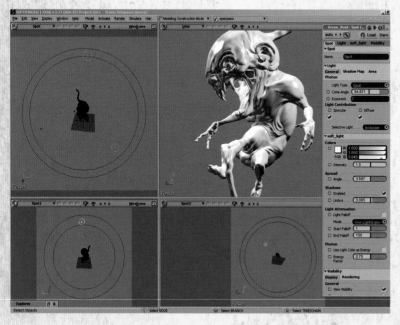

⑨ Lighting

For this kind of piece, I like to use Area Lights. They take a bit longer to render, but you get softer shadows and a more realistic look. For this particular picture, I used three Spot Area Lights. I make the Key Light a bit yellow, with an intensity of around 1.5. I make the umbra around .85 to get a darker result on the shadow. Once I turn the area on, I make its geometry a disc, and the samples 8 on U and V. To make the shadow wider I play with the scaling of the area. I make the Fill Light and Rim Light a bit less bright and change the colours, but I keep the same type of shadow.

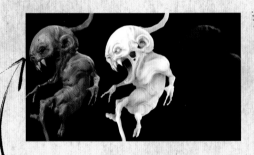

10 Rendering

For the rendering I use Mentalray, which is included in XSI (but again, use your preferred 3D app). Make sure the scan line and ray tracing are in 1 and 0, and the threshold is almost black (around 0.02). For the filtering I use Mitchell with a scale of 3 on X and Y. I do three passes of renders: Diffuse, Specular and Ambient Occlusion. Once I've found a couple of different angles I render them on a big scale and play with the resolution scale. Make sure the Pixel Ratio is on 1, so the image doesn't get any weird deformation.

PROSECRETS

PLAN BEFORE YOU EXECUTE
With 3D art, it's always good to draw and design before you start creating geometry, especially when you're modelling your own design. Try to get as many references as possible, and try to plan the pose in 2D before doing it in 3D.

11 Building the image

After rendering all the passes, I bring them into Photoshop. I always start with the Diffuse pass, duplicate the layer and delete the original layer. Go into Channels, select the Alpha, delete it to get rid of the black space, then put the other two passes on top of the Diffuse, and do the same.

Copy the Diffuse pass, and apply Filter>Other>Highpass. Bring the ratios to something like 1.1, and overlay it; this will make the bump and all the creases and details a lot more defined – kind of like what Sharpen does, but with a cleaner result.

Make the Occlusion pass overlay, and play with the opacity: this will make the shadows of the picture more contrasty and the edges softer.

You can also apply it on Multiply to make the shadows darker, and to give an effect of dirt.

Put the Specular pass on screen, and play with the Opacity; this will give the illusion that the character is wet, as it would be within the womb. For the background I get a base photograph to simulate water. Then I get a bunch of different pictures and patch them together to simulate underwater movement.

After that I Select>All, and Edit>Copy Merged and Paste, then blur the image a bit and erase some areas. This gives the illusion of depth of field.

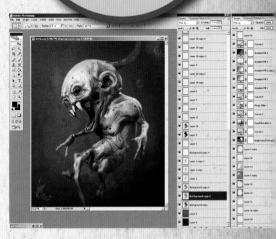

12 Final comp

The only thing left to do is comp the picture. First I start adjusting the levels, to give it more contrast – it also can be done with Brightness and Contrast; this will also saturate the image a bit. Then I apply two curves, one just to make it more contrast, and another for colour correction. For this last one I go on RGB and tweak red, green and blue curves individually, then I put a photo filter to give it an overall blue tone, and make the blacks a bit bluer. To break up the colour and give the lighting a direction, I make a gradient for each light I make and blend it with a soft light, overlay or screen.

WAYS TO BE A BETTER ARTIST

Being a great artist has as much to do with your state of mind as it does your skill. **ROBERT CHANG** explains…

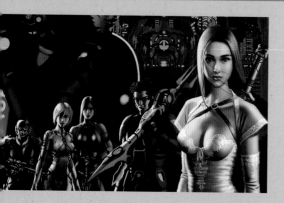

10 LEARN THE FOUNDATIONS

Buckle down and really learn the foundations (composition, perspective, anatomy and figure work, colour theory, values, lighting and so on). You cannot really call yourself a competent artist until you have done so. Ideally you should not only learn them, but master them, and when you do, you're not merely competent, but confident and authoritative as well. This doesn't just apply to beginners, but advanced and professional artists too. Artists at any level of expertise could gain from strengthening our foundation skills, and I definitely have my own weaknesses I need to work on.

9 BREAK OUT OF TUNNEL VISION

If you are obsessed with animé and manga, superhero comics, photorealism or any kind of specific style and have not been exposed to other art movements, styles, cultures, and time periods, then you need to become more well-rounded. Tunnel vision is creatively crippling and it breeds homogenised artists who can't think outside the established box. Crosspollinating and hybridising a range of art styles and influences is the healthiest and most creatively interesting thing you can do.

8 DON'T BE A MINDLESS ARTIST

Think about why you are creating. Do you even have anything to say as a human being living in a complex society? Is everything about your creative work disposable and meaningless? If you are only serving the basest level of gratification, then maybe it's time to dig a little deeper. This isn't just about being

deep, it's about quality – the difference between shallow films and cinematic masterpieces is down to how much heart and soul the creators put into the writing.

7 DON'T JUST COPY REALITY

We invented the camera for that. As artists, we have the power to stylise, exaggerate and simplify, so it would be a shame not to utilise those powers. I'd rather see works that have obvious artistic footprints left by the artist, than those that could be mistaken for photographs. Artists like John Singer Sargent, Gustav Klimt and Craig Mullins are far more interesting to me than artists whose works are so uptight and rendered to death that all the spontaneity and life has been snuffed out.

6 FORGET SURFACE POLISH

It's the last thing you should worry about. Loose or tight brushwork, sketchy or clean lines – they're simply options you choose from to match different subject matters. Much more important is the underlying structure and foundation knowledge. A good artist should be able to utilise all

kinds of surface treatment approaches effectively, not just be locked into one and knowing nothing else. Experiment with different mediums and styles, the way chefs experiment with different ingredients. You'll gain insight into how each is best used and be able to deploy the technique.

5 PRACTISE SMART

Do not simply practise hard – you must also practise smart. You must target your weaknesses and not dwell on things you can already do in your sleep. Be scientific about it. Treat it like an experiment with a structured plan that attacks the problem efficiently with purpose. Analyse failures. Avoid wasting time on things that don't serve an obvious purpose. Observe, deconstruct, and recognise the structures and patterns or approaches that yield the best results.

4 REALISTIC EXPECTATIONS

Rome was not built in a day. It takes years of working hard and working smart to get good. Filling up a sketchbook or two means nothing in the grand scheme of things – it takes so much more. Artists don't just draw a few dozen heads and then get it right – they draw hundreds and thousands over the years – decades – and they don't do it mindlessly. They are studying the underlying bone structure and muscle shapes, the effects of various facial expressions, lighting conditions, age, the idiosyncrasies of race and many other things. And that's just the human head. The journey to becoming a good artist is in reality more like a life-long journey of creative fulfilment.

3 LEARN TO TAKE CRITICISM

Artists always get comments, and if you can't take criticism you will be miserable. Treat criticism as a valuable arsenal for your growth. Whether it's negative or positive comments, be grateful and behave graciously. A bruised ego is an ego that's being conditioned to be stronger and more open-minded. If you can't see beyond your

bruised ego, you will become crippled by it. If you aren't getting helpful critiques, just keep learning the foundations and you'll automatically improve.

2 BE WELL-ROUNDED

Learn about the world we live in. You'd be surprised how many things are interconnected beyond our understanding. The more insight you have about the world we live in, the better an artist you will be. Maintain healthy relationships, since family, friends and lovers often form the core of our emotional expression. An intellectually and emotionally sterile or vacant person will have very little to offer as an artist. Being closed-minded and disconnected is nowhere near as fulfilling as being open-minded, knowledgeable and connected.

1 ONLY DO IT IF YOU LOVE IT

Your personality may not be suited to becoming a good artist. If you are impatient, cannot sit still, lose focus quickly, cannot take criticism, want instant gratification and are unwilling to pay your dues then you won't become a good artist. Whether you're talented is not the deciding factor – it's whether you can work hard and smart. Your ability to persevere through hardship, frustration, self-loathing, and discouragement will determine your chances of success. If you're always miserable, then maybe you love the idea of being an artist but your personality isn't suited for it.

If that describes you, don't feel bad. You might discover something else that you're passionate about and actually enjoy the process as well.

VAMPIRES AND DEMONS

PAINTER AND PHOTOSHOP

ARTIST PROFILE
MÉLANIE DELON

COUNTRY: France
www.melaniedelon.com

Mélanie is a freelance fantasy illustrator who paints covers for a range of publishing houses. Most of her time is spent on her personal artbook series, published by Norma Editorial.

21ST CENTURY VAMPIRE

Watch as **MÉLANIE DELON** recasts the prince of darkness as an ageless Lothario who's seen and done it all, and still wants more

I'm not used to painting male characters, let alone a male vampire, so creating this piece was a great challenge and a lot of fun. Of all undead creatures, vampires are the most interesting – they inspire fear, but also generate sexual tension.

I decided to avoid the classic movie vampire look – think Béla Lugosi, Christopher Lee et al – and instead aimed to create a modern-looking nocturnal predator with details referencing his long life. The art editor suggested that the character could have been a Celtic warrior leader at some point, and asked me to add some kind of cross tattoo around his eye.

I always carry out a lot of research before starting a painting, especially when I'm unfamiliar with the subject. I uncover plenty of images online, but the only one I have in mind is the awesome Count Dracula, played by Gary Oldman in Coppola's 1992 movie. For me, it represents exactly what a vampire should look like: a deadly, romantic beast with plenty of style.

At this point I'm ready to begin the painting. I don't do a lot of preliminary sketches and dive straight into Photoshop and Painter. This is just my method – feel free to do thumbnails if you need to.

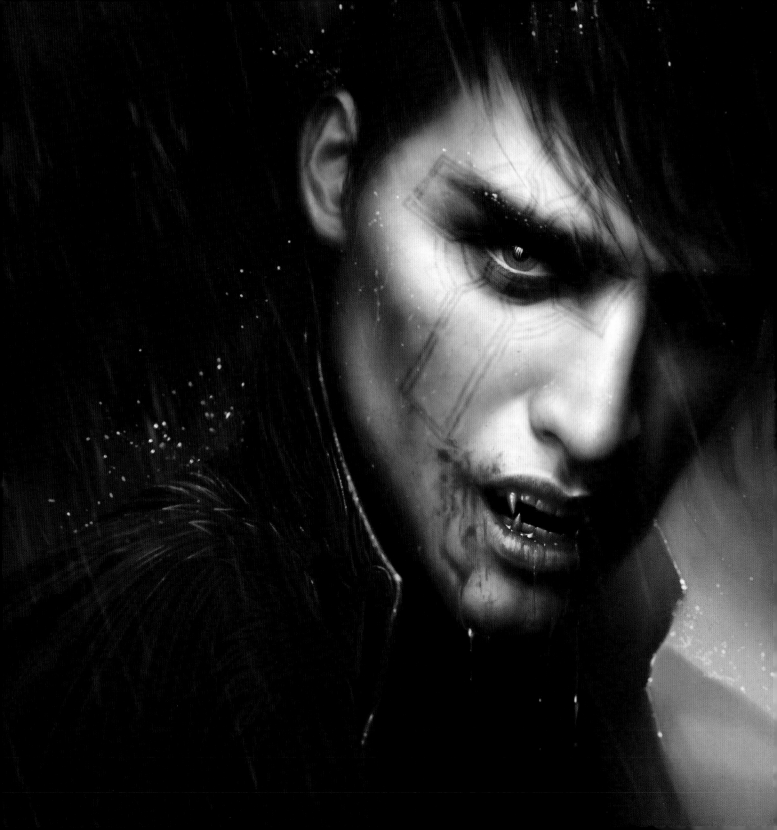

① First bite

I only try to put down what I have in mind. There are no details or real lighting sources in this initial sketch – just the idea and the first pass at the composition. I always do this step using a basic Hard Round Edge brush, with a huge diameter size and a small canvas size. It helps me to keep focused on the general shape of the composition, rather than getting bogged down in the finer details. I'll have plenty of time for these later in the process.

sHORTCUTS
TRANSFORM TOOL
Ctrl+T (PC)
Cmd+T (Mac)
This enables you to select an element that you want to resize, deform or flip.

② Colours of the night

Deciding on colours is probably the most important step in the process. I always start with the background colour and build around it, which helps keep everything together. I choose a dark red and a desaturated light blue that creates contrast and adds intensity to the red. This blue isn't my light source, but I keep it in mind for the character's skin colour. Once I'm happy with the background, I can decide on the skin tone. I select the primary background colour and adjust it until I have something close to a skin tone. Then I add more light to the red, play with the yellow and desaturate it.

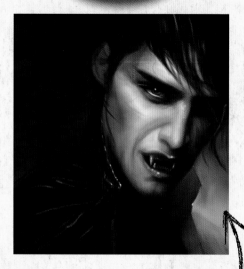

③ Emerging from the darkness

Light is one of the key parts of a painting: it determines the mood, the scene and even the story. A vampire is averse to sunlight, but I need some light to make him pop out of the painting. I decide to add an unreal light that could come from anywhere. This light isn't coloured, because I want a neutral colour on his skin. I'll try to add the same pale blue that I have in the background, leaving the other half of his face in shadow.

PROSECRETS

PAINT WITH PAINTER
I used Painter at every stage of the image. It helps me achieve perfect colour blends and brings interesting textures to the painting. It's also pretty useful for colours. It's difficult to achieve the same results in Photoshop, which is primarily optimised for photos. Painter may not look as friendly as Photoshop at first, but once you've created your own personal brushes you'll quickly become addicted.

4 · Red eyes

The eye will be a key part of the painting and needs to grab the viewer's attention. A vampire (or any kind of fantastic creature) offers a lot of freedom in terms of colours and creative design. Here, the background and the mouth are red, while the light, skin and background are pale and mostly blue, so the eye could be red and the under-eye blue with hints of purple. The eye is a round shape, even if it's half-hidden by the eyelid, so I must keep that in mind when I'm painting it.

5 · Deadly smile

The other key element of any vampire illustration is the mouth, which has to be scary and seductive at the same time. So I opt for an evil smile that reveals his blood-covered teeth. I'm still working with my Hard Round Edge brush and the Soft one, slowly refining and adding more details to the mouth. I choose a pink red for his lips, which I feel looks really good on a guy who's meant to be dead. Adding some colours here helps draw more attention to them.

6 · Wild haircut

I want his haircut to be modern, but also to reflect a certain age and wildness. I don't want a long, dark, gothic haircut, so I give him a wild, wet streak of hair that'll add movement and dynamism to the painting. I start it with blocks of colour and slowly add light on top of it. I don't paint individual strands, I work on them in blocks. With a Spackled brush, I bring in colour variation here and there for added realism.

SHORTCUTS
OVERLAY MODE
Shift+Alt+O (PC)
Shift+Opt+O (Mac)
Quickly change the mode of the layer you're working with in Overlay mode.

8 · Pale skin

Vampire skin must be pale, but not white – there needs to be plenty of colour variation for it to look realistic. I paint transparent skin – I want to see hints of veins under it. I go for pale red with orange and violet touches around the eye – violet can represent illness or dead skin. Pale blue is also a good choice. I add orange on the eye, implying a thick layer of old skin, and bring more richness to the red iris. I apply colours softly on a low opacity layer – everything must be suggested.

7 · Dark eye

I add more details around the eye to make it look as realistic as possible. I pay attention to the folds of skin and increase the shadow on his eyelid, which almost completely hides it. This helps to give more intensity and contrast to his red eye, as well as a seductive look. The eye is a ball shape, which is transparent on the top of the iris, so the light must follow the curve of it. The iris needs to be detailed, so don't be afraid to add small brush strokes on this element, and play with the layer mode to create a cool iris effect and texture.

21st Century Vampire: Mélanie Delon

Skin details

9

Once the colours are in place, I add some pores using my Spackled brush. This is a cool detail that helps to bring the skin up to another level. I don't add them everywhere, just on areas that are focal points, such as the nose or the cheek. I blur and change the opacity of the layer and repeat this step until I feel that I've got something satisfying. I also apply some pale yellow and pale green to push the colour in certain areas – such as on the nostrils.

Veins

10

Now I'm going to add more details to the skin, even though the blending, the light and the general texture of the painting is far from being finished. It's actually a part of the texturing, and is a very important step. On a different layer, I paint some veins all around the eye, the nose and the mouth. For this step, I choose a light red and a blue/purple colour, and change the settings of the brush to introduce more colour variation where appropriate. Once the veins are done, I play around with the layer modes (I usually favour Overlay) and the opacity setting. I don't need them to be too obvious. I repeat this process several times to generate more texture and create a sort of 'under skin' effect.

Stormy skies

11

The background is here to bring more realism to the piece and must reflect the character's state of mind. From the outset, I wanted to give it a dark red tone, and now it's time to develop a stormy scene with rain and lightning. To create the clouds, I use one of my favourite brushes, a Soft custom one. I slowly paint and define the clouds, which are in the distance and don't require too much detail. I add a bit more red light to give more shape and dynamism to the clouds.

Rain of blood

12

Once the sky's finished, I have to reproduce the rain's constant motion in the painting. So I paint a few raindrops on a different layer (they look like shooting stars), then duplicate this layer, place it somewhere else on the background and merge the two rain layers together. I duplicate this last layer and place the new one somewhere else again. I repeat this several times until I have enough rain. Then I blur the whole thing, erase some of the drops and add some dots of light on the foreground.

13 More blood

Blood isn't pure red – rather it's a mix of red, yellow and orange. I want the character to

have a lot of blood around his mouth, with some drops of it falling down his jaw. I'll use the orange and yellow where there's less blood, and a saturated red where I need to have a huge concentration of it. Blood is like water – it reflects light and is also transparent. So where the light is strong I apply some dots of bright red.

14 Fangs!

My vampire's attractive features would be ruined by a pair of goofy looking fangs, so I have to take care here. The teeth follow the head's curve and tilt, so I roughly sketch the position of them. The fangs are in the canine position here (but you can play around with where you place them), so they must be towards the corner of the mouth. Their colour is pretty similar to the eye: a pale blue with hints of yellow – the same colour as ivory. They're also very reflective, so I add strong dots of light here and there.

15 The cross

The tattoo is an old one that's become faded over time, and because it's around the eye, it mustn't be too much of a distraction. I decide to paint it in a dark red/orange instead of the usual blue/black tattoo colour. Once I'm happy with the design, I erase and blur some parts. Then I change the layer mode to Overlay with the opacity set to 50 per cent.

16 Extra details

To work the details I use a basic Round Edge brush set to Dynamic Shape (minimum diameter). I also use the Other Dynamic > Opacity Jitter setting. This helps with the effect and colour variations I need. It works well for hair, lashes and skin pores. I paint the extra details on a new layer and blur them slightly so that they don't look too obvious.

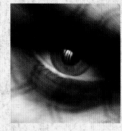

17 Antique clothing

This guy needs to wear something that represents his story and old age. I choose a black jacket with a phoenix design. The embroidery needs a lot of colour variation, so I use a Soft brush and adjust Other Dynamic > Opacity Jitter to 30/40 per cent to paint the base and add small dots of light. Then I blur the results.

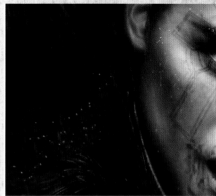

18 Dots of rain

To connect the rain to the character I add splatters on his back, ear and neck. I blur the wet areas with the Blur tool and splash a little water on his face and hair. For this, I use a basic Round Edge brush set to Dynamic Shape (minimum diameter) and Wet Edge.

19 Unleash the beast

I'm almost done, and what I usually do at this stage is add a bit more contrast and adjust the colours with the Color Adjustment options. It's a tweak more than anything – I don't want to kill my colours and light, but this helps to brings everything together.

ΛRTIST**PROFILE**
JONATAN IVERSEN-EJVE

COUNTRY: Sweden

Jonatan has got big dreams and aspirations like the next guy, but he settles for paintings of silly dogs, dragons and robots. Currently he's attending art school in Stockholm where he's not allowed to draw as many robots as he would like. But that's okay.

PHOTOSHOP

A BOY AND his CERBERUS

Creature creation can be a tricky discipline to master. Swedish artist **JONATAN IVERSEN-EJVE** shares how he imbues his with personality

When I was asked to create a humorous creature with personality for this workshop, I soon realised that's about all I ever do. I think it's more of a struggle for me not to do it. Last year, when working on a book about dinosaurs, I tried to keep them free of character and make them look more like neutral dinosaurs. However, the brachiosaurus still ended up looking like the Swedish actor Johannes Brost. So why fight it? I think creating silly personalities for my creatures is a big reason why I'm in this business to begin with, and probably why it's so much fun. So with this article I intend to show why I do what I do, and I hope you'll be able to learn something from it too. If not, you can always enjoy the fluffy clouds, the cute doggy and the pretty colours. Hey, I know I do!

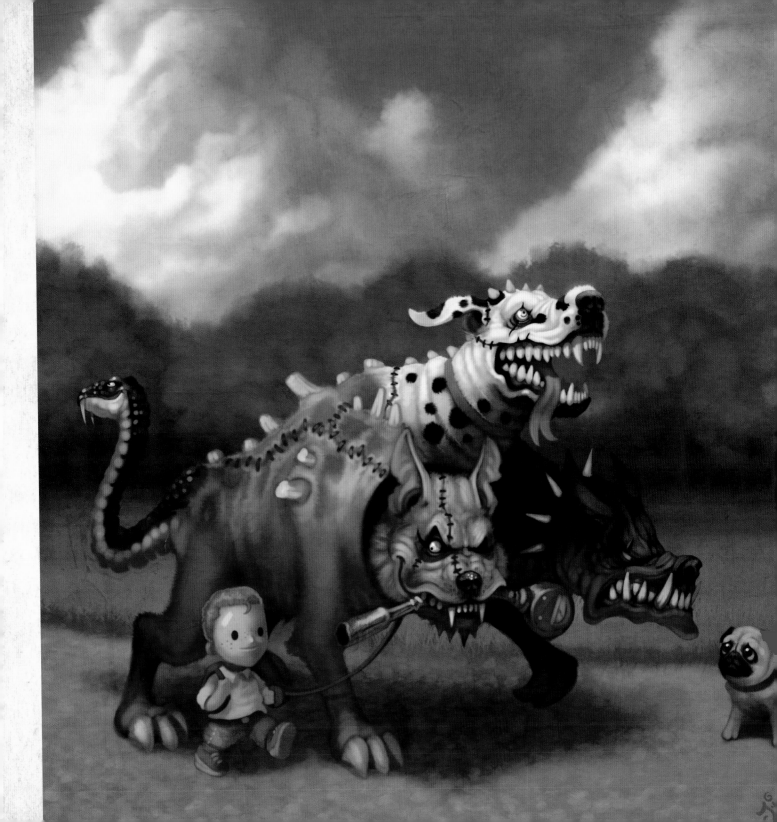

1 Starting out

Trying to come up with an idea of what to paint can be a tedious process for me since I usually get a million of them – and none of them very good. Sketching randomly can help sometimes, but usually I just have to wait for that single spark of inspiration to strike. This time I thought something along the lines of 'If I can't settle on one idea I'll just have to draw something with multiple heads,' and Cerberus from Greek mythology immediately sprang to mind. The first sketch is the one I keep working on, with Cerberus being the pet of a young boy. I think it's kind of funny that such a small child has a beast like that for a pet.

SHORTCUTS
SAVE FOR WEB & DEVICES
Alt+Shift+Cmd+S (Mac)
Alt+Shift+Ctrl+S (PC)
Lets you edit the image while saving.

2 Defining the character

Since Cerberus, being the guardian of hell and all, is a monstrous and terrifying beast, I think it will be fun to mix him with an ordinary dog – in fact, several dogs – he should have three different personalities after all! I pretty much already know what I'm going for here: one head from a whimsical mutt, one from a more neutral, if slightly ravaged dog, and one from an intimidating hellhound. I even give the tail a personality, since some incarnations of Cerberus depict him with snake-tails. After putting them in a Central Park-ish setting it's time to add some colours on a new layer beneath the sketch.

3 Basic colours

Sometimes I know exactly how I'm going to colour a painting, and sometimes I don't at all. This is one of the latter occasions. All I know this time is that I want it set in ordinary daylight with a bright blue sky and verdant green trees, so that's pretty much what I paint. It might be extremely basic, but it gives me something to work with. The beauty of digital art is that it's incredibly easy to change the tone of a painting whenever you want, so I leave that for the future me to take care of. Cerberus gets a bland, dog-like colour, but at this stage I'm only really interested in him having any colour at all, rather than his finished look.

 ## 4 Merging

After adding some more distinctive colours on Cerberus, I pull down the opacity of the sketch layers to about 50 per cent, since I'm about to start painting over them. I also merge the Cerberus sketch, which was on a separate layer all along, with his paint layer. Why merge? Because I really like to have all of my character on a single layer. This helps me move it, mould it, adjust it, and most importantly allows me to lock transparent pixels on it, which is a huge help when I'm painting. With that on you can paint with as big a brush as you want and it will still only affect the pixels on that particular layer.

6 The dalmatian

For some reason I think of a dalmatian first when going for more of a household pet-look, so he gets to be the whimsical one. I want him to look like he has a playful, puppy-like demeanour, but still be very dangerous since he's so wild and, well, monstrous. So I give him silly eyes, a happy expression and a hanging tongue – but at the same time lots of big and dangerous teeth, stitches, horns and a forked tongue for that demonic effect. It's pretty much Pongo from hell.

5 Painting over

Now I start to paint over and render Cerberus, still on the same layer, by adding highlights, shadows and details. Locking transparent pixels is a great way to get rid of what's left of the outlines here. When designing a furry creature, I prefer a simple natural brush for the fur and hairs, especially when used with the Smudge tool. Smudge the edges of your creature for a nice, fuzzy effect. At this stage I also experiment with some adjustment layers, adding a brown colour layer and a yellow overlay layer on top of the others.

7 The red dog

I'm not 100 per cent sure of what kind of dog inspired me to paint the red dog, but I suppose German shepherd and coyote were two of them. I want him to be the brains of the creature, who could probably fight as well as the next head, but relies on wit rather than brute strength. I accidentally give him more of a smile than first intended – but it made him look even more sly than before, so I keep it. And what else would a giant canine from hell chew on if not a parking meter?

A Boy and his Cerberus: Jonatan Iversen-Ejve

Here I also change the sky again, and start to render the trees in the background with a tree brush I got somewhere on the internet. I also use the brush with the Smudge tool, in this case to make the trees a bit more blurry and the characters stand out more in contrast.

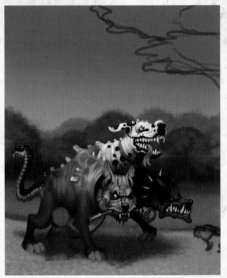

8 The hellhound

Naturally, every Cerberus needs to have at least one mighty pissed-off head. In this case I want it to look the most hellhound-like, but with a touch of Doberman. Since even a small boy is able to take this monster for a walk I suppose the Hellhound wouldn't actually attack anyone, but it still means serious business. The skin on the nose and forehead is almost fur-less, and the red colours make it even less like a real dog. Also, that jaw is ridiculous. He shouldn't even be able to close his mouth.

9 More rendering

After some more fleshing-out of the heads and the body I add another adjustment layer to increase the brightness and contrast of the overall picture. When I render the characters, I sometimes like to change the brush to Colour Dodge and use a bright yellow on low opacity to lighten up my highlights even more. To make the ground feel more dirt-like, I use a Speckle brush I got from the internet on low opacity and slight jitter, and paint a thin layer on top of the old one. For the grass I paint with the same natural brush that I used for the fur.

10 Level adjustment

Every now and then I make another adjustment layer to adjust the levels of the painting. This can be really useful when you feel like the colours you have don't really cut it. In this case I mostly tweak the blue level until I get something that I feel unites the picture better. You never really know what you're going to find when level adjusting, but it can sometimes be worth the effort.

11 The snake

Sometimes I like to get someone else's input on a painting, so I showed it to a friend of mine. One of his suggestions was to change the snake's personality entirely and make it more sly and snake-like. I don't really use a reference for this one, and I change it pretty much in one go – but I think it turned out for the better.

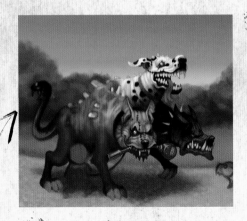

⑬ Boy and clouds

After putting it off for too long I finally start to paint the little boy. I know exactly how I want him to look – sweet, naive and very oblivious to the fact that his pet is a giant monster. Other than that I didn't want his design to stand out very much at all. He's simply an ordinary boy with a not so ordinary pet. When I started out I wanted both clouds and a city skyline in the background, but I settle for the clouds alone. I use a Cloud brush with a slightly yellowish hue, and erase away the parts of the clouds that fade into the blue sky. As with the trees, I use the brush with the Smudge tool to blur the edges of the clouds as well. Using this method I actually end up pretty happy with the final result, which I otherwise never do with my clouds.

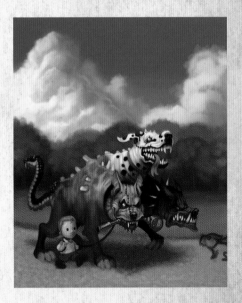

⑫ Trees and sky

I realise the dalmatian's head didn't stand out very well against the sky, so paint the trees bigger so they separate the two elements. This also helps the perspective a bit, making the trees look more like actual trees and less like bushes. I adjust the sky colours – again – to better match the colours of the character.

⑭ Final touches

I completely remake the flimsy sketch of the little dog in the corner and put in a frightened little pug to get a comparison between Cerberus and a real dog. The very last thing I do is to put texture over the whole thing – in this case some corroded metal. The texture layers are on top, set to Overlay and have very low opacity. I really like the look it gives to a painting.

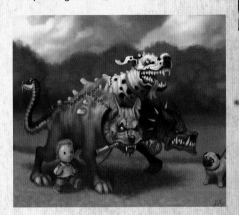

PROSECRETS

USE YOUR SOFTWARE
Digital art is very different from traditional art in that you don't have to rely on just your two hands and a brush or a pen. Don't be afraid to use the tools your software provides. It took me a while to realise that it's not a sin to use adjustment layers for colours, levels or anything that can help your painting when working digitally. Bear in mind that some Photoshop filters will make your work look like crap, though!

A Boy and his Cerberus: Jonatan Iversen-Ejve

ARTIST Q&A

 How do you paint dead, rotted flesh?

 DAVE KENDALL REPLIES

I've always been a fan of documentary photography. Among the work of photographers like James Nachtwey and Don McCullin you will come across pictures of dead bodies in different states of decay. Using a degree of respect these images can, and should, be used to inform your painting and drawing. An artist shouldn't reject any source of reference or inspiration. With this question I am not approaching it in a step-by-step way, but more relating to the thought process you could use in your designs. Flesh will decay and respond in very different ways depending on environmental conditions. Using a skull as the underlying foundation I'm attempting to depict a desiccated corpse and a bloated, water-logged corpse. Human beings are all alike under the skin.

I sketch out a skull (1) to use as a base for my two different corpses. This is a great exercise in anatomy. Knowing the structure of a skull will allow you to place eyes, nose and mouth with confidence.

This character (2) has been left in the drying conditions of a desert or Arctic wilderness. For great reference, research mummies from around the world. Keep the colours dusty and dry, with the skin pulling like parchment to the forms of the skull.

The flesh can reach outlandish proportions if allowed to waterlog and inflate with decomposition. Keep the colours varied (3). Blood will pool and there will be blooms of green, blues and purples. The skin will be tight and shiny, most unlike the dried rot of the first picture.

When approaching your own projects, think about the surroundings of your characters and how they will be affected. It will really help the credibility of your image-making and storytelling.

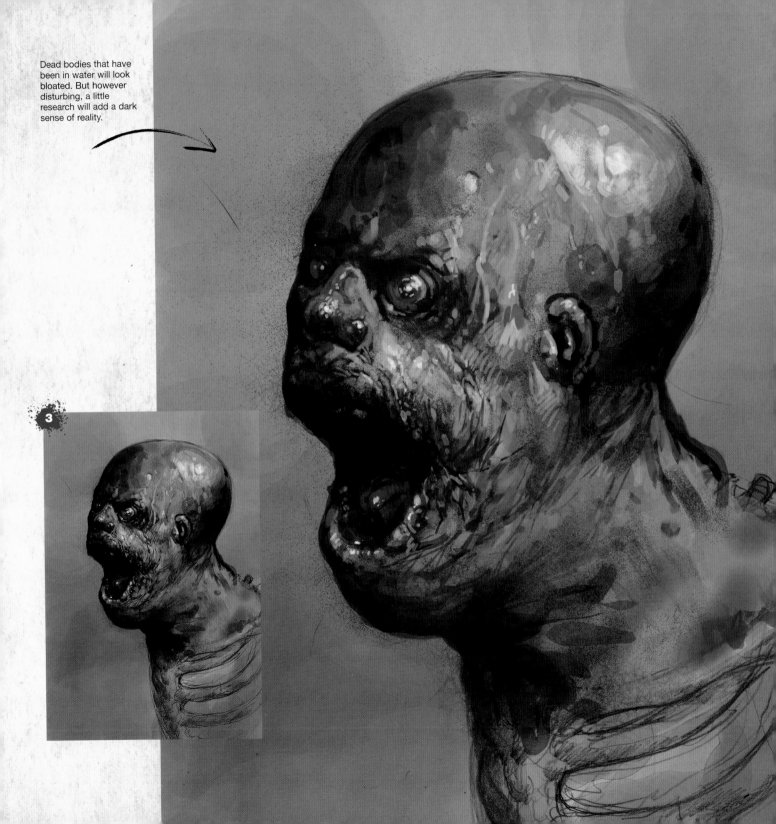

Dead bodies that have
been in water will look
bloated. But however
disturbing, a little
research will add a dark
sense of reality.

3

ARTISTPROFILE
DAVI BLIGHT

COUNTRY: USA
www.conceptart.org/davi

Davi is a concept artist and illustrator with a passion for creatures and the worlds they live in. He recently helped craft a community of professional creature designers and illustrators at www.creaturespot. com. He now works at a studio in Louisiana.

PAINTER

Demonic creature concepts

How to create, design and illustrate an original demonic concept creature for the video games and film market, with **DAVI BLIGHT**

emons are often an obstacle in a hero's journey in legendary adventures, because of their clear iconic nature of being a representation of pure evil.

When coming up with an original idea for a demon concept I first consider the iconic visuals that usually make up a demon: red skin, horns, hooves, being disgusting. Once I have determined the features that should be considered for the designs, I feel confident that I can create something unique, believable and iconic, but not clichéd.

In this workshop I will go through the initial concept phase of creature design through to the end product – a presentable illustrated concept. I hope this not only teaches you how the process works, but inspires you to jump into the world of creature design.

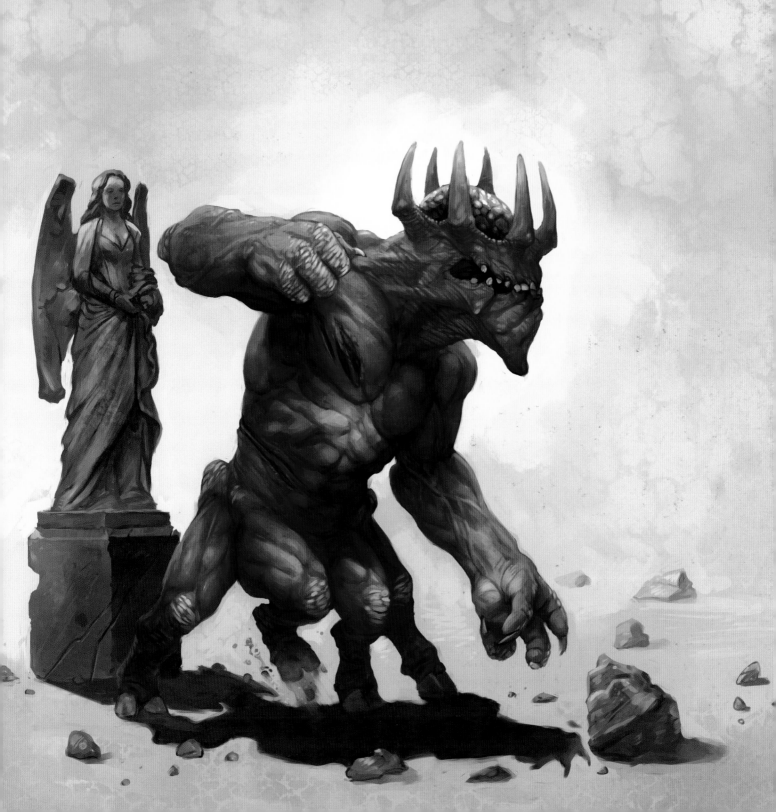

① The process of thumbnailing

Flesh out a series of thumbnails to explore different angles of the same concept. While you may feel your first idea is awesome, your tenth might be ground-breaking. I consider what type of personality, history, body-type and motifs I would like to explore in the design. The most important elements to portray are the gesture, structure, silhouette and personality. The only brush that I use is the Sargent brush, at 100 per cent strength. I paint these thumbnails on a canvas size of 5000x5000px, which enables me to use the thumbnails later to help start the final illustration.

CONCEPT 1: THE GORILLA

The first thumbnail is based around the silhouette and stance of a gorilla resting on its fists. When I have a silhouette I like I can expand and distort its structure by adding and subtracting shapes. I want the creature to be a hunter, so I consider what earth's hunters are and what visually identifies them – a tail for balance, muscles for fitness and strength, and thick bones.

CONCEPT 2: THE HUMANOID

I sketch in humanoid anatomy and alter the silhouette and structure with large simple masses. I find the figure to be a little boring and dull, so I dig around in my head for anything related to demons and find the cross. I add a demonic graveyard to the back of the unholy spawn to offer some originality.

CONCEPT 2: THE CENTAUR

I create a contrast between the legs and upper body. The mass of the upper body couldn't be supported by my initial design so I add a second set of legs for support, which creates a centaur-like design. I remind myself of the order of power in the demon world, and sculpt his head design into a motif seen on a king's crown.

CONCEPT 2: THE FATMAN

I start the third thumbnail progress as a complete juxtaposition of masses. A fat man's lower body contrasting with the gangly arms reaching out from the ripped gut. Using strong contrasts in design helps the viewer's eye separate forms – but be careful to avoid overdoing contrasts that are so strong they split the design into being an incohesive mess.

PROSECRETS

MAKING PAPER
Learning how to control the paper grains and pattern tools in Painter can offer a unique way of painting that's ahead of other programs. Experiment by using and creating your own papers to build a library of effects and textures that are completely and recognisably your own.

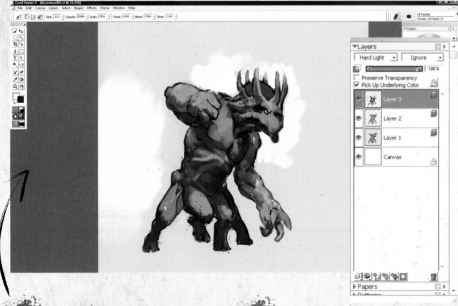

4 Don't ignore issues

While I did approve my thumbnail to start the process, I didn't notice how unacceptable the raised hand and arm was until I really started to get involved in the piece. I will not overly turn any flaws into something that works, but I do take the time to adjust and repaint out the arm and hand.

Fixing a flaw, like this one, causes viewers to look at the whole of the piece instead of pinpointing any issue they have. If you get upset and leave mistakes in a piece, it will always be remembered as a piece with a mistake, and everything else you did will sadly be ignored.

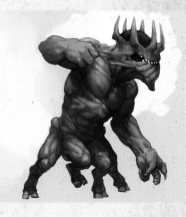

2 Determining the colour and values

The first step I take after deciding which thumbnail I enjoy most is to start two new layers: one layer set to Colour, and the other is set to Hard Light. In the Colour layer I set down an idea of what basic colours I would like to use to shape my creature. The colouring on this layer doesn't have to be precise at all because it is just to help define a starting point. I then jump into the Hard Light layer and paint in with my Chunky Oil Pastel 10/20/30 brush. This is the time to determine the values, the temperature of the light and shadow, and how aggressive you want the intensity of light to be. In this piece I went with a dark cool blue and a slightly intense warm orange light source. This stage is also very loose and is just meant to define the principles to work from.

3 The rendering begins

I create a new default layer and begin rendering out the forms using the already established values and colours. This is one of the longest procedures of the piece, but it's also extremely important.

I don't start by rendering select areas of the figure, but jump into the highest area of mass and establish a point that I can refer to when rendering the rest of the figure. This enables me to keep a nice handle on the overall detail. I start by rendering out the torso, then leading into the lower limbs. During this process I don't zoom in; the figure will always be as large as the screen. I find that if you zoom, you separate the area that you have zoomed into from the rest of the piece. If I were to go in little by little it would end up looking like a disjointed mess. When possible, always paint large areas of form to get the best results. I continue this process from top to bottom, until the figure has an overall cohesive detail level.

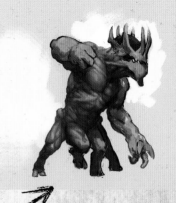

Demonic Creature Concepts: Davi Blight

5 Loving details

One of the most fun stages of the rendering is when you get to the point where you can start adding in the details. These pull the character past the point where it's merely made of forms and give it unique elements of detail to bring in the viewer's interest. I start by roughing out the brain and adding slight white spots to the figure, which help separate the large areas of red from each other. I also take time and start adding more refined details to the head, which will generally be the first focal point that the viewer will check out, and therefore deserves a bit more attention.

After reviewing the concept a little more I feel that the figure is too clean for a demon. I experiment by adding open wounds to his torso and stomach, which adds just enough gore without going over the top with blood splatter all over the scene. The wounds are deep, but do not need to make the viewer cringe.

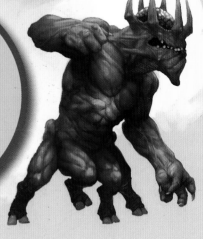

shortcuts
BRUSH CREATOR
Ctrl+B (PC)
Cmd+B (Mac)
The Painter user's best friend. Play around and customise your own brushes.

6 Placing the character

Are we dealing with a large or small creature? Is he in his own environment or terrorising another reality? These questions can be answered by adding simple environmental cues. To put the demon into a grounded reality, I add ground! I create a new Hard Light layer and pick a nice cool to contrast against the warm light hitting the figure. I add a tombstone in the form of a female angel, which not only helps describe the size of the creature, but gives a narrative contrast to his demonic nature.

7 Colour balance

I notice that the demon's colours are too contrasting, so I decide to rein them in. I create another Colour layer and slowly start taking away some of the cool colours that were too overpowering. I also use some of the ground colours to dirty up the demon, again trying to make sure that the creature doesn't come off as being too clean looking.

PROSECRETS

ALTERNATIVE ENVIRONMENTS
Don't trouble yourself with how your creature would live in our reality, but visually present the character in its own environment. Bring your creature's personalities, habits, and visual history into the design to make it more tangible in the viewer's imagination.

8 Finalising

There is a time when we must commit to finalising our piece, and move onto the last touches that will help add more life to the scene and a little more depth to the subject. I spend a bit more time on the scene by adding in some wreckage to show that he's been causing trouble. I adjust the value of the statue and shadow so that they tie in more with the values of the demon and add a bit more contrast to his fist to separate it from the red body so that it reads more clearly.

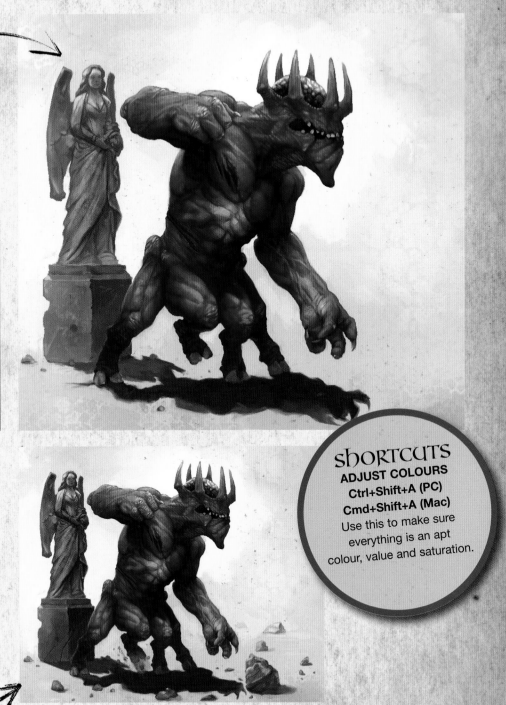

SHORTCUTS
ADJUST COLOURS
Ctrl+Shift+A (PC)
Cmd+Shift+A (Mac)
Use this to make sure everything is an apt colour, value and saturation.

MASTERCLASS

VAMPIRE TIPS

ARTISTPROFILE
ANNE STOKES

COUNTRY: UK
www.annestokes.com

Anne has worked on many projects in the games industry, including illustrations for Wizards of the Coast's *Dungeons & Dragons* rule books. Her artwork has been licensed on a range of merchandise.

ANNE STOKES reveals how to portray these moody, menacing creatures of the night in a believable way

arkness, danger and seduction make vampires great subjects to paint. Human in form, they blend in with us, but are always set apart. Creating mood and character in these night walkers is an interesting challenge, and one I've always enjoyed. As iconic and ever-popular fantasy subjects, I've painted lots of vampire-themed pieces for gothic-style T-shirts, and for jigsaw puzzles and posters. I also worked as an illustrator on the vampire-themed Castle Ravenloft game. I'll give you some tips on how to concept and paint a vampire character, design its costume and setting, get the skin tones right, and look at which teeth you should turn into the fangs.

1 Bat wings

The flapping wings of a flock of bats adds atmosphere to a vampire scene. Look at photos of bats so that you depict the wings and face more accurately. Bat wings are made from what would have been hands, with skin stretched between elongated fingers, as you can see here. Bats have high, squashed noses. The ones in the image over the page aren't meant to be real, but a muscular, aggressive fantasy version.

2 Moody lighting

Because of their susceptibility to sunlight, vampires always appear in dark or night scenes. Side-lighting is a great way to add atmosphere. It could be from the moon, a street lamp or a candle. Under-lighting can give a horror look to the picture. In this vampire mouth T-shirt design, I used dark colours and a strong fade out to complete black, combined with a shine on the

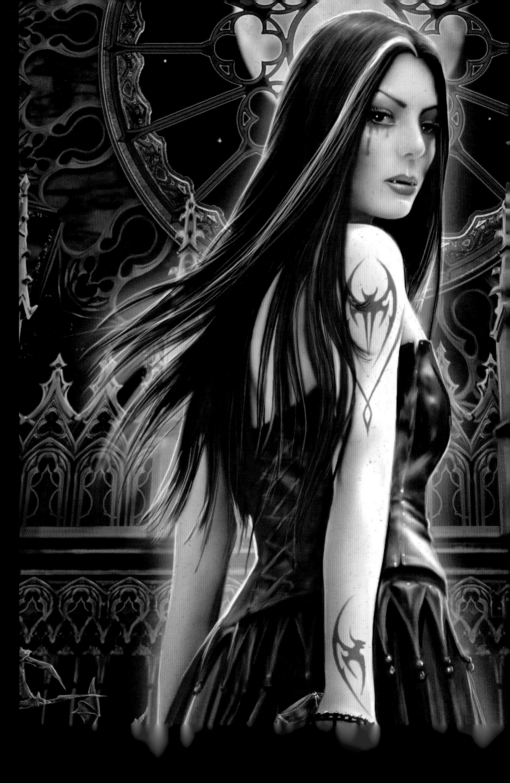

3 Design imagery

There's some brilliant iconic imagery associated with vampires. Bats, crosses, coffins, silver chains and red jewels can be combined to make your own vampire logos, such as this one.

4 Pale skin

Vampire skin is deathly pale and should be drained of almost all colour. In my Gothic Siren piece here, you can see that the skin is only made up of white and cream. You can also bring some subtle blue tones into the shadows of the skin to give a more unearthly look.

5 Gothic style

Gothic doesn't just refer to a type of music and teenagers who wear black! The gothic style of architecture and design is based around tall, thin, towering shapes, with swirling embellishments and carvings. For a more classic vampire painting, this style is reflected in the dress, background stonework and tomb.

6 Vampire faces

Most vampires are depicted with human-looking faces. However, some can be painted with more extreme animal characteristics to their face, such as ridged foreheads or pointed ears. These more inhuman vampires often take on some bat-like features, so have a good look at some bat photos to get more ideas.

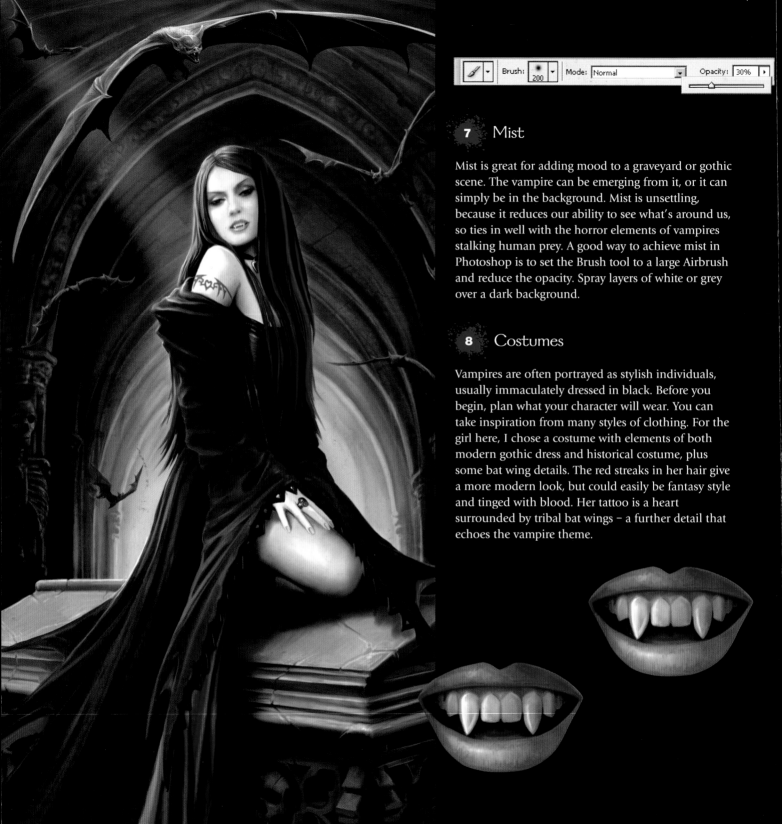

Brush: 200 | Mode: Normal | Opacity: 30%

7 Mist

Mist is great for adding mood to a graveyard or gothic scene. The vampire can be emerging from it, or it can simply be in the background. Mist is unsettling, because it reduces our ability to see what's around us, so ties in well with the horror elements of vampires stalking human prey. A good way to achieve mist in Photoshop is to set the Brush tool to a large Airbrush and reduce the opacity. Spray layers of white or grey over a dark background.

8 Costumes

Vampires are often portrayed as stylish individuals, usually immaculately dressed in black. Before you begin, plan what your character will wear. You can take inspiration from many styles of clothing. For the girl here, I chose a costume with elements of both modern gothic dress and historical costume, plus some bat wing details. The red streaks in her hair give a more modern look, but could easily be fantasy style and tinged with blood. Her tattoo is a heart surrounded by tribal bat wings – a further detail that echoes the vampire theme.

9 Fangs

Which teeth should you make into fangs? The most popular choice is to elongate the already pointed canine teeth (as in the centre picture), which is what I did in the main image. Certain more animal and horror-style vampires, such as the classic Nosferatu, have been designed with elongated incisors as fangs (right). You can also choose the second incisors (left). These options have the advantage of being more easily visible if your vampire's mouth is only partially open.

10 Colour schemes

A very minimal colour scheme can work well for moody night scenes and the gothic looks. This provides strong contrast between light and shade, and creates deep-cast shadows. In the main image, the colour of the entire picture is muted, save for the bright red of the hair, lips and costume details. It's meant to be reminiscent of blood, and contrast with the surrounding pale blue tones.

11 Contrast

Painting a figure wearing black in a dimly lit night setting can be problematic. To achieve good contrast between the different elements in the picture, you can use strong side or backlighting, or place a light object behind a dark figure. I've put pale blue arches behind the figure so that she stands out as a dark shape against a light background. Other good light elements to put behind vampires could be a large moon, or pale mist rising from the ground.

12 Charisma

Some creatures have characteristics that make them very obviously fantasy. The vampires of legends were beast-like and horrific, but most recent vampire depictions are essentially just humans with pale skin. To give an added impression of their mythical nature and being set apart from ordinary people, a charismatic pose and intense expression are helpful tools. A powerful stance combined with seductive charm is an ideal look for a vampire. Tilting the head or the viewpoint of the picture up a little, so that the vampire looks down at the viewer, can give an air of superiority. When painting human forms like this, it's useful to use a photo as a reference, even if it's just a very basic snap to establish the overall body pose.

13 Setting

The setting can help create mood and atmosphere, and give further information about the character. Gothic architecture goes well with the classic vampire, so a reference photo of gothic buildings is useful. In the UK, we've got lots of gothic-style churches, but you can draw inspiration from simpler buildings and embellish them with your own gothic design. Old graveyards are great sources of inspiration, and I based the tomb in this image on one I saw recently. Arches are good gothic structures, casting shadows for vampires to lurk in. More modern-day settings can include industrial ruins or railway arches.

14 Blood drops

Blood is thicker than water, and can collect in small droplets. To make a realistic blood drop effect, start with a deep red blob, then add lighter areas on the edges with a smooth Airbrush or Dodge tool. Complete it with a small spot of solid white to show the light shining off the surface.

Myths and Monsters

4

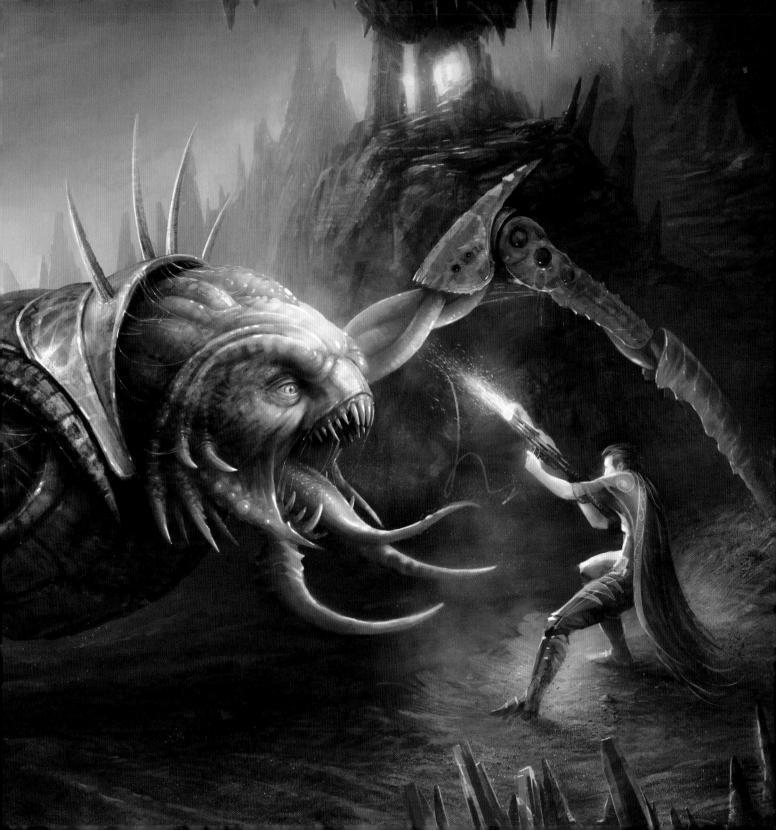

ARTISTPROFILE
RAYMOND SWANLAND

COUNTRY: USA
raymondswanland.com

Raymond Swanland began his art career at the video game company Oddworld Inhabitants. It was there he learned the creative process and built up his skills over the better part of a decade. He then moved on to illustration – of books, comics, advertising and film. He currently works as a freelance illustrator and plans to move into the storytelling field.

PHOTOSHOP

CREATURE DESIGN

Designing an imaginary creature in a fully formed illustration –
RAYMOND SWANLAND shows you how

Creature design is a nuanced process, with many applications – from reanimating extinct animals to creating movie monsters. If the goal of the design is to invent a creature that performs certain actions and which can be seen from any angle, a solid silhouette is important, but the overall composition should take a back seat to anatomy. In this workshop, I'll be painting a piece that's meant to create a unique creature within a balanced composition which stands alone as a finished illustration and not just a design rendering.

Aside from a few thumbnail sketches on paper, I create my illustrations entirely in Photoshop with a Wacom tablet. While I use tools such as layers and colour adjustments that don't really exist in the physical world of painting, I approach the digital painting process in a fairly traditional way. I paint dark to light with simple brushes and flatten my image on a regular basis to keep it cohesive. Ultimately, my process is more about the basics of colour, lighting and composition than the digital tools. That said, the computer's by far the best artistic tool I've ever gotten my hands on.

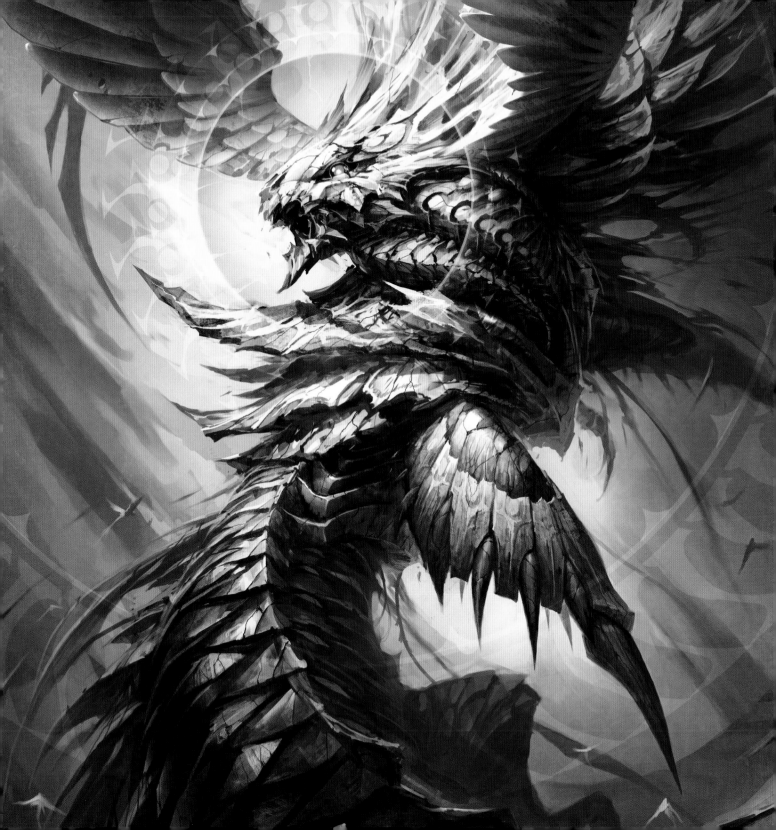

1 Inspiration and concept

I find that the strongest designs, whether they are creatures or architecture, arise from a solid purpose for that design. While designing something with the purpose of simply looking cool can sometimes yield beautiful work, a design with a strong sense of history and usefulness will invariably be richer and resonate more deeply with the viewer. Therefore, I believe the first stage of any design is a solid concept followed by extensive research.

There's something I love about dragons, both aesthetically and symbolically. However, our notion of the dragon has strayed pretty far from any basis in reality. For the piece on which this workshop is based, titled First Light, I chose to search for a design that sought out the potential origins of the dragon. Much of my research led me to the earliest creation myths of many separate ancient cultures. From China to Egypt to Mesoamerica, a recurring theme was that of the beast taking the form of a feathered serpent. Perhaps ancient man symbolically combined the sinister ground-dwelling snake with the magical flight of birds to create a being of duality, or perhaps they retained some genetic memory of dinosaurs. Whatever the source of the dragon, the question is strong enough to inspire a wealth of design ideas and a goal to create an image that conjures a feeling of archetypal ancient power.

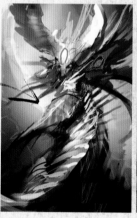 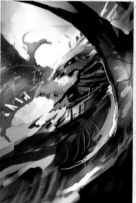 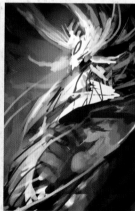

2 Compositions

In the past, I used to spend large amounts of time labouring with pencil and paper on the basic composition and details of a piece before moving on to any shading or colour. I've now come to find it far more inspiring and productive to dive right into painting full-colour thumbnail versions of my paintings. This approach enables me to let go of any hang-ups related to the details and just feel out a balanced overall design. Creating miniature versions of the finished piece, with all its colours and values, helps me decide immediately whether it will have the impact and legibility that I'm looking for.

Working small, both in resolution and in the size it's displayed on my screen, enables me to move through many fairly complete ideas very quickly. Even if I happen to hit upon a composition that I really like, I still explore a couple more ideas just in case I encounter an experimental surprise along the way.

By the time I've come to the end of the comp stage, I've narrowed down the rough design, lighting, colour and composition. Having these important basics mostly resolved at this early stage spares me time-consuming reworking later on, and gives me a strong base with which I can explore the details with confidence and efficiency.

SHORTCUTS
LIQUIFY
Shift + Ctrl + X (PC)
Shift + Cmd + X (Mac)
This quickly opens the Liquify tool in Photoshop – helpful for sculpting organic forms.

6 Structural details

With the lighting direction established, it's time to start dropping in design elements such as feathers and scales to show the solid structure of the body. The scales on the back are created by simply painting one set of scales and repeating the pattern by copying, pasting and transforming each set as it wraps around the form. I then use the Liquify tool to adjust the curve of the pattern to fit perfectly on the rounded body.

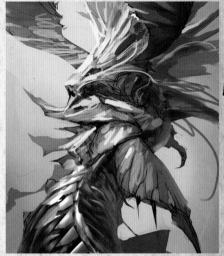

3 Rough drawing

These days, once I've found the composition I like in a colour thumbnail comp, I generally just start adding detail. However, as a result of the experimental nature of this design, I'm adding the stage of a rough drawing to start me off with just a little more structure. Keeping it loose, I digitally sketch the basic design and composition to create an intentionally rough version as a starting point. Even though I'm basing this sketch on the small colour comp I've already partly refined, I still avoid committing to any tight details in order to let the design evolve as I go. Details that may look great in the line drawing may not work once the basic lighting and values are there. I keep the process flowing by not bogging myself down with too many details at this early stage.

4 Separating layers

Before refining the design, I define my basic shapes within the composition by dividing the basic layers of foreground, middle-ground and background. From dark in the foreground to light in the background, I adjust the values of the layers to create spatial separation and a basic sense of atmosphere. I can now see the creature's silhouette to judge its weight and balance.

5 Basic lighting

Taking the key from my early comp, I rough in the basic lighting of the creature's form. Again, I don't worry about designing the various patterns of colours and materials across the body. Keeping it fairly monochromatic lets me move quickly towards defining and balancing the mass of the creature.

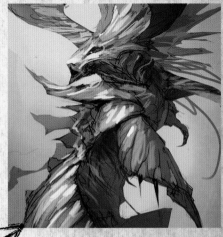

Creature Design: Raymond Swanland

7 Translucency

Defining areas of translucency creates separation between the materials and brings in a more organic quality. By seeing a little light shine through the forms, a real sense of skin, cartilage and bone comes across. Even though light shining from within the creature is somewhat unnatural, the suggestion of a backbone coming through grounds it in anatomical reality.

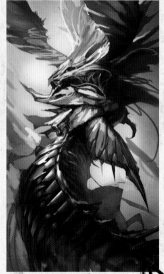

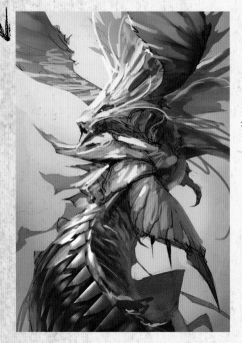

8 Value refinement

With the forms and lighting loosely defined, it's now possible to adjust the values from foreground to background relative to each other once again. This time, there's enough information in the overall composition to bring the piece very close to its final values.

9 Colour separation

I now begin to define the colours of the materials on the creature's body and to separate the creature from the background. I do this by adjusting the colours of the basic layers. In this case, the creature shifts toward golds and coppers while the background fades towards cooler tones. This is more accurate to the final materials and enables the warm foreground to naturally come forward in a spatially simple way, because of the interplay between warm and cool colours.

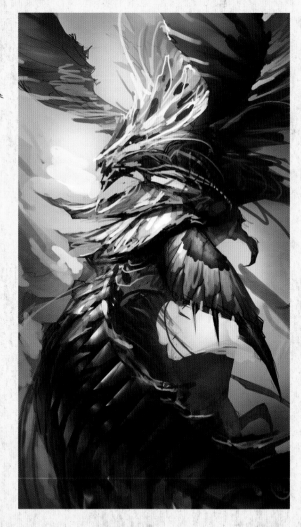

10 Focal details

Although much of the painting will remain fairly loose and impressionistic to provide a sense of life and motion, detail is concentrated in the area which should be the focal point of the whole composition. In this case, that main focus is the head. A creature like this, which has so many segmented areas, presents an opportunity to work quickly and smartly – from the scaly back to the overlapping bone feathers of the wings. With these, for example, I paint just one feather and then duplicate that layer for each successive feather, Transforming and Liquifying each to a unique shape. Very quickly I have the full wing. I then add detail like chips and scratches to break up any obvious copied artefacts.

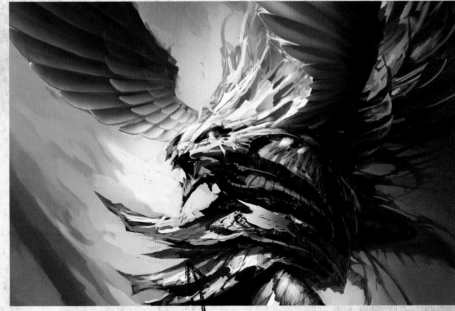

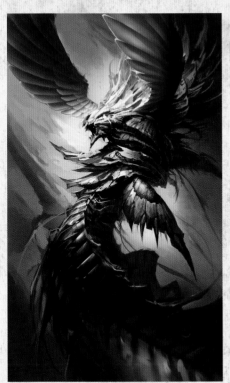

11 Complementary colours

With most of the colours and details squared away, there's room to expand the colour palette by adding accents of colour which will pop against the dominant colours. In this case I use a complementary turquoise accent to lead the viewer's eye up along the body to the neck and eye of the creature.

12 Texture details

With the overall structure and detail built up, it's time to truly establish the scale of the creature and the types of material it's made of, by adding very fine detail that's texture specific – such as cracks, pits and scratches. Achieving an effect of huge masses of weathered scales and bones is achieved through emphasising the striated structure of organic tissue. Directional lines, much like those in wood, create a familiar texture that we recognise in living things.

At this stage in the painting, I tend to use a custom-made brush that mimics dirt and unevenness to break up any pristine solid surfaces. Rather than dragging the brush with the pen, I usually click it several times in place with the mouse to build up the level of noise I desire. To enable this dirt and noise effect to be subtle, I primarily use non-opaque tools like Dodge/Burn or Colour Overlay.

Creature Design: Raymond Swanland

13 Graphic overlays

To reinforce the sacred nature of this proto-dragon, I paint a luminescent halo. A mix of Overlay and Hard Light layers with increasingly bright colours makes the halo appear to be formed completely of light. This also focuses the eye within the overall composition.

PRO**BRUSHES**

PHOTOSHOP
Custom Brush: Dirty Brush
BRUSH TIP SHAPE
Spacing: 60 per cent
SHAPE DYNAMICS
Size Jitter: 15 per cent
Control: Pen Pressure
Angle Jitter: 50 per cent
Roundness Jitter: 0 per cent
OTHER DYNAMICS
Opacity Jitter: 0 per cent
Control: Pen Pressure
Flow Jitter: 0 per cent
Control: Pen Pressure

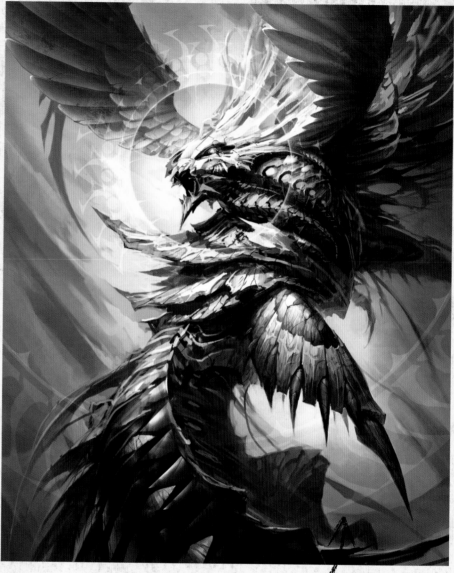

14 Reinforcing graphic elements

To bring in just one more element to accent the composition of the piece and guide the eye back to the focal centre, I add a silhouetted form of the feathered tail wrapping in from the background. Although this departs from pure realism, in combination with the halo it adds to the overall symbolic quality of the painting.

LAYERS OF INVENTION

When designing directly in Photoshop, you can do iteration after iteration of a design in different layers as you refine your vision. Save out these different versions into separate files, or you could lose them when combining layers or flattening. You can also explore ideas, then circle back around and end up preferring the image you began with. It's real a shame to forget where you started.

15 Texture overlays

Different materials such as time-polished scales and carved bone are given richness by overlaying photographic textures at a very subtle opacity. Images such as corroded metal and fossilised bone are not only excellent overlay textures, they're invaluable reference for the textural qualities that are painted by hand, which in this case are the majority.

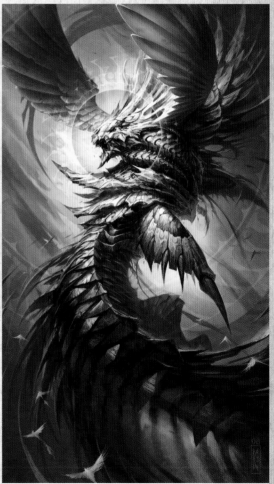

17 Final stylistic touches

Finally, I weather the piece, lending an organic sense of age to the painting. Sometimes I use dirty brushes or a Smudge tool. For this, I overlay a corroded metal texture at an opacity of less than 10 per cent and erase any existing roughness.

In the end, I believe the human eye sees slight imperfections as an indication of reality. When I'm creating a creature so far from the tangible world, I endeavour to bring the roughness of our daily reality into the realm of pixels and ground this flight of imagination in just a little bit of truth.

16 Motion and scale details

To capture a sense of action, I paint in loose fragments of material flowing with the wind and creature's motion. Bits of feather and flakes of bone being shed by it as it moves add to this, intensified by adding some motion blur to the fragments in the foreground.

Also, by dropping in familiar animals such as birds, we instantly provide a context of scale for the creature and also add yet another sense of directional movement to the final piece.

Creature Design: Raymond Swanland

ARTISTPROFILE
BART TIONGSON

COUNTRY: USA
www.riceandeggs.blogspot.com

Bart studied classical animation at Ontario's Sheridan College. He then spent ten years in the games industry, and is now a concept artist at Robot Entertainment, Texas.

PHOTOSHOP

Release The Kraken

BART TIONGSON gives the iconic sea creature a contemporary look while creating a painting that has plenty of action and movement

Using Photoshop, I'm going to redesign a beast from ancient Greek mythology. I'll try to maintain a traditional approach to the composition process and keep any Photoshop trickery to a bare minimum. I'm not out to bamboozle anyone here!

One thing I hope you get out of my workshop is that, of course, in today's world of digital art it's absolutely necessary to use the many clever features of a paint program to keep up with current trends. But bear in mind that it's equally, if not more, important to have an understanding of basic art fundamentals and to not rely too heavily on the program, which is just a tool.

When I think about the Kraken, there are two things that spring to mind: its mammoth size and its numerous tentacles.

The Kraken is the central element of this piece and so it needs to immediately grab the viewer's attention, yet stand apart from previous interpretations. In addition, with the creature taking up so much space on the canvas, my challenge is to prevent everything around it from becoming superfluous.

Because the piece practically demands lots of action and movement, I also need to keep the focal point exciting while making sure that the rest of the canvas is full of motion. It's crucial to keep the viewer's eye constantly moving through the image without having them grind to a halt on any particular section. My rule of thumb is to have fun with the painting and then, with a bit of luck, everything else will fall into place!

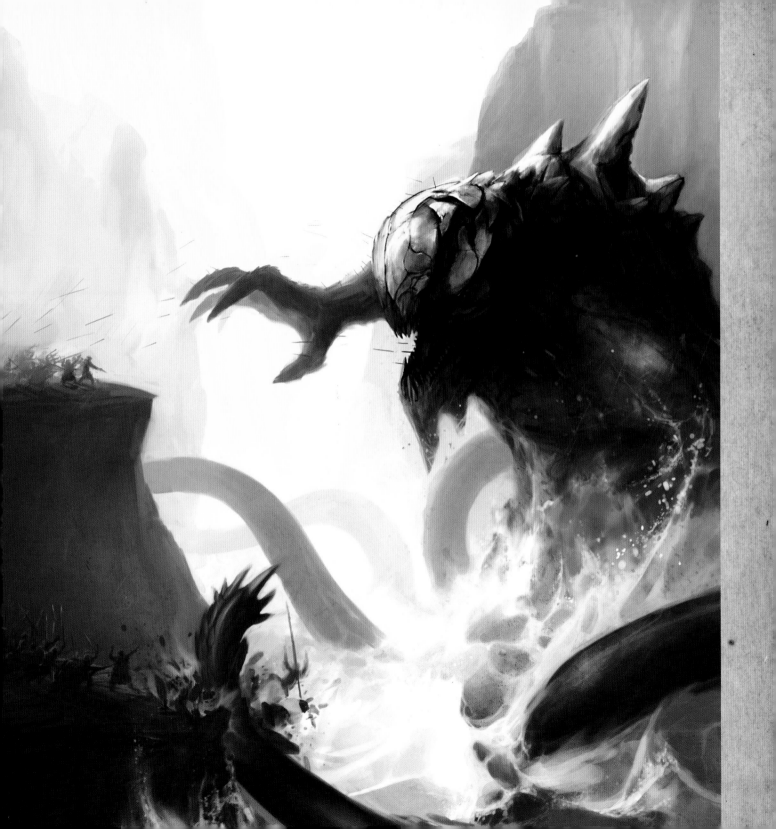

1 Quick thumbnail

I sketch a thumbnail to establish the creature's general pose – I'm not trying to design the Kraken at this point. After I have some large shapes painted I add a little line work, hinting at features such as teeth, eyes and claws. I try to design the image to follow an S-curve so that the viewer's eye starts on one end, travels through the image and then ends up back at my point of interest, which will be the Kraken's head.

SHORTCUTS
FREE TRANSFORM
Ctrl+T (PC) Cmd+T (Mac)
Use this command to carry out several actions on the fly to a selected area: warp, scale, distort and so on.

2 Setting the mood and tone

After I've done a quick detail pass with a dark line I consider the Kraken's surroundings. I paint in crashing waves and think about the amount of movement that something of this size would create if it suddenly emerged from the sea. I want the Kraken to have massive, boney material on its back. I imagine that in shallow water this bone structure juts out to mimic a rock formation, so that ships would sail by unaware of its presence.

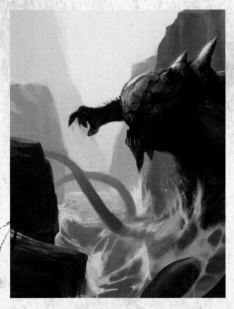

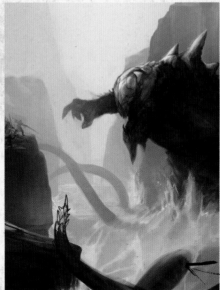

4 Atmospheric perspective

In a piece like this where the scale of the scene is epic, you don't want to lose sight of your foreground, mid-ground and background elements. I push the mountains in the distance way back and create some foreground objects to give the illusion of depth. Then I create some mist on separate layers and bring the opacity down or up, depending on how much or how little I want to push something back.

3 Adding subtle colour

Now it's time to think about colour and light. At this stage I keep things fairly subtle, knowing that I may change my direction later on. So I experiment with some light along the water to try and add a splash of colour. Although the scene is set during the day, I'm keen to avoid a setting that ends up being light-hearted and playful.

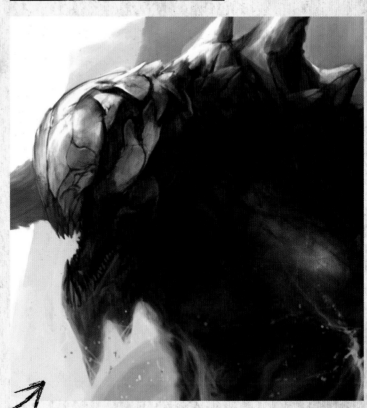

5 Committing to some decisions

My details are starting to come together now. In particular, the head and back of the Kraken are beginning to look like how I originally envisioned. I'm really digging the face area. I find that if you want something to look creepy or scary, the eyes – or lack of them – can make or break a design.

6 Correcting some problems

Never be afraid to redo a detail, or even an entire section for that matter. Here I'm redrawing some of the shape and form of the stomach area. I just draw on top of the existing section on a new layer. I'll usually flip the canvas periodically while I work. This makes it easier to draw certain lines from different angles and enables you to see small mistakes that normally you might not see before flipping it. I'll flip the image, then go grab a snack or something. When I return, if something immediately jumps out then you know it's time to address that issue.

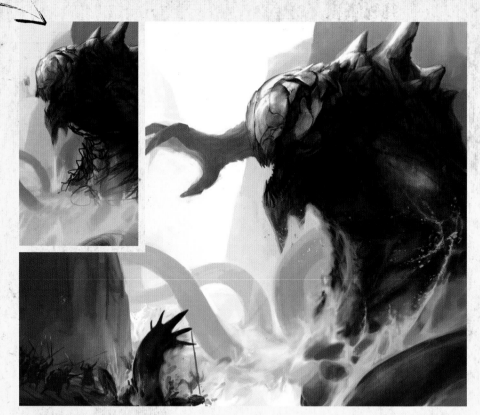

7 Add some action

I always intended there to be an army battling the Kraken. This gives me the crucial action element – to give the viewer something to look at apart from the creature – and also helps with the epic scale of the piece. There's no happy ending for these tiny soldiers!

PROSECRETS

BE READY TO EVOLVE YOUR ART
Try not to fall in love with a particular brush stroke or design element of your painting. If it breaks the image in any way, lose it and evolve your piece. Of course, the goal is not to have to scrap anything and that's why thumbnails are so important. Yet because it's so easy to 'redo' things in the digital age to make them better, it'd be silly not to.

shortcuts
HUE/SATURATION
Ctrl+U (PC) Cmd+U (Mac)
This command enables you to play with the colours of a selection as well as the saturation levels. Very handy!

8 Apply some textures for extra realism

Sometimes I like to bring in a texture for some additional 'noise'. At www.mayang.com/textures you'll find thousands of free downloadable textures that are great for referencing and for 3D texture work. I'll make the texture almost transparent and then I just let the various shapes help me to add some real-world grittiness to the scene.

9 Final polish pass

I'm close to finishing the image now. I often find that this is the most difficult part of creating a concept. Much like in running a marathon, the last mile is where you need to stay the most focused. I continue to push on and draw in the little elements that make this painting as good as can be.

10 Cross the finish line

Finally, I merge my layers to tidy things up (keep a layered version though, just in case you need to make revisions to the image). Here I play with the colour balance to make things a bit punchier (select Image>Adjustments>Color balance). Level adjustments can also help sometimes (Image>Adjustments>Levels). I use these tools sparingly and subtly. It's easy to become dependent on them, and by relying on them completely you start to lose your ability to see things on your own. Use the tools to aid you, not to do the work for you.

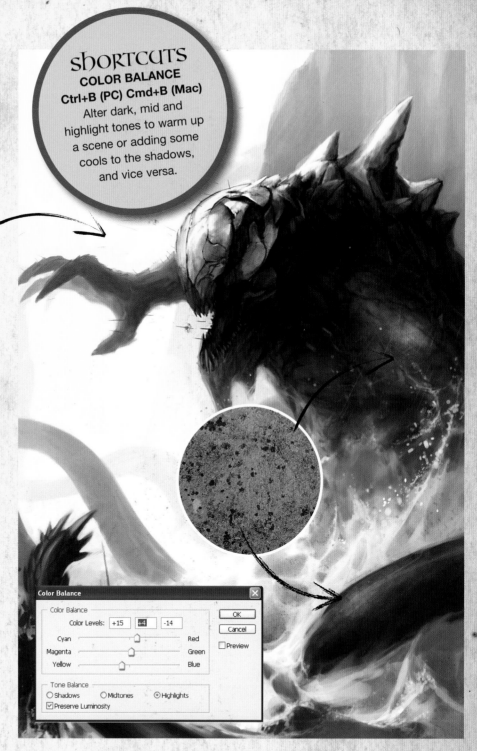

SHORTCUTS
COLOR BALANCE
Ctrl+B (PC) Cmd+B (Mac)
Alter dark, mid and highlight tones to warm up a scene or adding some cools to the shadows, and vice versa.

Color Balance
Color Balance
Color Levels: +15 +4 -14
Cyan —— Red
Magenta —— Green
Yellow —— Blue
OK
Cancel
Preview
Tone Balance
Shadows Midtones Highlights
Preserve Luminosity

Release the Kraken: Bart Tiongson

ARTIST Q&A

Q I've designed a serpent creature – do you have any tips for painting it up?

A RACHAEL HAUPT REPLIES

Serpents, snakes and the like are great creatures to paint. There are a multitude of design and rendering choices to be made and you must decide early on in the process what style of artwork you're hoping to achieve. The main point you need to bear in mind when painting a serpentine creature is that it's tubular in shape. Consider the creature as a tube, bent into whatever pose you have decided on, but still essentially cylindrical. This will affect the lighting and the texture dramatically. If you don't let the light and scales wrap around the tube you'll be left with a very flat, two-dimensional artwork that won't be as successful as you'd imagined.

Do some sketches to decide what kind of features you're going to include (1). Are the scales large? Small? Does the serpent have any bony bits? This was a sketch I started with, but I subsequently ended up totally redesigning it!

Paint your layout (2) – decide where the light is going to hit and where the textures on the serpent will change from the back to the underbelly. It's a good time to establish the cylindrical nature of the serpent – try to make it look rounded rather than flat.

Now start adding the colour and drama (3). Think about what kind of scales you want – I've started to paint in a rougher, more colourful back in this image. I've also begun to redesign the head. Paint the scales so they feel as if they're wrapping around the creature.

Here's a close-up of the paint strokes I'm using. They're very loose when you have a good look – I'm 'suggesting' the scales rather than painstakingly drawing every one. Don't be afraid to add a range of colours and patching. Look at photos of real snakes – you'll see they're rarely perfectly uniform.

Don't over-detail

Remember – you don't have to paint every scale! In fact, it's a good idea not to. Remember, you are creating an artwork – not a technical diagram, so don't painstakingly render every one. If you paint more loosely you'll end up with an interesting texture, overwork the serpent and it'll look less convincing.

As you paint, pay attention to the roughness of the scales. You'll create much more interest if you vary the level of detail and have some areas that contrast with others. In fact, it's a great idea if you go so far as to make some patches seem almost smooth. That way some areas will appear translucent while others nearby may be very rough and dry. I've exaggerated this variance slightly in this image – rough, spiky, saturated scales lie alongside smooth, almost milky areas. If you look closely at photographs of snakes, you'll see a more subtle amount of contrast – but it is there!

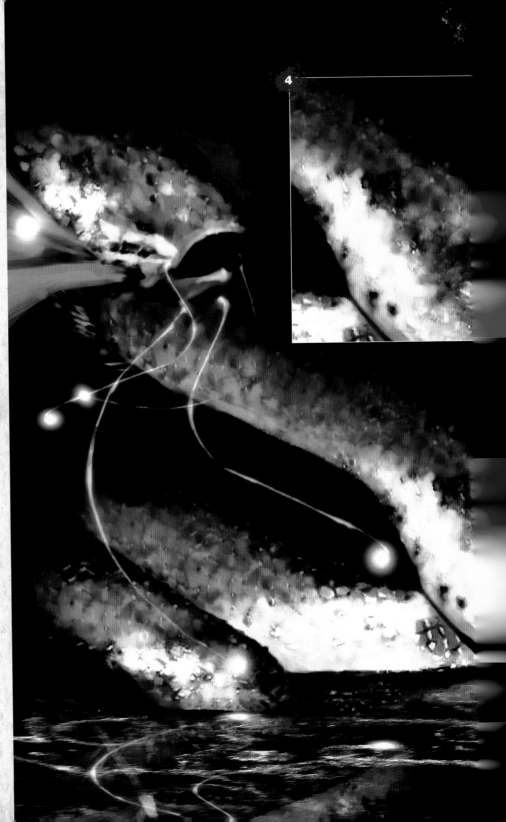

ARTISTPROFILE
JOHN KEARNEY

COUNTRY: UK
www.brushsize.com

John has over seven years experience as a 3D graphic artist in the video games industry. He is currently freelancing on various projects.

PHOTOSHOP

MONSTER CREATIONS

The creation of The Malesquis: an insight into the evolution of a beast.
By **JOHN KEARNEY**

My first task is to assess what is required and set a few targets. I'm being asked to paint a striking monster, which immediately gives me the main focus of the painting. My design has to be solid, unique, and convincing enough to clearly visualise its movement. I want it to look stylish and be able to captivate the viewers' imaginations. Lastly, I want to place it in a setting of some peripheral interest and create a composition with visual impact. It's good to be ambitious! I realise that this is no easy task, and that preparation will aid in making my goals a reality. A basic story will give a design purpose and direction, and I normally scribble down some ideas that will be used throughout the project as a source of inspiration and guidance.

My beast will be from a breed of alien creatures called The Malesquis. They can only be found on one planet, a barren and desolate place called Arrazine. This world is a hostile environment; a deadly battlefield for the warriors and hunters who are brave or stupid enough to enter its domain. The deadly Malesquis are a prize trophy for those wishing to better their reputation and wealth.

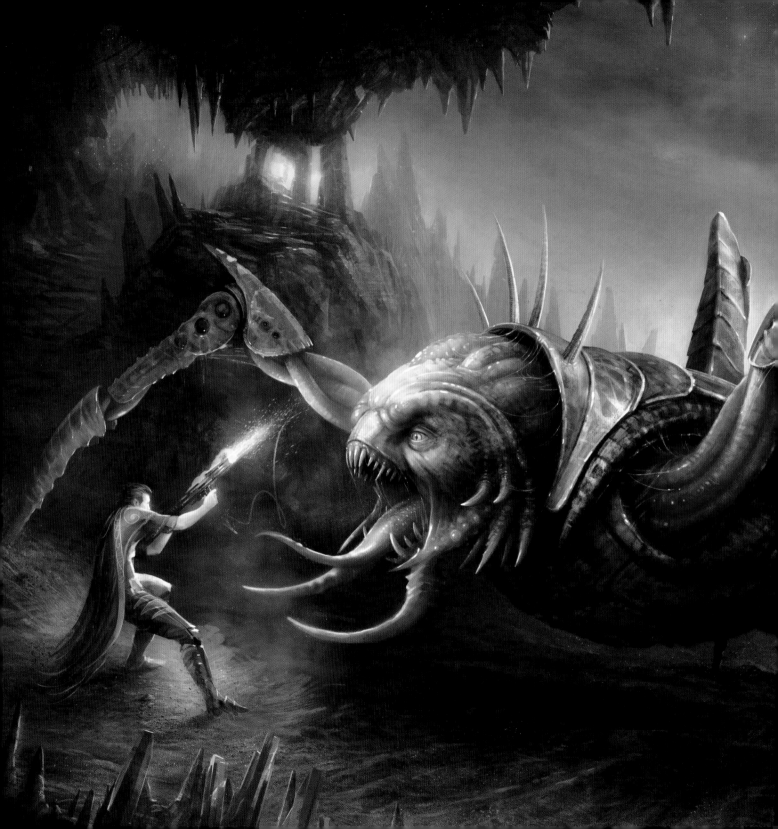

3 Selecting and developing a sketch

Usually, I take quite a lot of time to develop my chosen sketch. This time, I feel impulsive and eager to get straight into Photoshop. I choose a thumbnail that is barely enough to start with, scan it in, and get straight to work. I quickly create rough landscape dimensions for my canvas and then begin adding to the pencil sketch, digitally. I know the pose has to be fairly strong and clear enough to show off the design, so I get stuck in with some basic, loose shapes. A rough impression of the caves is introduced so that the environment is indicated for compositional purposes. If ideas are flowing, it's usually a good idea to go with them and capitalise on the inspiration.

1 The Malesquis concept

I've been given landscape dimensions, which influences my decision to go with a quadruped rather than a biped. The monster has to be the main focus, and I feel a biped would have made the composition potentially problematic. Using my story line, I'm able to get a feel for the kind of beast that would work well in a harsh habitat. I think the perfect mix would include armoured shells, mobile limbs for climbing rocks, an arsenal of weapons for attack, and a few vulnerabilities, indicating that adept warriors would be able to challenge them.

2 Gathering reference material for inspiration

I write a quick list of insects, animals, and anything else that might provide useful eye candy. Then I go about searching for some reference, on the internet and in books. I end up with a folder packed with numerous photographs. Included are scorpions, turtles, crabs, earwigs, wasps, rams, and even seashells! Many thoughts begin to flood my mind, so I take advantage of them by knocking out some crude and rudimentary sketches. The purpose of this is to get my ideas down on paper. I don't worry too much about the quality of my thumbnail sketches; they are just mental notes to be built upon.

4 Canvas set-up

I carefully review the dynamics of the creature and think more about composition. I also make mental notes of places where I could add the hunters and then rotate, crop and scale the image to half of my intended final resolution. I do this for two reasons: I know that I will eventually refine and detail the whole picture once all the basics are in place – this is the stage where the resolution matters. Secondly, I want to use Photoshop quickly during my initial sketching.

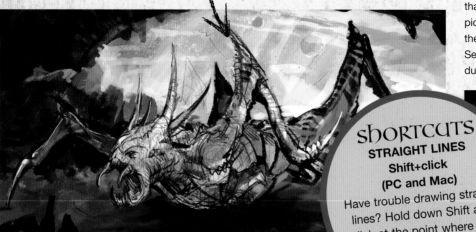

SHORTCUTS
STRAIGHT LINES
Shift+click
(PC and Mac)
Have trouble drawing straight lines? Hold down Shift and click at the point where you want the line to end. Et voila!

5 Brush management

Texture is always important to me. More often than not, I prefer to manually draw a lot of it rather than use large brushes; it can make things look linear and samey. You can define contour and shape much better with smaller brushes that are endowed with a hint of texture. One of my favourites that I use in 90 per cent of my work is the Pastel Brush, which ships with Photoshop's Natural Media Brushes. It gives me a bit of grain and a nice shape, which I personally prefer for painting. I supplement this with custom brushes that I have drawn myself, usually with pencil on paper. You get a lot of organic grain for free, and this makes things look very natural.

6 Colour and tonal foundations

I consider that tones, values, contrast and overall lighting generally take paramount importance. Colours can be changed incredibly easily when working digitally. As long as I am near the mark, I don't worry too much about having a palette laid out. With the knowledge that new light sources will be added at a later stage, I proceed to paint some blue hues of differing brightness to give me a basic ambience and an underpainting on which to work. Doing this provides an effective starting point, because the fundamental tones of the image are set. I recommend getting rid of the white canvas as quickly as possible.

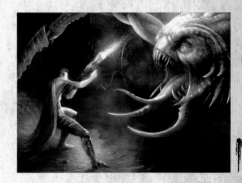

7 Lighting and colour

Lighting affects absolutely everything, so consider its colour and intensity carefully when selecting and mixing surface colours. Think about the quality of light and the effect it will have on shadows. Light can be used to add areas of focus, contrast, create atmosphere, or describe form. Since my scene is going to be set in a dark cave, I use the foreground hunter as a source of light via his weapon. This is planned and necessary, or the Malesquis' face will be in darkness.

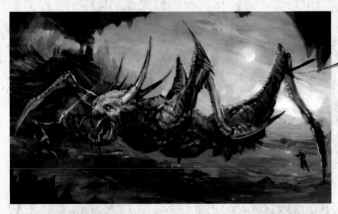

8 Compositional enhancements

Stalactites and stalagmites provide ideal contrast points against the sky and foreground, which frame the picture and add interest. While painting the ground, I try to incorporate natural patterns that will help lead the viewer's eye into the picture and create depth. Complementary light sources often add colour interest. If placed correctly, they can also enable you to use rim lighting and highlight one edge, a technique often used in film and photography for dramatic lighting. It's most striking when used in high contrast.

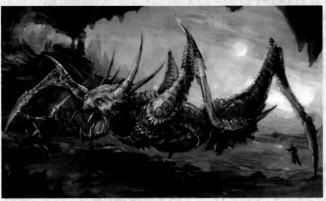

Monster Creations: John Kearney

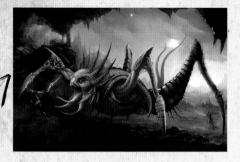

11. Complementary elements

I always try to think of things that will add decorative interest and be complementary to the look of the finished painting. What is complementary? It boils down to personal preference and artistic vision. This is where individuality shines through. I decide that crystal sparkles from the rocks would work well. Partially obscured light sources tend to create glow effects on camera lenses, so I decide to implement them at the back of the cave. Doing so gives the area a cinematic feel with a hint of mystery and atmosphere. The area that has a rocky stepped pathway is one of curiosity and encourages the viewer's eye to roam around the picture. These little touches can add a lot to a painting.

9. Improving weak areas and correcting mistakes

It's necessary to make some comments regarding the organic nature of painting fantasy artwork. Making critical decisions on the quality of your painting is vital every step of the way. Learning to critically assess your work is the first step in being able to point out problems and make corrections. Fantasy artwork is not like drawing a portrait. You have no real direct reference; as a result, the painting has to be given a chance to evolve.

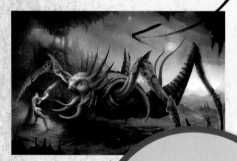

10. Character and detail considerations

I rarely make a proper design for character clothing in a painting like this because the scale means that most of the detail is just suggestive. My initial foreground character pose isn't working too well, so I change it to something more dynamic. The revised character's feet are positioned to give the impression that they have slid, with bits of debris spewing up. The decorative cloak adds balance to his body position. It's important to plant the Malesquis' front legs into the ground and to add further dust and rubble around them. I make the landscape fairly inhospitable by adding sharp rocks and convey depth by drawing a few distance layers that gradually fade into the sky.

12. Adjusting dull sections

If an area needs a bit of life or slight colour variation, I'll simply create a new layer, change it to Overlay or Hard Light, and hit this layer with hints of my desired colours using a soft-edged brush. This keeps the texture you have underneath but changes the underlying colour, the intensity of it, and adds vibrancy in the process. I use this sparingly.

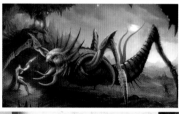

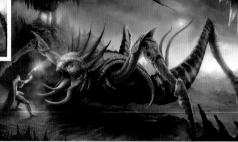

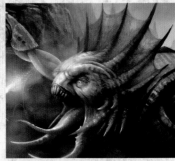

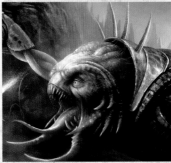

14 Adding effects and finishing touches

My custom brushes are used to create the debris, dust, and little sparkles. The debris/sparkle brush consists of noisy smudges and dots. I adjust the Scatter and Angle Jitter settings of the brush, so it's sprayed randomly when painting. As a final measure, I flattened the image and make colour corrections using Levels dialog. At this stage, I sometimes like to hit the image with a few subtle glows in key places. I do this by creating a new layer, setting the layer mode to Colour Dodge, and painting the blooms with a soft-edged brush.

Debris & Sparkle Brush

15 Summary

It takes a great deal of time and effort to be able to put something down in a way that enables others to capture the essence of your idea or fantasy. You need to balance technical ability with creativity and be willing to suffer plenty of frustration in the process. Painting a picture is often a struggle against yourself, but the sense of achievement when you are finished is enough to make you go through it all over again.

Overall, I think I manage to achieve quite a few of my goals with my picture of The Malesquis, so I am reasonably pleased with the result! I hope this article has inspired you, and has helped demonstrate a workflow for creating your own fantastical beasts from concept to completion.

13 It's bugging me!

If anything is catching my eye and annoying me, then I feel compelled to change it. The horn crown feels a bit too clichéd and too similar to a Triceratops for my liking. This design doesn't work too well when I imagine the Malesquis brought to life. If placed in a film or game, the head movement would have looked severely restricted due to the horns clashing into the shell. It bugged me the whole time, so I decide to try an alternative near the very end. It occurs to me that the themed muscle tissue might work well as a neck and be consistent with the design of the limbs and tails. The tissue suggests the neck can extend out, increasing its manoeuvrability, and enabling Malesquis to quickly strike with a snap of its jaws. The result is a weirder design, similar to a tortoise, but definitely more threatening!

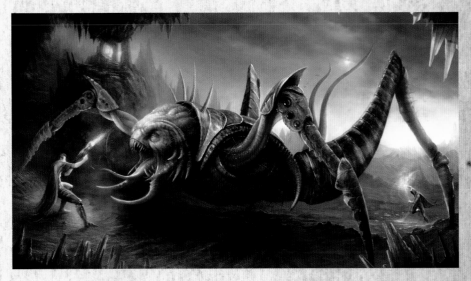

ART SINS

Francis Tsai reveals ten common pitfalls of digital art – and how best to avoid them

10 LENS FLARE

One piece of advice you've most likely heard as a digital artist is 'no lens flares.' It is important enough however that it bears repeating just to be sure. Using the Lens Flare filter tends to be something that someone very new to digital painting does; I know, I did it myself when I first started out. It's a quick and easy, yet dramatic way to make your image 'feel' realistic, which is exactly the reason you shouldn't use it – it's easily spotted by anyone with some amount of experience using digital art tools.

9 FILTER EFFECTS

Some similar, but slightly less used filter effects are those that give an entire image a painterly feel. In Photoshop, these might include the Paint Daubs or Watercolour filters, and should probably be avoided or at least used carefully in conjunction with other effects; the reason again is that with any single click process, the effect is usually obvious to an experienced Photoshop (or insert your favourite digital painting program here) and can take the viewer out of the painting in a negative way.

TOP: Filters should be used with caution. This is my original image in Photoshop without any effects applied to it.

BOTTOM: Here I have applied a range of filters to the image, but also made lighting and texture adjustments to make filter use less obvious.

8 AIRBRUSH ALERT

One of the first things I abused when I was learning to use Photoshop was the Airbrush tool. It's amazingly useful for indicating rounded forms, and indicating radiosity type shadow effects. I'm singling out the Airbrush tool here, but really the same principle goes for any useful digital tool – use it in moderation, and in conjunction with other painterly techniques to achieve a natural blend and balance of effects.

7 MUD

One common practice of novice artists is to use black or grey to indicate shade and shadow. It's a natural approach, since shadows seem darker, but simply adding black has the effect of making a colour muddy and ambiguous. A simple rule might be to use the opposite colour temperature to depict a shadowed surface – for instance, using a cool blue to indicate the shaded surface of a warm red/orange coloured object.

6 STRAIGHT OUT OF THE TUBES

Because it's so easy to lay down a lot of colour, what often happens is that an artist is tempted to use all of them at once. It's easy to end up with an oversaturated painting, especially since digital colours are additive (meaning they don't get muddy or grey when mixed). That's not to say saturated colours are never appropriate. Without getting into a longer discussion about colour theory, one simple approach

LEFT: Green is the spot or dominant colour in this illustration. All other colours are subservient to it.

RIGHT: If all the colours are used in a fully saturated way, the result will be garish and unfocused.

might be to determine a dominant colour in an image, and keep other colours, especially other primary or secondary colours, more subdued.

5 CHALK

Similar to sin 7, there's a natural inclination to add white to show a lit surface. In the same way that adding black creates 'mud' in a painting, adding white can be said to create 'chalk'. In most cases, when a surface receives direct light it reflects its local colour – to (over)simplify, bump up the saturation and brightness of the colour to indicate a lit surface. Using white for a highlight is OK if you use it sparingly.

4 GIMMICK BRUSHES

Painting programs often have built-in custom brushes and are appealing to use because they save us the tedium of having to paint certain varied and complex objects. Rather than using them straight out of the box, try using the Dual Brush option to camouflage the brush shape so they're not instantly recognisable.

3 MORE PIXELS PLEASE

Even if you're not planning to print your image, it can often be useful to paint at a higher resolution than your screen can display. For instance, if you are painting an image to be used on a trading card, and the final image will be printed at an inch and a half or less, make your original much larger. Painting an eye with a few pixels is much more difficult than painting it with a few hundred – let the painting program interpolate it down to the right size for you.

2 JAGGIES

The Magic Wand can quickly select large areas of a painting with a single click. But using this tool tends to create hard-edged, pixelated selections that don't look very clean. Creating a new Alpha Channel and painting a selection can create a more organic looking selection. If the aim is to isolate line art, the entire line art layer can be copied to a new alpha channel, creating a duplicate of the line art as an editable selection.

1 BIG PICTURE

Because digital painting programs enable you to zoom very closely into a drawing, artists are often tempted to zoom in very closely to do very detailed brushwork. It's important to zoom out as often as possible to maintain a big picture view of your piece – areas of detail are one of many tools an artist uses to create focal points in a painting, and zooming in to work on details in an unimportant area of a painting can undermine the overall effect.

ARTISTPROFILE

JIM PAVELEC

COUNTRY: USA
www.jimpavelec.com

Jim lives in a dark world surrounded by demons, monsters and devils. He's the author of the cracking how-to monster painting book Hell Beasts.

PAINTER AND PHOTOSHOP

MONSTER MYTHOLOGIES

Learn how to create your very own mythologies through concept and design, with a little help from **JIM PAVELEC**

There are lots of monsters out there in literature and on the big screen. They have terrified humanity since the first tales of men and morality were crafted thousands of years ago.

With such a rich tapestry of existing flesh-devouring fiends, you need to do much more than just draw or paint another hulking beast in order to catch the eye and imagination of today's savvy creature connoisseur. You need to focus as much energy on the concept and design of your beast as you would on its actual rendering.

When I create a monster I want the viewer to get more out of it than the brief 'That's cool!' elation. I want that beast to get the gears in their head turning. I want them to see within its design the foundation of a story, one that they can play out in their imagination, that will keep bringing them back to a wonderful place of horror and epic fantasy.

In this workshop, I'll take you through my process for designing and painting such a monster. I will share with you my initial ideas and sketches, and show how I hone in on a final concept through to the final furious digital rendering.

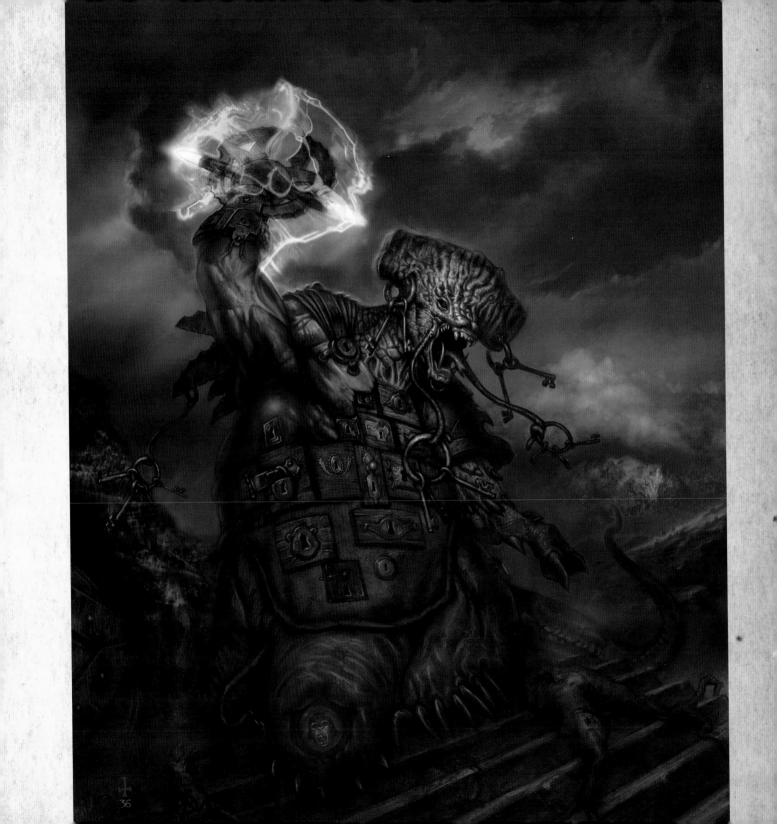

1 Thumbnails

To start, clear your mind of all of the everyday garbage that gets clogged up in there, and focus intently on the task at hand. With your drawing tools of choice (I use paper and a light grey marker and pencil) begin making random marks on your surface.

Don't tighten up and begin to worry about detail. Draw from the shoulder and really let your arm move around. As these random marks begin to build up, your brain starts to see shapes and gestures that you are be able to use as the foundation of your creation.

This initial step, while the most random and chaotic, is the most important in the process and requires the most concentration. Don't spend a huge amount of time on any one piece. If it is not working within the first few minutes move on to a fresh one. For this workshop, I went through many pages before I came up with something I liked.

2 Stepping away

Once you have come up with some shapes and a suitable gesture, think about what this creature is, and what it does. Is it an eight-legged monstrosity awakened from hibernation and hungry for blood, or is it a horrific ancient gatekeeper?

I struggle with this piece for about 30 minutes before stepping away from it. Entering a different environment can help you produce fresh ideas. Pulling out into the real world, you can draw ideas and objects from there to take back into the fantastic. In this case, as I was relaxing with family, I had a vision of a piece of body armour that was covered with old skeleton key locks. I quickly returned to my sketchbook and jotted the idea down.

3 Fleshing it out

Back at the drawing board I take the skeleton key lock idea and run with it. I thought it would be cool if the creature was covered in skeleton key locks, with key rings hanging off of it. Behind each lock will be a small compartment in the physiology of the creature that contains a prisoner, making the creature a jail in itself. I find some reference for old locks, and begin working on the details of the head and torso. I also want to finalise the weapon it will be holding in its upraised arm. With the concept in mind, I come up with a weapon that could function like a pair of giant brass knuckles and a taser.

4 Finished drawing

With the head and torso fleshed out I move on to the lower body. I opt for a slug-like lower body, with tentacles. To evoke the huge scale of the creature, I make portals in its lower body behind which the tortured face of a human captive can be seen. To finish, I use extreme perspective to work out the details of the ground plane and the background. As the creature's design is very detailed, I keep the landscape simple. I add in stone steps and a large tree behind, with a thick round steel door set into it that suggests another holding area. I don't draw in sky details, because I like to figure that out in the paint.

5 Traditional start

Now on to the painting. I begin all of my paintings traditionally. I print the drawing out on to a piece of hot-pressed watercolour paper, and mount it on to a piece of masonite with an acrylic gloss medium. To do this, first coat the back of your drawing with the medium, and then the front of the masonite. Press the drawing down into place and use a brayer to flatten out the drawing and get all of the air pockets out from underneath it.

After this, coat the front of the paper with the gloss medium (there are numerous types of media and gessoes you can use at this stage, so find one that you like best). Once that dries, I use a wide range of concentrated and transparent watercolours, as well as inks, and apply them directly to the surface with an eyedropper. I then spray them with a water mister, allowing the pigments to swirl into each other and pool into interesting formations and colour mixtures. Once dry, I scan it, open it in Photoshop and drop the drawing back on to it in a Multiply layer.

The piece may seem quite a mess, but I like to use the randomness that the water-based media provides as a foundation that I can build on to, with all of the great digital tools that Photoshop provides.

6 Sky photos

Since I was trained to paint traditionally, I tend to work that way on the computer as well, roughing in the background first, and moving into the foreground.

For the sky, I open up five or six interesting sky photos that I have taken with my digital camera. Some have dynamic cloud formations while others have brilliant colours. I copy and paste these on to the painting and scale them to size using the Free Transform function.

SHORTCUTS
LEVELS ADJUSTMENTS
Ctrl/Cmd+L
Ctrl/Cmd+L brings up your Levels sliders to adjust tonal levels of a selection.

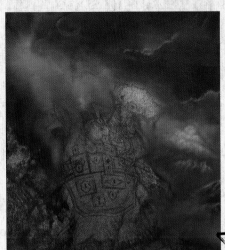

PROSECRETS

BRUSH VARIETY
Choose a brush, click on the brushes tab, and play with some of the options in the drop-down window. I like to click the scattering and texture boxes to give my marks some rough edges, and then untick them to hit up the tight highlights and hard edges.

7 Roughing the background

Next, I start to change the layer modes and the opacities of the layers until some interesting formations begin to take shape. Once I have a something I like I go back and forth between Painter and Photoshop and paint in the sky.

In Painter, I use a very limited set of tools; the Oily Bristle brush and the Oil Palette knife. I use the same procedure to work in some mountains in the lower right of the background.

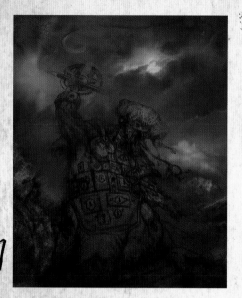

 ## Dramatic changes

As I get into it, I notice that the creature's head isn't separating from the background as much as I would like it to, so I work on the sky around its head. I open up another sky photo and drop it in, but when I go to change the layer mode it accidentally lands on the Hue mode.

Wow! It changed the entire feel of the piece and I like it better so I stick with it. The background has now gone from an intense blue to a more neutral green hue, and where the layer covers the Gaoler, the skin is fleshy like a human's. This is one of the great things about the digital medium; one little thing can transform the entire direction of a painting.

11 More figure

When working on figures in Photoshop I use only two or three kinds of brushes for most of the work. As the upper body comes together I decide to keep the lower portion of the body the neutral purple shade I had laid in for the previous lighting scenario. I think it makes for a nice variation in the creature's skin colour.

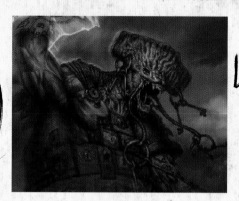

8 Lighting

The background is developing into a nice moody blue-green setting. I go into the figure by drawing a rough outline around it with the Lasso and dropping a gradient over it that runs from a warm orange around the head to a more neutral purple at its base. I want the effect of a warm light source off camera streaking across the Gaoler's upper body. I paint the figure with this lighting in mind.

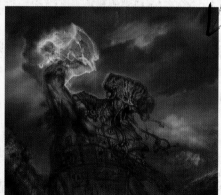

10 The figure

With the new background I decide to scrap the idea of the warm light source highlighting the creature's upper torso, and go with an ambient light source.

I now need to decide what colour the creature's skin will be. I need something that separates itself from the background. I decide on a warm yellow and then begin to paint the Gaoler's face and upheld arm.

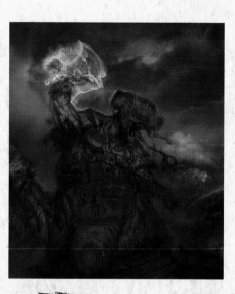

12 Rendering

Now it's time for the grunt work of rendering the figure. Since I have a rough value scale for the entire figure, I can go in and work on sections at a time, jumping from one to the other. For example, I work on the head and chest until they are about 80 per cent complete, and then move onto the locks on the Gaoler's torso.

I know that the locks will be tedious work, so I paint a few, move on to tail, and then come back to the head. This is not really the way that I would work traditionally, but since tonal and colour changes are so easy in Photoshop, I am able to shift my interest and work piecemeal, which enables me to work for longer stretches at a time.

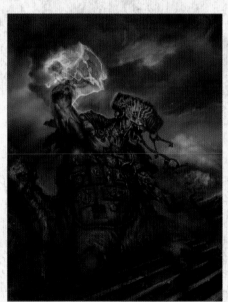

13 Issues of scale

I constantly zoom in and out to ensure things are reading properly on a large scale, and when shrunken down. I work on the stairs beneath the beast so that I have a solid ground plain instead of a floating monster on the screen.

In fantasy work, stone is a texture you must master quickly as it occurs often. It's easy to get carried away with excessive mark-making on weathered stone. Paint it with enough detail that it reads as stone, but doesn't detract from the focal points.

14 Save it

At this point I would like to take a minute to talk to you about saving your files. It's absolutely essential that you save frequently and that you save multiple versions of your files as you go along. I usually just give the piece a name and then put a # at the end of the file name as I save progressive versions of my work.

The reason that I mention this is because I made a mistake early on in my work on this piece, and if I had not had a previously saved version of the image it would have cost me a great deal of time to fix the problem. I had created the energy coming off the Gaoler's weapon by laying a light source over it in a Linear Dodge layer set at 77 per cent. However, as I was working, the file was becoming far too large and was slowing down my machine. So I flattened it and just kept on working.

But I had wanted to work on the weapon with the Linear Dodge layer on top, so as not to interfere with the energy effect that I liked. Fortunately, since I have a version saved which has the layers separated, I can simply open it up and, with a quick lasso, circle the weapon and a bit of the area surrounding it. Then I just need to copy and paste it onto the version that I'm working on.

Then, going back to the earlier version, I can copy the Linear Dodge layer and copy and paste that onto the current version, setting it to the same mode and opacity as before. Now I can work on the weapon without altering the energy.

15 Finishing touch

Finishing the piece is now just a matter of completing some of the details, and making some tonal adjustments. I also apply an Unsharp mask to the piece to tighten it up for printing.

ARTIST Q&A

 My dinosaur looks puny! How do I make it more aggressive and muscular?

 PAUL GERRARD REPLIES

When I think of dinosaurs, words such as strength and brute force come to mind. I want to take the perception of a dinosaur a step further, a step into an imaginary nightmare world where even a defensive herbivore like the triceratops becomes a fierce killing machine.

Relying on past pictures of dinosaurs for reference isn't enough. Take inspiration from other existing predators such as the lion, for example. To me this big cat represents sheer aggression. The muscle structure of its shoulders, chest, forelegs and back give the animal a dominating presence. Therefore, to create a convincing and scary dinosaur you need to concentrate on its outer armour and texture.

Start with an outline of the triceratops. Like any anatomical image it's best to begin with the bone structure and work outwards. To create the impression of an aggressive stance you can over-exaggerate the shoulders and the front half of the torso. The dinosaur's back is naturally fairly narrow in comparison.

Following the bone layout and encompassing the dinosaur's horns, I gradually build up the mass of muscle. The head of the triceratops should have more muscle tissue and, for extra effect, incorporate thick leathery skin onto the body with ripples of tissue that fold over the muscle. These techniques will give you a new take on a simple grass eater.

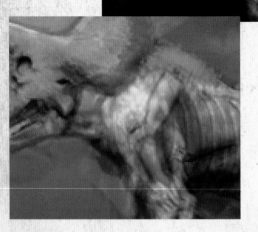

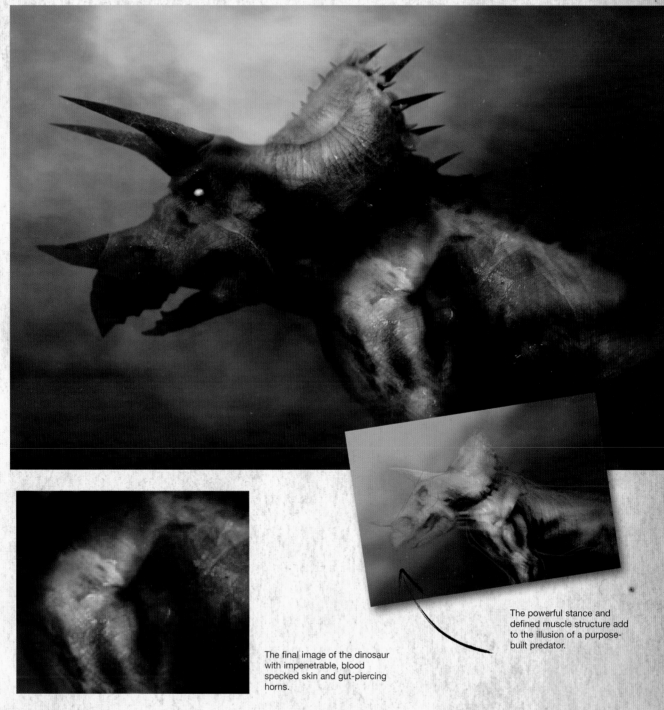

The final image of the dinosaur with impenetrable, blood specked skin and gut-piercing horns.

The powerful stance and defined muscle structure add to the illusion of a purpose-built predator.

ALIEN RACES

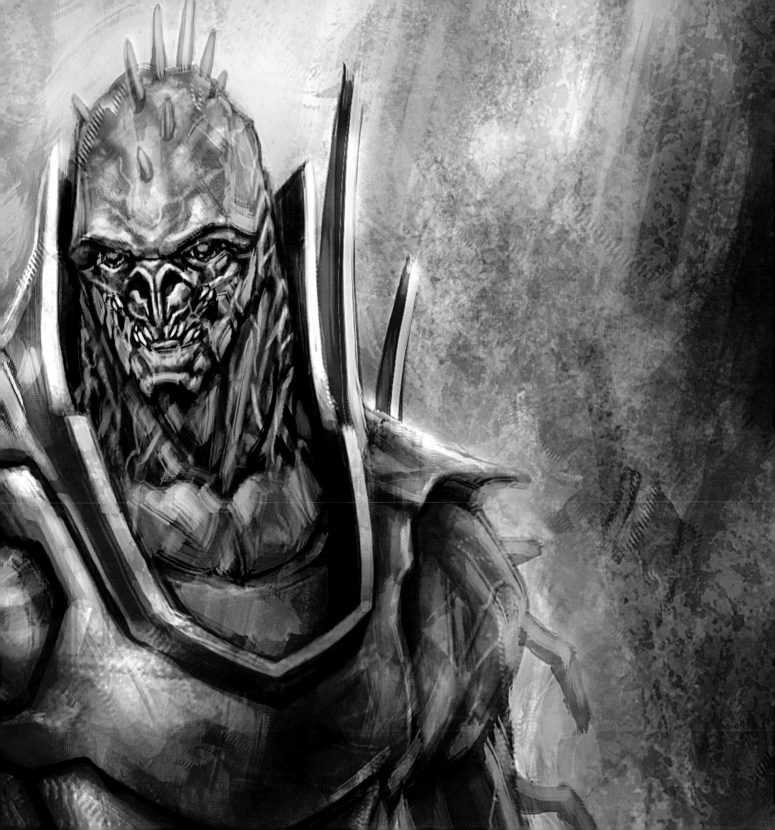

WORKSHOPS

ARTISTPROFILE
MICHAEL KUTSCHE

COUNTRY: Germany
www.michaelkutsche.cgsociety.org

Michael Kutsche is an award-winning conceptual artist and illustrator based in Berlin. Since 1998 he's worked in the VFX industry, where his experiences have ranged from direction to music video animation.

PAINTER & PHOTOSHOP

Photo-Realistic Sci-Fi Portraits

MICHAEL KUTSCHE shows you how he created a human/chimp hybrid to illustrate his technique for painting lifelike characters

P hotorealism can be time consuming, especially when compared to other forms of illustration. However, photorealistic paintings are particularly good at making an outlandish concept into a believable design, and can be less time consuming than a full 3D render.

When you start a photoreal portrait of a fictitious character, the most important thing is to take your time and find some suitable references that fit your vision. The challenge is to only use a bit of each of the references you look at and create a unique idea from their combinations.

While it's good practise to do lots of speed-painting, sometimes you should take the time to carefully finish your artwork. It's good to learn the full production process. I've seen artists out there who are able to create amazing speed-paintings, but fall down when it comes to defining the forms and features of a character or landscape.

To go the full, painstaking way without losing the natural feel of the initial sketch is the real challenge, and I know only a few artists who are capable of this consistently. It's my hope that this workshop will help you join them.

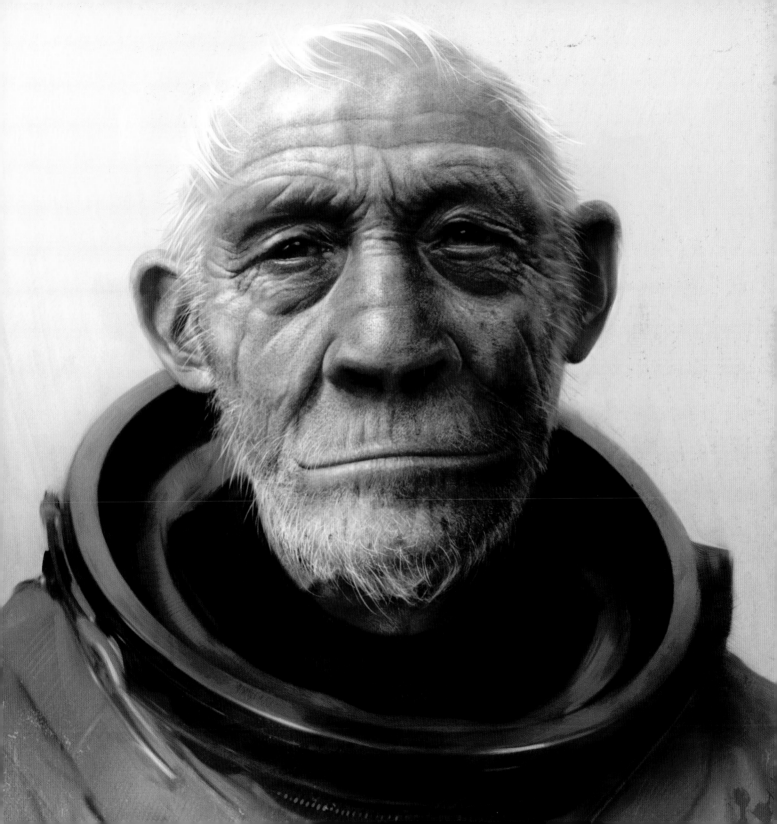

2 Skin colour

After choosing a background colour, I define a shape for the silhouette with some fast strokes. Next, I focus on getting the skin colours and the rough colour of the spacesuit right. I add some red to the skin colour for the ears and take notice of the reflective material of the suit's aperture ring. Both the head and the background should reflect on its upper side, which is important to bear in mind for the detail stages later. For now I simply block in a few tones and move on.

Next I add some rough strokes for the folds of the suit, looking at the references to get a feel of how the fabric behaves. You should only start with more detailed strokes after you've had a look at the layout in a thumbnail and said to yourself: Yes, this is the right composition, proportions, and so on.

3 Loose definition of the face

Now I'm happy with the overall composition, I start to work with smaller brushes, adding definition to my rough. I begin to define the position of the character's facial features and, being careful with my brush strokes, I paint dark spots for the eyes and the shadow under the nose. I decide this is a good time to experiment with expression, so I try out shapes and positions for the eyes and mouth on different layers, keeping the versions I like best.

When painting facial details, always bear in mind the direction and strength of the light. Be especially aware of how light falls on skin around the nose and ears, and how the colour temperature changes in shadowed areas.

Once the features are loosely defined, I do some rough strokes to create the beard. Remember that white hair in shadow still appears bright and reflects the ambient colour – in this case the pale background.

1 Start big

First up, I collect my references: in this case I got hold of loads of photos of old men, chimps and spacesuits. After drawing inspiration, the next thing to do is decide what kind of lighting to use, since it's this starting point that I'll build the whole image around.

Then I begin to find the right proportions and composition by roughly blocking in the main shapes and colours with big brushes and strokes. I don't bother much with the details here as it's always hard to paint over them later if they took a long time to create. I tend to use the brushes in Painter with colour-blending abilities for my roughs: The Chunky Oil Pastel brush, Loaded Palette knife and Wet Detail brush from the Acrylics family are all great tools for capturing life at the early stages of a painting.

shortcuts
FREE TRANSFORM
Ctrl/Cmd+Alt/Option+T
Copy, scale and rotate a layer or a selection with this function.

6 The space suit

Next, I draw some careful strokes to define the small folds of the fabric of the space suit. I also add in seams, attempting to do this with a natural flow. While looking at my reference images, I notice that some materials, such as the orange fabric, have no grey/black shadows because of their translucence; instead their shadows are a saturated, dark orange. The blue sky also reflects on areas of the suit because of its sheen, which makes the orange appear desaturated. It's a subtle effect to try and capture, but these nuances really add vitality to the image.

4 Adding more detail

With all the forms defined, I can now go on to detailing. When it comes to portraits, the main area of interest is likely to be the eyes, so they seem a good place to start the detail work. I choose one of the brushes mentioned in the first step and, using a small brush size, paint the eyelids and pupil. I add highlights on the wet parts around the eyeball where the water catches the light. Using reds I paint some defined wrinkles around the eye, particularly at the border between the eyeball and eyelids. I also notice that the eyelid throws a small shadow on the eyeball and paint that in, too. Try to give the wrinkles an organic form, to prevent them from looking too stylised or cartoony.

5 More definition

With the focal point captured, I add more detail to the face. I try to work on different areas simultaneously to keep the features of the character well-balanced. Beware of getting lost in the small details in just one area, because this could lend a disjointed feel to the image. I find facial expressions particularly challenging when creating a believable character, as it can be difficult to capture how the different parts of the face influence each other. A realistic smiling face is not achieved by drawing curved lips: the eyes, cheeks and nose are performing the smile movements, too.

Photo-realistic Sci-fi Portraits: Michael Kutsche

7 The beard

With a soft tipped brush, draw some branches of white hair to define the beard. When drawing hair, it's a good idea not to start by drawing single hairs: instead it's better to split the hair into strands by using a broad brush with a soft tip. After defining the flow and lighting of these strands it's easy to add in small strokes, creating texture and the illusion of thousands of hairs.

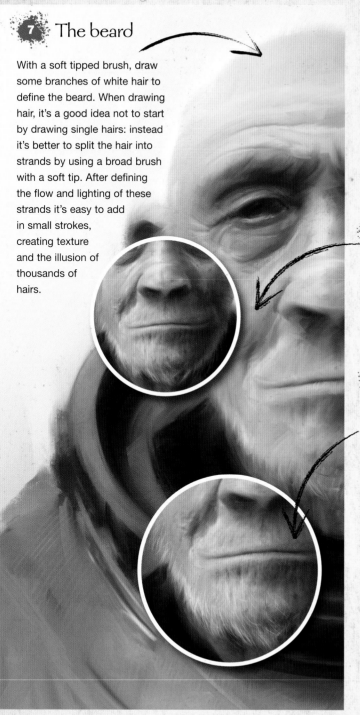

8 Adding more details

For the ape look I add in wrinkles around the mouth. The seams of fabric often crumple, so I add some small lighter and darker orange brushstrokes on the fabric to achieve this effect. There should be differences in the spacing between the strokes, otherwise it looks artificial.

9 Single beard hairs

Use a brush with a hard tip to paint the single hairs of the beard. Steer away from automating this step, because no single hair should look like any other to achieve a truly realistic effect.

I recommend the use of a Pastel brush on a grainy paper with low contrast, which I think gives each hair a suitably messy and organic look.

11 Add some textures

To give the suit a used look which fits better with the concept, I start to add some texture layers. First, I take ink, a brush and some textured papers and create swatches with real dirt spots. Then I scan the ones I like the most, put them in a layer set to Multiply and carefully arrange them over the suit. In a new texture layer, set to Overlay mode, I try to give the fabric a structure, again carefully arranging my textures. Finally, using the Loaded Palette knife I add some strands of hair to the traveller's bald head.

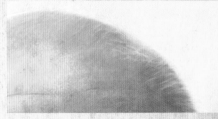

10 Refining the character

This may be the most time-consuming process, because I now have to take care of every little detail. A good foundation, which I've laid down in the previous steps, is of great use here. But I don't draw every detail of the image with the same level of sharpness: the sharpness of edges should vary, depending on the characteristics of the different materials and, of course, the camera's 'lens'.

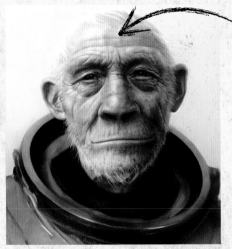

13 Tweaking in Photoshop

Under Layer>New Adjustment Layer select levels, shift the three arrows to refine the contrasts of the image. You can also use the Sharpen tool to add crispness to several areas. Adjustment Layers are good for preserving the older version of your artwork in case you change your mind. You can also use a Layer Mask for adding an effect to areas which require particular attention.

12 Skin textures

I decide to add some skin textures to the face to achieve more realism. For this step I took some high-resolution photos of skin, applied a High Pass filter in Photoshop and used the result as a new layer with an Overlay blending mode. When taking photos of skin, I always use a soft lighting set-up, which produces even tones. This gives a skin texture that you can use in any artwork without worrying about different lighting situations. Don't apply the same texture over the whole face, as each part of the body is uniquely textured.

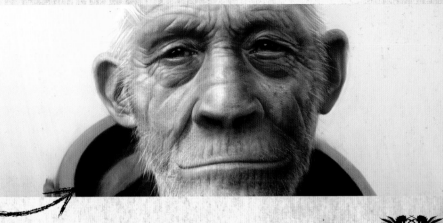

ARTIST Q&A

Q Are there any tips you can provide for making a monster or alien creature feel like it has intelligence?

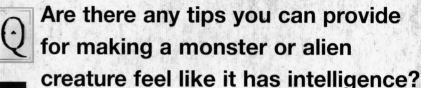

A FRANCIS TSAI REPLIES

I've found that the more bizarre and alien a character or creature appears, the more difficult it is to find emotions that you can relate to in the face. That's not to say that a really bizarre looking creature isn't cool, but that the specific task of making that creature feel 'intelligent' becomes a bigger challenge.

Start with an underlying facial structure that's fairly close to what we recognise as a human being (1) – two eyes, nose and a mouth arranged in a more or less bilaterally symmetrical arrangement. This creates the abstracted human face as discussed above.

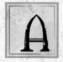

Once the basic structure is in place, we can play with the expectations people might have for a face (2) – bifurcated mouth, nasal cavity and so on – but maintaining the symmetry so the changes appear to be part of the physiology of the character.

Once the major 'moves' have been made, we can refine and polish up the rendering (3). This becomes a job of finding a balance between bizarre details and familiar landmarks. I'm trying to keep the focus on the eyes, as the 'familiar landmark'.

One way of preserving that ability to relate to a character on an intellectual or emotional level is to provide some familiar cues – bilateral symmetry, obvious eyes (eyes are a big one, a primal cue that you're looking at a face), perhaps a mouth. Scott McCloud wrote

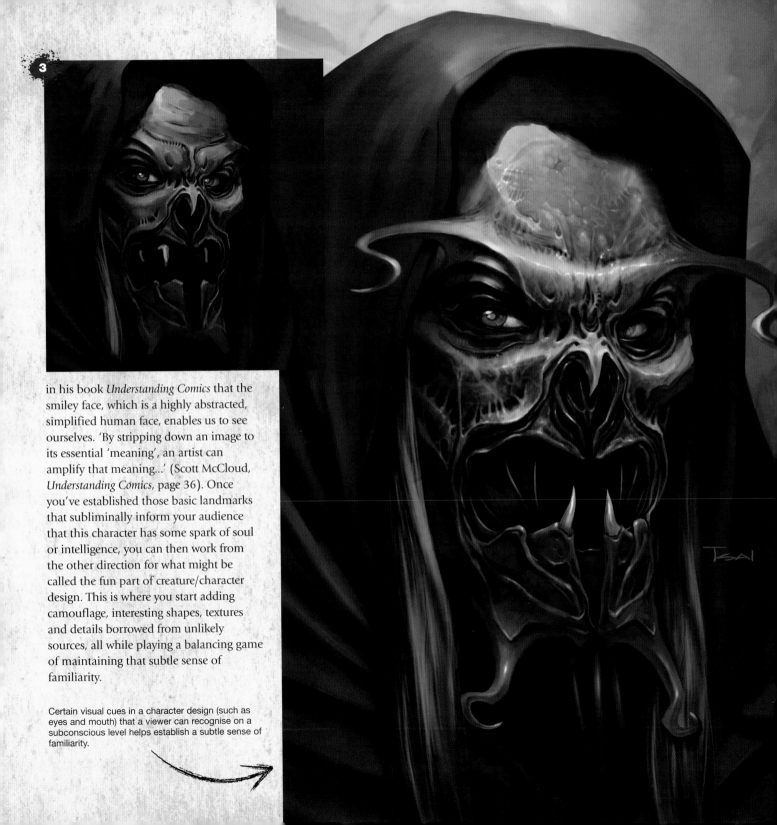

in his book *Understanding Comics* that the smiley face, which is a highly abstracted, simplified human face, enables us to see ourselves. 'By stripping down an image to its essential 'meaning', an artist can amplify that meaning...' (Scott McCloud, *Understanding Comics*, page 36). Once you've established those basic landmarks that subliminally inform your audience that this character has some spark of soul or intelligence, you can then work from the other direction for what might be called the fun part of creature/character design. This is where you start adding camouflage, interesting shapes, textures and details borrowed from unlikely sources, all while playing a balancing game of maintaining that subtle sense of familiarity.

Certain visual cues in a character design (such as eyes and mouth) that a viewer can recognise on a subconscious level helps establish a subtle sense of familiarity.

WORKSHOPS

ARTISTPROFILE
ANDY PARK

COUNTRY: USA
www.andyparkart.com

Andy Park is a concept artist and illustrator who's worked on a variety of comic books, magazines and TV shows. In recent years he's worked as a video game concept artist for Sony, working on the acclaimed God of War 2 and its upcoming next-gen sequel.

PHOTOSHOP

Quick Martian Concepts

Sony concept artist **ANDY PARK** explains his way to develop a character in Photoshop

When illustrating a character or creature, the approach I take will vary depending on many factors, such as who I'm doing it for, what I'm trying to communicate, the time I need to do it in, what effect I'm going for, and even what mood I'm in. All of these make a difference to my approach because, depending on those factors, I'll attack an image differently.

If I'm given the freedom to design a character without the constraints of a really quick turnaround and the need for many variations, I'll treat the concept more like an illustration – planning and painting an original piece of art at my own pace,

while at the same time meeting the needs of designing the character or creature. This was more of the approach I took when tackling this image.

I wanted to paint a sci-fi character, and so I decided on a Martian. Next I asked myself, 'What does a Martian look like?' I wanted to bring both expected and unexpected aspects into the design. Martians are from the 'Red Planet' and are typically depicted as little green men. So I decided to use red and green as the two main colours in this painting. This was a great foundation for the beginning of my illustration.

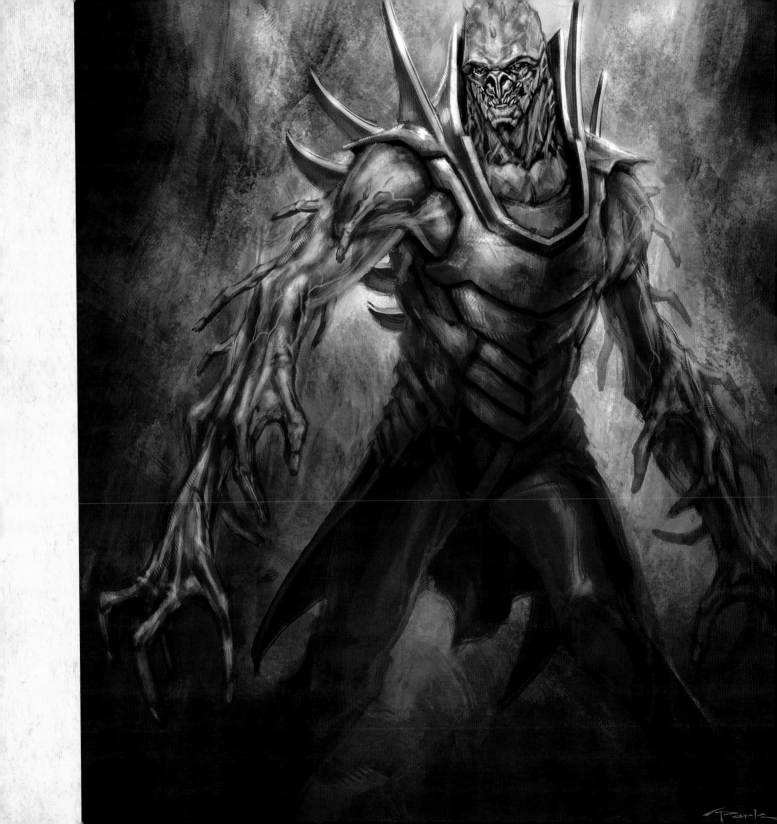

1 Background base

When starting a painting I almost always begin with a background base. At the very least I'll make the background a mid-value grey. In this painting, I decide to do a few things to get my creative juices flowing. The idea is to get rid of the scary white canvas and make things interesting.

I start by making a simple gradation. I then use the standard Leaf brush and paint all around the canvas. I want to create some kind of motion, so I use a Motion Blur filter with the distance pixel value set to 279. Next, I decide to sharpen things up by using the Unsharp Mask filter (Amount: 172, Radius: 71.5, Threshold: 0).

After that I adjust the overall colour palette to include more red, because I know that the Martian will be green. I create a Hue/Saturation Adjustment layer (Hue: -20, Saturation: +15, Lightness: 0). Lastly, I apply a circular gradation on a new layer set to

Multiply, in order to darken the overall painting and reduce the focus on the many different textures and colours.

There are a million ways you can create an interesting background base. This is merely what I came up with for this particular painting, so experiment and find your own different ways to create an interesting background.

2 Character sketching

I create a new layer and set it to Multiply. I then start to paint the basic silhouette of the Martian. I go back and forth between painting and erasing to find a silhouette that I like. I'm creating as I go, and that's the great thing about Photoshop. You can go in a specific direction and make drastic changes at any time – you're never committed like you would be with real paint.

3 Fleshing out specifics

I create a new layer and begin painting the specifics of what this Martian will look like. I want to create a civilised and intelligent being – not just a creature or monster. I give him a typical science fiction-style armoured jumpsuit costume. I also hint at evolved anatomy.

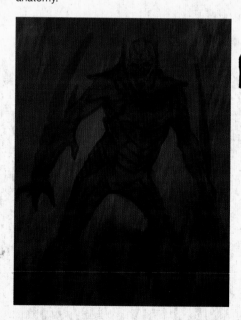

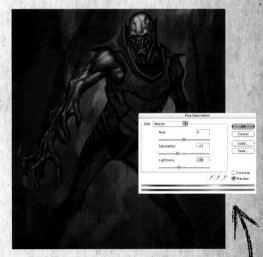

5 Defining form

Now that the character is pretty well defined, I begin to work on his forms. This is the fun part because it's where it comes alive and jumps out of the screen. I decide where the light will be coming from and allow that to dictate how I'll render out the forms. This will be a basic top-down light source, so everything I render will adhere to this.

4 Continuing to define the character

I continue painting opaquely, defining what this thing looks like. As I paint, I decide to give him a hand within an arm, or an arm within a hand. I don't want to give him a straightforward-looking human anatomy. As he's from Mars, I think he could have evolved in a very different manner than a human that breathes earthly air. I also continue defining his suit of armour.

6 Overall adjustments

At this point I realise how dark everything is and make two Adjustment Layers: a Levels layer (with the input levels set to 28, 1.00 and 102) and a Hue/Saturation layer (set to 0, -25 and -19). The Levels adjustment brightens everything up but also adds unwanted saturation with it, so the Hue/Saturation adjustment works to correct this by lowering the overall saturation.

7 Adding texture

I use a texture brush to give more texture to the background and (subtly) to the character, too. You can create your own texture brushes, use the default ones in Photoshop, or even use photo textures to add texture to your paintings.

PROSECRETS

ADJUSTMENT LAYERS
Adjustment Layers are great for making non-destructive adjustments to your image. Just click on the circle that looks like a yin-yang symbol in the Layers palette and it will give you a list of options (much like Image>Adjustments). Click on any of them and you can make adjustments that can be deleted or adjusted later on in the creative process. The Adjustment Layer will affect all the layers below it. It's great because unlike Image>Adjustments, it's a non-destructive method.

8 Background variation

I now want to create a separation between the background and the character. I decide to experiment and try painting on a new layer set to Colour Dodge. I choose a turquoise colour and begin painting around the character. This helps separate him from the background, making his silhouette stronger. You'll also notice that the image has been flipped. I often do this to get a fresh perspective, helping to minimise my mistakes.

10 Add details to tell a story

I continue to add details by painting in teeth and suit attachments. This helps the Martian to stand out, not only in the picture, but also in the society he lives in. It gives him a regal look – perhaps he holds some kind of higher position. Normally when I'm painting a character concept I try to get all the background information and study it before tackling the design. As this is more of a fun exercise, I'm designing as I go – if you're painting for yourself, this is totally fine.

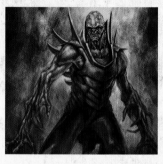

11 More design adjustments

I decide to make more design adjustments at this stage. I want to lessen the twist and exaggeration in his lower torso, so I make a copy of the entire image (again check out the 'Pro Secrets'), select just the waist and legs, and delete the rest. I then adjust it using Edit>Transform>Warp. I straighten out his waist, hips and legs a bit, and the end result is a stronger and more imposing stance. I also decide to adjust his arms. With the evolution of the Martian's arms it would be good to enlarge and elongate them overall, which will help make the design unique as well as bring more emphasis to it.

9 Make design decisions as you go

I step back from the painting and feel that the Martian's head looks very squat, so I decide to give him a longer neck. It also makes sense with the design of the suit/armour. So what I do at this point is to make a copy of his head and move it higher up, to where it looks right (see 'Pro Secrets' for more on making a copy). I then paint in the necessary details in his neck to complete the change.

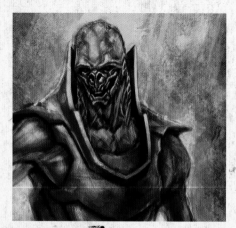

 ## 12 Darken the edges

I create a new layer and set it to Multiply. I then use an airbrush to paint around the edges. The point here is to emphasise the focus, which in this case is his head area, so I paint around it with a low opacity brush.

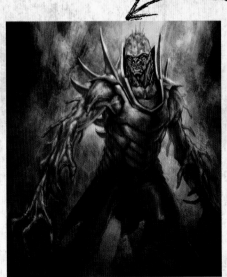

13 Adding highlights

To add highlights, I create a new layer and set it to Colour Dodge. I then use a warm, dark-brownish colour and paint highlights along his arms and armour (especially in areas closer to the light). You'll also notice that I've added more finger appendages coming out of his arm. Maybe this is how Martians' bodies grow and evolve with age.

SHORTCUTS
HIDE ALL WINDOWS
Press tab
This hides all the windows, so you can view the image without any clutter.

PROSECRETS

COPYING AN ENTIRE IMAGE ON TO A NEW LAYER

This is very useful for many reasons, one being when you want to make big adjustments to certain areas without having to flatten the whole image. First, create a new layer and then hold down E, Shift, Option/Alt, and Cmd (for the Mac), or E, shift, Alt and Ctrl (for the PC). This makes a copy of the entire image on to that layer. Select only the area(s) that you want to adjust, delete the rest and make whatever adjustments you need to make in that area.

14 Value check

We're pretty much done at this point. I do a final value check by creating a Levels adjustment layer. I push up the highlights and darken the shadows a little and it stands out nice and strongly. Using adjustment layers are a great way to check your work to see if something needs adjusting (hence its appropriate name).

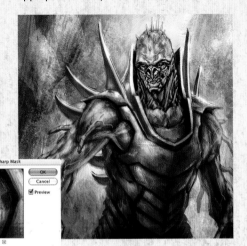

15 Sharpen filter

Lastly, I apply a sharpen filter to the entire image. I do this by first making a copy of the entire image on to a new layer. Next, I go to Filter>Sharpen>Unsharp Mask and set the amount to 90, the radius to 2.4 and leave the threshold at 0. This gives a sharpened-up look to all the edges and detail of the painting. You can always erase wherever you don't want the sharpened effect to reveal the unsharpened painting underneath. And there you have it – the painting is finished. Of course I can continue adding detail to the forms and colours of the design, but this is meant to be more of a concept illustration or a looser type of drawing, and so isn't really needed.

Quick Martian Concepts: Andy Park

MASTERCLASS

25 WAYS TO DESIGN AN ALIEN

ARTISTPROFILE
KEV CROSSLEY

COUNTRY: Earth
www.kevcrossley.com

Kev Crossley has worked as a video game artist for 13 years, juggling this position with a growing demand for his freelance services. His love of monsters won him lots of work among D&D publishers and he also has many graphic novel and art book credits to his name.

The truth is out there... **KEV CROSSLEY** has searched the galaxies and discovered 25 probing tips on alien creation

Aliens have been a love of mine since I saw the funny, Roman helmet-wearing Martian in a Bugs Bunny cartoon when I was three years old. Then, at the age of seven, I saw stills of Giger's groundbreaking *Alien* and I was hooked. Why was its ribcage outside? It had two mouths! What WAS it?

I was completely fascinated by these strange beings, and soon began to decorate the walls of my bedroom with lurid crayon renderings of creatures that looked a bit like people, but that were, well, twisted in some way.

It soon became apparent that there was no end to the beasties I could concoct and, with that realisation, my imagination unfolded into dizzying vistas that I'm still exploring today.

This journey is more concerned with thought processes and the unbridled joy of sketching than it is with technique or medium, so take a tremulous step into alien territory and see what you can find... or what might find you!

 1 Finding inspiration

Inspiration is a funny old thing. You can go looking for it, but more often than not it finds you – although you might not realise it at the time. Surround yourself with interesting objects, books, art and people, and take notes while you're out and about. Inspiration can be in any, and every, thing.

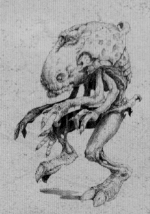

 2 Researching

Don't be scared to immerse yourself in high profile shows like *Doctor Who*, *Star Wars* and *Star Trek*, just to see a few different ways of designing non-human life forms. Get hold of art books and artist tutorials to obtain some insight into their creative processes.

 ## Sketching

Sketching is possibly the most potent tool in your skills arsenal. It should be your first activity of the working day and also the last. Sketching is exploration, a trail-blazing exercise to let your imagination run riot. Try to fill a page a day, every day.

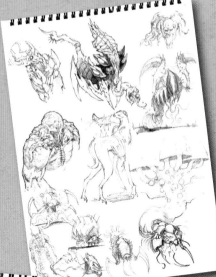

 ## Draw from the shoulder

For sketching, I would recommend sharp HB pencils or a fast-flowing biro pen. Try drawing from the shoulder if you can, too. Don't simply rest your wrist on the paper as this will deaden your linework and can fix your focus for too long in one place. The trick to getting the most out of sketching is to keep moving around the paper.

 ## Make models

As a kid, I loved Plasticine and I would use it to create all manner of monsters and aliens. I still use it today, as well as softened wax, to play around with ideas. The simple act of physically modelling is great for loosening up your fingers ready for when the drawing starts.

 ## Let's get anthropomorphic

Alien life need not adhere to the same principles that define us, so feel free to create lifeforms out of inauspicious subjects. Predatory lichens, angry soil, vegetables that bite – any object can be imbued with an other-worldly personality.

 ## Re-re-inventing the wheel

We've all seen walking plant people and grey aliens with ellipsoid eyes, but that doesn't mean you shouldn't play around with your own personal take on established concepts. Chances are that during the processes of your own sketching you'll touch upon concepts that you might not have seen before. Now that, my friends, is paydirt.

 ## Twisting the everyday

If you're struggling for inspiration, try that simple old chimera concept of taking part of one animal and mixing it with something else entirely. Human heads on spider bodies, octopus tentacles where a creature's eyes should be, a JCB digger arm instead of a tail. It's great fun too.

Form inspired by function

The smallest physical attribute can be defined by its function. The natural world is filled with examples, and it's another thing to consider if you find yourself stuck for extra terrestrial ideas. Perhaps your alien eats space ants that live in really deep burrows? Give it a really long snout, with sentient teeth at the end. You get the idea...

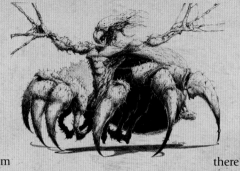

10 Environ-mental

There's a reason why whales don't have wings and trees don't have swim bladders (apart from it being rather silly). It's all down to environment. The ecosystem a creature lives in or comes from dictates what it must look like to survive.

11 It's all biology

The physiology of an organism is the rational and biological reasoning behind why it functions and how its composite parts contribute to the whole. It sounds like pretentious nonsense, but a deep understanding of your alien's physical make-up will enable you to make better design decisions.

12 Disregard the above

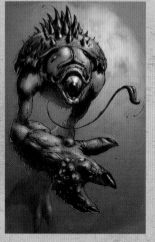

The great thing about aliens is that you don't have to conform to anatomical structure if you don't want to, or if you aren't very good at it! Make their arms too long and inflate their eyes if you like. Stretch the face, give them two faces if you wish. Everything is allowed.

13 What lies beneath

Can you invent a past that might explain why your alien looks the way it looks? Why has it stitched the faces of enemies into its hide? Why does it live in a swamp? A bit of backstory can add weight to your design decision process.

14 Horrific scenes

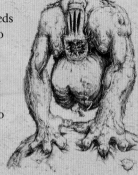

What makes good visual horror? Teeth are always good, and claws too – or why not too many or too few eyes, or writhing organs that shouldn't be there? The colour of horror is usually dark, so rather than show a lot of your alien, allow mere glimpses of it to poke out of the shadows. Put your nightmares on the page.

15 Work those guns

There are times when every artist needs a bit of brute strength, so get ready to pack on the muscle. Beasts are big and powerful and are usually quite angry as well, which is a really great way for you to expend any negative feelings you might want to vent. Who says fantasy art can't be cathartic?

16 Hello, my pretty

Beauty may be in the eye of the beholder, but there are certain features or principles that seem to encapsulate beauty better than others. Think carefully about the set of facial features – a feminine aspect works well. Steer clear of sharp angles and wrinkles, and try to add a graceful flow to the overall physique.

17 Ethereal aliens

Beauty can be ethereal, which is in itself an other-worldly attribute. Ethereality can be extreme exaggeration of lithe limbs or slender build. It might also drift into slight abstraction... soft features and glowing almond eyes floating amid a

wisp of vaguely formed mist. It's clichéd of course, but sometimes that's okay.

18 Small wonders

Sometimes all you need to do is give a person eyes that blink sideways, or overly long limbs and that's all it takes to turn them into an alien. If you find yourself burned out exploring the wilder, more fanciful landscape of your imagination, then kick back and see how it's possible to create a lot from very little.

19 Cartoonified critters

Cartoons don't pop up often in fantasy art, which isn't to say they're not allowed. Injecting humour into your aliens can add great personality, and raising a smile is never a bad thing. It's a good way of blowing off steam too, especially if you've been working hard at something complex.

20 Problem skin, sir?

The texture of skin and clothing is another dimension for you to consider. Is your alien reptilian? Does it have veins near the surface of the skin? Do its eyeballs have an iridescent patina? Is it warty? Scaly? Smooth? Flaky? Is it covered in slime or grit perhaps? It all adds to the flavour of the art.

21 Dynamic posture

Injecting dynamism into your alien creations is something that'll become easier the more you practise filling up the pages of your sketchbook. As you develop a looser sketching style you'll automatically find yourself injecting your creatures with movement and purpose. It's that extra dimension to

a pose that can make a world of difference to your designs.

22 Cool for cool's sake!

Sometimes you simply have to go with the design that looks the coolest. The anatomy might be wonky, the features can be all wrong and the neck might be simply too skinny to support the immense bulk of that enormous head. But if it looks cool, that's all that actually matters.

23 Giger is god

Giger's incredible visions have influenced me immensely, and many people say they see a little of his work in my own. So if there's a particular artist who inspires or moves you, then go ahead and let it show through your work. We're all the product of whoever we've loved or studied, so don't be afraid to let it show.

24 Giger can shove it

Having said that, you might be in danger of drifting a little too close stylistically to an artist you admire. Being branded a clone when you really want to be a creative in your own right can be rather detrimental, so try to influence your art with a good balance of different sources rather than following just one.

25 It Lives!

Aliens are a gift to fantasy artists and will richly reward all levels of ability. Set yourself a completely open brief to get the blood of creativity pumping through your veins again.

Masterclass: 25 Ways to Design an Alien 173

CREATURE FEATURES

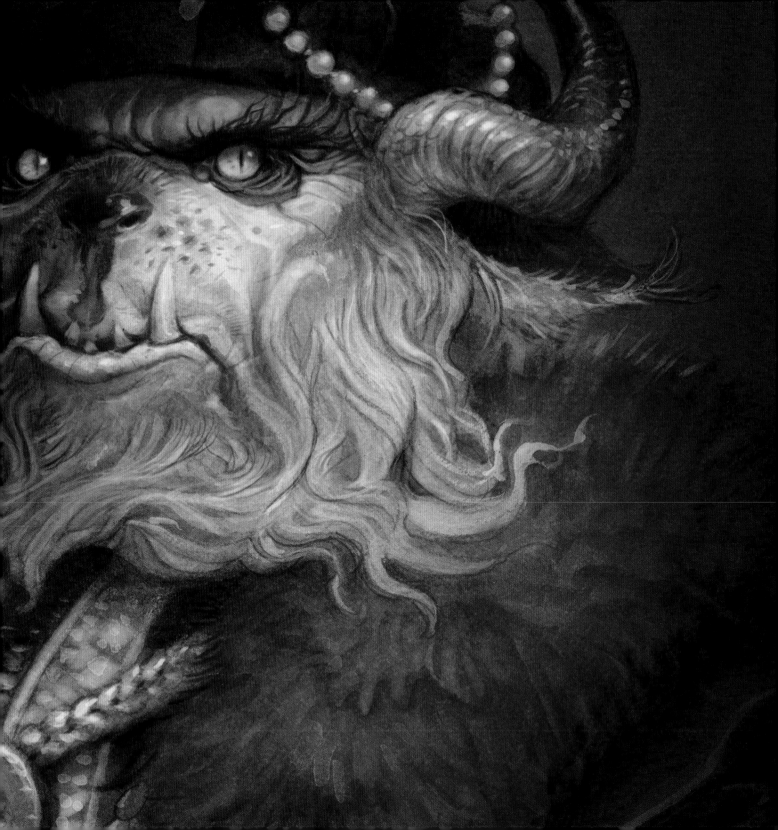

ARTISTPROFILE
JOE VRIENS

COUNTRY: USA
www.joevriens.com

Joe is a professional concept artist and illustrator with varied experience in many industries including comic books, animation and video games. He has worked with Microsoft, Udon, Sony, Capcom, Marvel, DC Comics, Sega and many more.

PHOTOSHOP

CREATE A ONE-HOUR MONSTER

JOE VRIENS reveals how to create a monster from blank page to illustration in just one measly hour

I 've always had a passion for monsters; I love drawing gnarly creatures with gruesome details. But I didn't have much time to do so. I had to figure out a way to squeeze them in without disrupting my day-to-day requirements. The solution came when I decided to combine my warm up sketches with my obsession. The challenge was to figure out a way to produce a fairly decent illustration within my one hour time limit. So I broke the hour up into four segments: thumbnail, grey tones, colour and final adjustments – and that's how the one-hour monster was born.

When trying your own one-hour monster remember that it is designed to be a warm up exercise. It's easy to become tense when you know you have a set time limit, but relax. The first sketch of the day is almost always a little rusty, after all. It's only after about the fourth thumbnail that I finally chill out and remember to have fun.

To prepare for your monster you should gather a variety of reference images – if you plan to use some – before setting that timer. Also have your texture library handy since these are a great way to add some visual flair to your work.

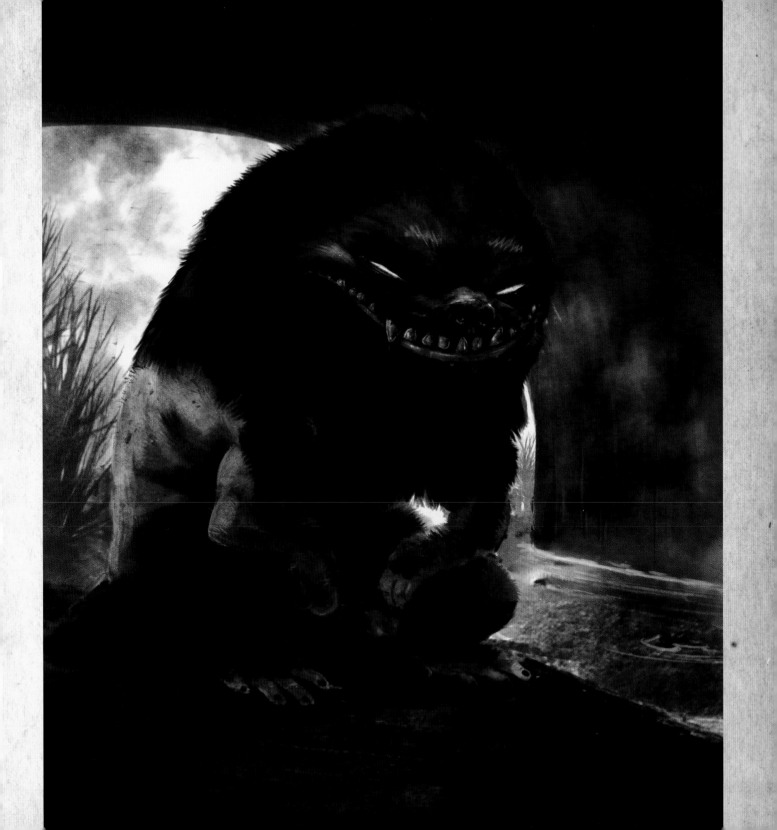

1 Thumbnails

Begin with thumbnails for 15 minutes. Try to do a variety of shapes and body types. Throw in some that could be bipeds or quadrupeds, bulky or skinny, winged or insect in nature. This will break you out of your usual patterns of drawing the same two-legged demon with horns on his head… You should be aiming to get 10-20 silhouettes done within this time, so don't spend too long on each one.

2 Narrowing it down

When 15 minutes are up, stop and look through the collection of silhouettes you've just created. This is where your imagination does the work, filling in the details mentally. Tick the ones you like or put a question mark beside the maybes. I usually choose three and work my way down to one from there. Cut and paste it onto a new layer and enlarge it to fill your canvas. Fill in blank areas.

4 Adding context

Continue building up the entire image and don't forget to give your monster a home. Rough in some type of background. Adding a background is optional but really adds to the overall piece by giving your monster a bit of story. Work around the entire canvas rather than focusing on one spot such as the face. You don't want that timer to buzz and have a thumbnail with a perfectly rendered eyeball, for example.

3 Blocking out

Start your 30 minute timer countdown and begin the process of blocking in shapes of light and dark to help you discover what your monster looks like. As you do this, you should start to see shapes form which will guide you towards the different features of your monster. This is your largest chunk of time, so be sure to cover a lot of ground at this stage.

SHORTCUTS
FREE TRANSFORM
Ctrl/Cmd+Alt/Option+T
Copy, scale and rotate a layer or a selection with this function.

5 Extra texture

With around 20 minutes to go, add your texture(s) on a layer set to Overlay and turn the saturation to zero. Textures are a great way to add some random detail or grittiness to an image and especially useful in a speed paint such as this. Even a simple greyscale image will improve dramatically simply by adding a texture overlay layer. If your image needs tweaking simply turn the texture layers off until you feel it's ready. I chose a concrete texture and a crumpled paper texture for this one-hour monster. The concrete was used for the dirt mostly while the paper was thrown over the entire image. You should experiment with all kinds of images for overlays. Even photos with crowds of people can provide an interesting layer of random details.

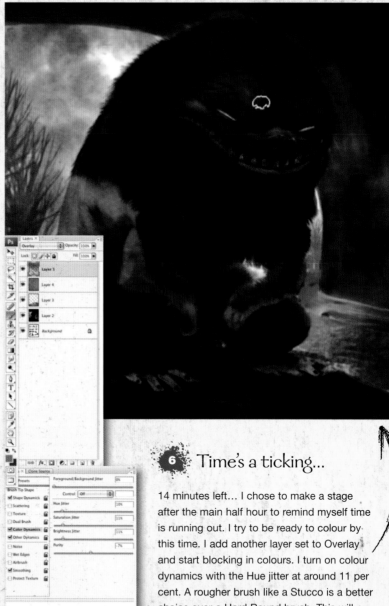

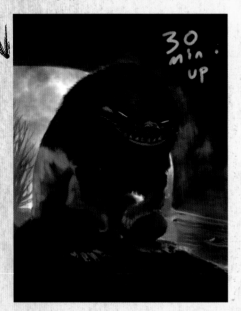

6 Time's a ticking...

14 minutes left… I chose to make a stage after the main half hour to remind myself time is running out. I try to be ready to colour by this time. I add another layer set to Overlay and start blocking in colours. I turn on colour dynamics with the Hue jitter at around 11 per cent. A rougher brush like a Stucco is a better choice over a Hard Round brush. This will prevent overlapping rings of colour that tend to accumulate with a round brush.

7 Refining details

Add another layer set to Normal and begin painting areas that need more control – for example, adding wet highlights to the eyes or teeth. You can also make a stamp layer to paint over areas. This tends to be the hardest part for me because I've reached a point where I can relax and build up the painting to a completed level beyond the one hour time limit.

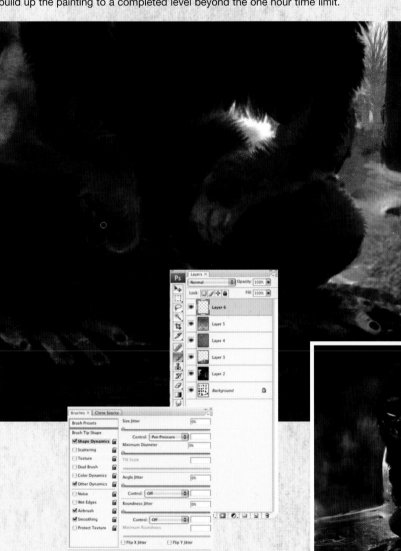

8 The end is in sight

Final minute: this one goes by so fast you'll swear you were cheated. You will barely have time to adjust the image using Levels or Colour Balance.

And there you have it! For better or worse you now have a monster illustration completed in an hour's time. You could also use the one-hour monster as a great way to speed up your usual process and get through the initial phases more quickly.

Create a One-hour Monster: Joe Vriens

ARTIST Q&A

 Q Could you offer any good methods for merging several animal references for when sketching a creature concept?

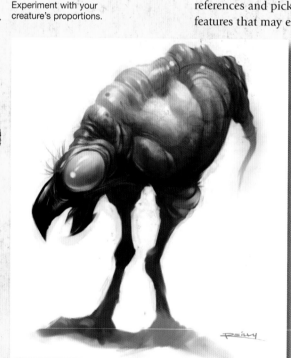

Experiment with your creature's proportions.

A **PATRICK REPLIES**

One technique I tend to use a lot is what I like to call the 'Frankenstein method.' First, I start looking through some animal references and pick out the ones with the most interesting features that may enhance my creature. For example, one animal's legs may look very interesting on another animal's body, or part of an animal's facial features may look interesting on another animal's head, and so forth.

Once I'm done gathering references, I then experiment with thumbnails sketches and interchange the animal's limbs and features.

When I'm satisfied with an overall creature design, I tighten the image up and then begin working on the smaller details.

These smaller details are important in making your creature interesting to look at, so spare no expense in delving back into animal references for inspiration.

You make the rules!
This is your creature, you make the rules. Don't feel obligated to maintain the proportions of the original animal. Experiment with distorting and exaggerating these elements. Also, if you feel you can come up with something original, try tossing it in and see what the result looks like.

This Arachnapus is an
example of combining
animal elements.
Overall body of an
octopus with added
spider legs and the skin
colouring of a jellyfish.

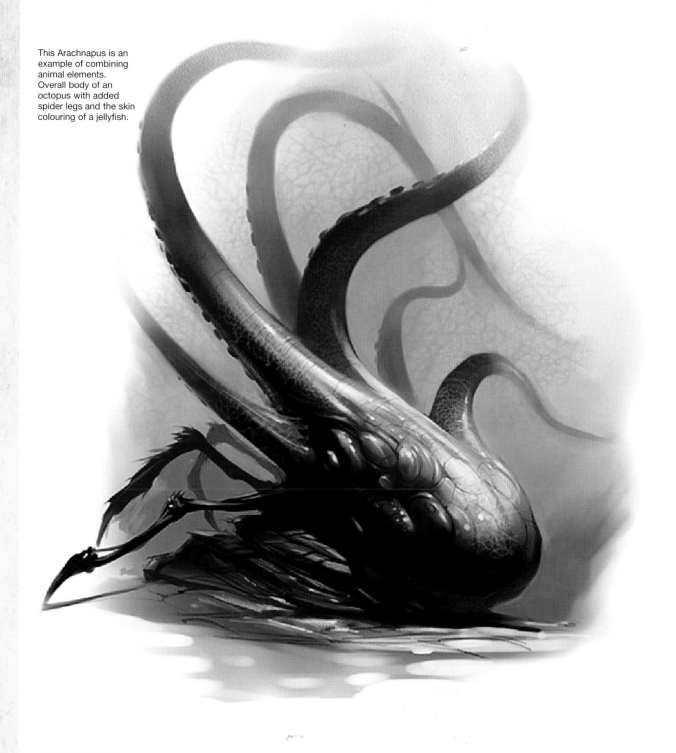

WORKSHOPS

ARTISTPROFILE
JUSTIN GERARD

COUNTRY: USA
www.justingerard.com

Justin Gerard is an illustrator who enjoys story-driven illustration. His work has been featured in Spectrum, Society of Illustrators and Exposé, and he is currently art director for Portland Studios Inc.

PHOTOSHOP

WATERCOLOUR TO DIGITAL

A watercolour and digital approach to painting a fine art portrait of a monster, by **JUSTIN GERARD**

L et's assume that you have been approached by a wealthy monster who wants to commission you to paint its portrait. Unlikely perhaps, but I've gotten stranger requests. Let's say that they feel that they have been misrepresented in film and literature, and unjustly categorised on the whole. They want to commission you to execute their portrait, to show the world that they are really civilised and noble creatures. The following demonstration in watercolour and digital will help you deal with just such an event – after all, it pays to be prepared, just in case.

I will be doing an underpainting in watercolour and then scanning the image onto the computer, where I will be adding the colours, refining the lighting and adding final details in Photoshop.

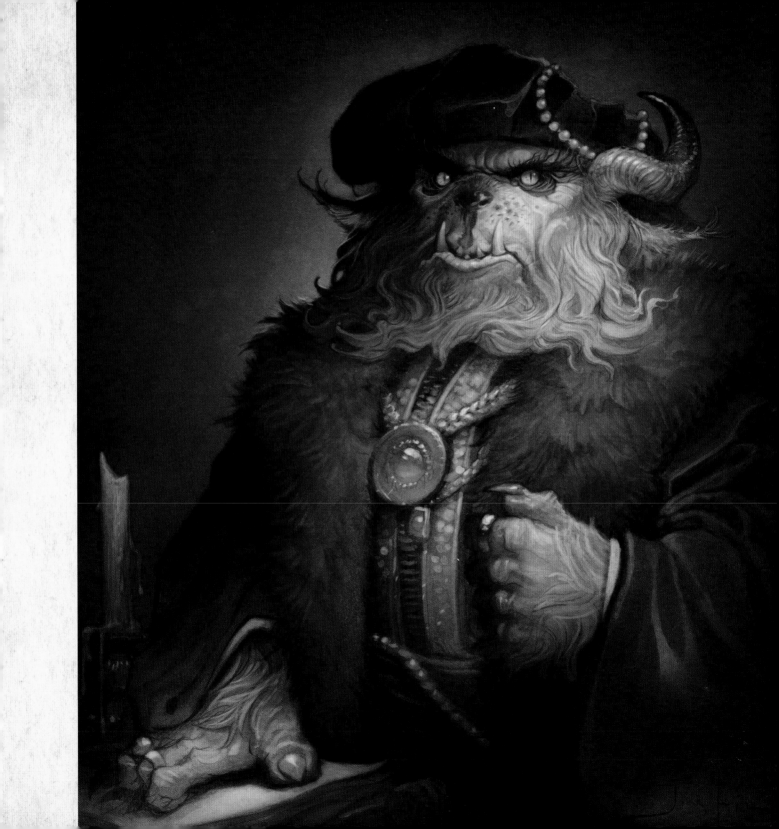

1 Drawing from life

Before I begin working on my monster, I warm up by doing studies from life. In this case I will be using pictures of wild animals as reference. The goal of these studies is to form a better understanding of the elements and characteristics of my subject matter. Wild animals are excellent reference for monsters because they personify human characteristics taken to extremes. I don't spend too long on any one of these. The goal is to commit the forms and details of these creatures to my memory so that later I will be able to work from my imagination without the aid of reference.

2 Thumbnails and exploratory work

Now I throw out all of my reference and burn my studies and I start drawing completely from my head. I will use my reference again later, but for now I want to work completely from my memory and imagination. I work quickly, using either ballpoint pen or a 0.7mm HB (number 2) pencil. This drawing is often the most fun for me. The possibilities of what could be are almost always more interesting than what actually is, and I try to get down as many ideas as I can. By the time I am done there are 20 or so tiny, two- or three-inch monsters to pull from.

3 Tight sketch

This particular monster looks promising. I now do more careful, detailed drawing using a General's 2B pencil. I will spend as much time as is necessary on this step to arrive at the right look. The drawing is the most essential element if an illustration is to succeed. There are ways to finish an illustration from a poor drawing, but it would be like wrestling a baboon into a lunchbox.

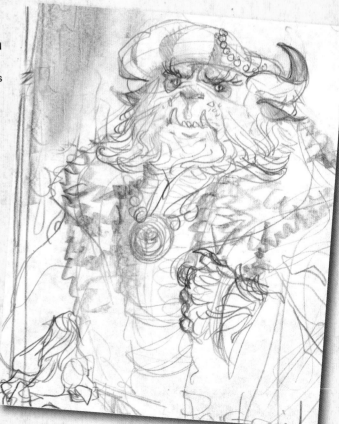

4 Adjusting proportions

Now that I have a sketch that I am pleased with, I am ready to transfer it to my watercolour paper. Before doing this there is one devilish little trick that I use that has totally reinvented my work. I scan the drawing into Photoshop, mirror it and adjust it before I print it back out and transfer it to paper. This minor readjustment often spells the difference between glorious success and miserable, shivering failure. Before adding this step, all of my pieces had an odd tendency towards disproportion and unbalanced composition.

6 Transferring the drawing

There are dozens of ways to transfer a drawing to paper: light tables, graphite transfer, Artograph, freehand and even methods of printing directly from a computer onto watercolour paper. Any of these methods are good, but I usually go with the ever-dependable Artograph. Whenever I am transferring a drawing I spend only as much time as is absolutely required to establish the basic shapes and outlines – drawings that rely too heavily on the transfer tend to lose their soul. After I have transferred the basic outlines to my watercolour, I begin working freehand and focus on refining the forms and doing a more accurate drawing.

5 Setting up the watercolour

Now I leave the computer and turn to setting up my watercolour. For this illustration I will be using Strathmore 500 series Bristol and working at 8.5 x 9.5in. This Bristol is an excellent paper that can take a lot of abuse, and enables precise linework. For this piece I want to tone my canvas before I transfer my sketch to it. One of the strengths of working digitally over a watercolour is the wonderful texture that watercolour lends to a digital piece. It responds beautifully to dodging and burning. For the wash, I mix up burnt sienna and Prussian blue. As it is drying, I fleck water over the surface to create blossoms on the surface for the interesting patterns they create in the background.

7 Working in sepia

I am not concerned with adding colours yet because I am treating this watercolour as an underpainting. I will be adding the final colours and effects later in Photoshop, so for now, establishing the forms through value is the most important task. I could add the colours in watercolour as well, but I want to play to the strengths of each medium. Digital painting is great for bright, intense colours, but it can tend towards looking plastic. Watercolour, on the other hand, struggles with achieving bright colours but can generate beautiful textures as the water dries on the surface, and gives linework a wonderful variety.

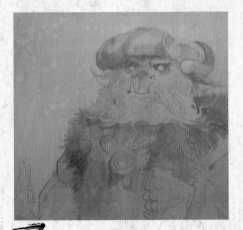

PROSECRETS

LAYER FLAIR
Keep your layers organised. Some layer types can be merged together without negatively affecting the image. Several Multiply or Screen layers can be merged. Try to keep your PSD file clean, so that if you find later that you need to add more shadows to an area, you can create a new Multiply layer, add your shadows and then merge this into your existing Multiply layer. This will save you headaches later on.

8 Opaque highlights

Once I have established the shadows, I use a white watercolour or gouache to add opaque details and highlights. This opaque highlighting step could also be done on the computer, but I really enjoy the feel of a natural brush a little more than a Wacom pen. (One day, when Wacom, in its wisdom, releases a digital brush with fibre optic hairs that works like a traditional brush, I will do this on my computer.)

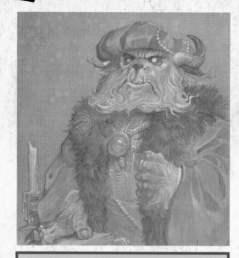

9 Scan and adjust

Now that I have arrived at a watercolour underpainting that I am satisfied with, I am ready to scan it. After it is scanned I use a Curves layer to pull back some of depth that was lost in the scan.

After this I add a host of layers to get the image to look correct before moving on. The key issue is to make sure that no areas on the image are absolute darks or absolute lights yet. I want the image to be in a midtone range. To do this I create a Lighten layer filled with a midtone ochre colour and set it to a lower opacity. This Lighten layer will help scale back some of the dark pencil work that is too intense.

10 Shadows

Once the image has been adjusted I am ready to begin laying in the shadows. I want them to be deep, and have the sense of a classical Edwardian era portrait. I want the scene and the image itself to feel as though it were lit by a candle, so I can make a natural focal point of our monster's face through lighting. Often I work with dozens of layers to arrive at the final Multiply layer. I work using a textured, soft-edged brush or an airbrush, and I erase out areas that aren't to be affected. I then take the layer's opacity down until it looks correct, and then begin again on a new layer. This process gets repeated dozens of times.

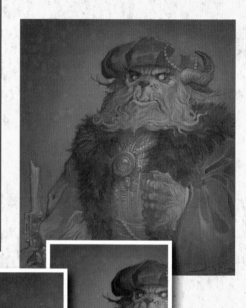

PROSECRETS

MINOR DETAILS
Don't worry about detailing every single tiny bit of your illustration. While this level of detail may be impressive on its own, it does not always help the image overall. When we focus on all the minor details of an image we lose a sense of the whole, and if we try to focus on the whole of an image, we lose our sense of the details. The successful illustration must reconcile these two.

11 To colour a monster

There are many methods of applying colours; for this illustration I'm going to use layers of Soft Light. I like working with Soft Light because it approximates the feel of colour glazing in oils and I want to maintain the look of classical portraiture. I build slowly, using as many layers as necessary. Often I'll paint an area and then take the layer's opacity down to 15 or 20 per cent and then repeat the process.

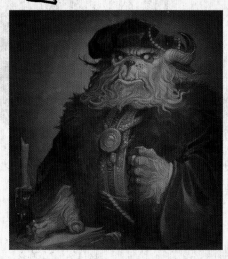

12 Stage lighting

Now it's time to make our monster glow. In many ways this stage is the inverse of the Multiply/Shadow stage and this is where the watercolour's texture really shows its worth. Using Colour Dodge layers, and a dark grey, I work in much the same way as I did on the Multiply layers, brushing in and then erasing out on several different layers until the image looks right. Colour Dodge reacts really wonderfully with watercolour, as it pulls up the contrast on the texture and the grain. I use it sparingly, and only in areas to which I want to direct the viewer's attention. If you use this all over the image, then the illustration will lack focus.

14 Colour balancing

At the very last I colour balance the image. I try not to use too many colour balancing effects. If they are used too much, they burn out an image, scorching the texture and exaggerating the highlights. This too is a bane of digital painting, and one to be careful of. I use it very sparingly at this stage of a painting. Here I have used it to pull the painting into a little warmer and darker range, and I have turned the opacity on the layer down to 50 per cent.

Now we are finished. It's time to take the image to the printer, and hope that the client doesn't eat me.

13 The hairy details

I now begin to work in my final hairy details. I paint using Screen and Normal layers. I work on the idea that shadows are to be painted transparently, and highlights are to be painted opaque. This helps maintain which areas are to be focal points, and which are to recede into the background. I try not to use too much Normal layering. If I work too opaque in Photoshop, the piece will begin to take on the plastic look that is the bane of most digital art – but there are some details that absolutely need to be sharp and opaque: the highlights on metal or teeth, the rim of a horn, the areas around the eyes. Along with using Normal to add sharp details to the eyes, I also use it in subtle glazes to diminish areas where the texture is too obvious. In the background I have laid in a thin layer of darks.

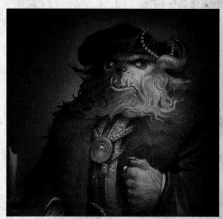

Watercolour to Digital: Justin Gerard

CORE SKILLS

ΛRTISTPROFILE
TOM GARDEN

COUNTRY: Sweden
www.tomgarden.co.uk

Tom is a freelance artist working mostly in the video games industry creating concept artwork, with some illustration projects too. He hopes to develop a game project of his own someday.

PHOTOSHOP

pen tool

TOM GARDEN takes you through the most useful features of the Pen tool and its many applications

The Pen tool can be used for precise creation of shapes in Photoshop. It combines the functionality of the Lasso and Shapes tools, enabling you to draw freeform vector shapes and paths, which can be edited with the Direct Selection tool. The ability to edit Pen tool shapes easily is useful for working in detail. The main options are the Pen tool, Freeform Pen tool, Add Anchor Point, Delete Anchor Point and Convert Point tool.

1 Making a mark

The Pen tool enables you to set anchor points that join a line, which forms a vector shape. Each click places a new anchor point. Clicking once for each point draws a straight line between them, but if you click and drag you'll see that it turns the line into a curve. The Freeform Pen tool enables you to draw a shape completely freehand – it's useful for quickly laying down vector shapes.

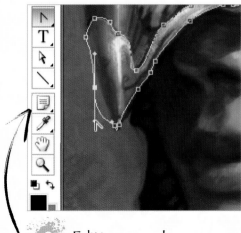

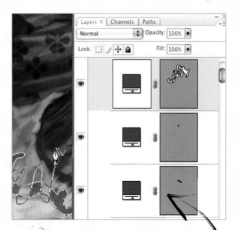

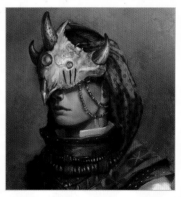

I use Photoshop's Pen tool to create a pattern for the character's clothing. I capture the pattern as a brush, which enables me to paint it onto the fabric on an Overlay layer.

② Editing your shape

The Pen tool draws a vector mask that is easy to edit afterwards. You might want to make a straight line into a curve. Choose the Convert Point tool, then click and drag to make it a curve instead. Clicking once turns a curve into a straight line. A good tip is to make sure you tick the box Auto Add/Delete as this enables you to add or delete anchor points after you've drawn the shape.

③ Further refinement

Once you've drawn a shape, you can choose the options Add, Subtract, Intersect and Exclude from the top menu. Adjusting an anchor point is easy too, as each curved point gives you a main anchor and two handles either side to adjust the tangent. To move only one of the handles, hold Alt then click on the handle you want. You can also grab the line in-between points to move it too.

pen tool TIPS & SHORTCUTS

There's more to the Pen tool than you might imagine. It's got a wealth of handy applications, so give some of these a try…

COMBINATIONS
Don't forget that it's easy to combine the Pen tool functions with the regular Shapes tool to add, subtract and curve points.

MASKING
The Pen tool is fantastic for complicated masking jobs because you have control over every part of the mask.

DUPLICATE THAT SHAPE
If you like the shape you have made and want to reuse it, why not try Edit>Define Custom Shape. You can now bring up the Custom Shape tool and apply your vector again and again.

VECTOR EFFECTS
You can experiment with the style dropdown menu for different effects on your vector shapes.

DIRECT SELECTION
If you hold Apple/Ctrl after drawing a vector, you bring up the Direct Selection tool so you can quickly edit the anchor points as you make them.

CREATE A BRUSH
You might also want to turn it into a brush to lay down a pattern like I have for the clothing of this character.

CREATURE ANATOMY WORKSHOP

ARTISTPROFILE
JOEL CARLO

COUNTRY: USA
www.joelcarlo.net

Joel Carlo has been a freelance artist for more than 15 years, and is currently residing in Denver, Colorado. He has a background in both traditional and digital media, and his client list is varied and ranges from commissioned work for small studio projects to larger work for big-name clients. He's also known by the name of MechaHateChimp.

JOEL CARLO explores the different anatomies of some of the most popular beasts of myth and folklore

R eal animals have always played an important part in shaping history's most famous mythological beasts, and the philosophy behind mixing real animal anatomies to create fantasy creatures is fascinating. While these creatures have taken the roles of either heroes or villains, it's their distinct anatomies that have helped define not only how they look, but also how they are perceived. A Minotaur is a classic example of this, taking on the characteristics of both a man and a bull. While a bull can be both physically powerful and dangerous, it's only when you add the intelligence and cunning of a man that it becomes an incredibly ominous being. It's this very relationship between physical and psychological characteristics, and the merging of animals' defining attributes, that have made for some of the most extraordinary creatures ever imagined.

Although a set of defined guidelines has never truly existed, most mythological creatures have been created by piecing together particular animals' recognisable traits. The traits chosen play important roles not only in the creature's overall appearance, but also define its capabilities and environment.

Aquatic creatures typically take on fishy or amphibian-like characteristics, while land creatures take on the characteristics found in birds or mammals. It could be said that it would make little sense to add a fish tail to a bird as it would probably serve no purpose, but then again, we are creating fantasy creatures.

If you have a healthy imagination, there's no limit to

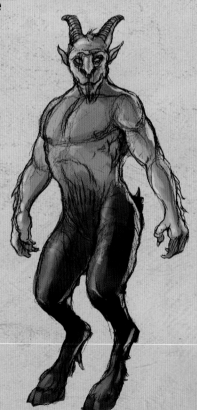

the number of conceivable variations; however, I tend to believe some care should be taken when combining anatomies in order to add to a creature's overall cohesiveness. So, how do we go about understanding which anatomies and characteristics work best in order to create a fantasy creature? Let's start by taking a look at their biology and environment.

Biology basics

Animal groups are defined by their biology, anatomies and individual characteristics. These characteristics enable us to immediately identify not only the type of environment an animal is suited for, but most importantly what type of classification each animal falls under. Each animal is first split into one of two categories: vertebrates (animals with spinal columns) and invertebrates (animals without spinal columns). From here they are then split into several classes and orders, but for this workshop we will only concentrate on the basic animal groups: mammals, reptiles, amphibians, insects, birds and fish. We will then select one animal from each group and isolate a defining characteristic that conveys both physical attributes and temperament.

The animal groups

 Mammals

A large majority of creatures in myth and folklore take on the visual characteristics of mammals. Mammals are characterised by several distinct visual features, the most well-known of these, for most mammals, being the presence of hair, which can vary greatly among different species. They are also characterised by nursing their young. This explains their naming: the word mammal is derived from the Latin word 'mamma', meaning 'breast.'

As I stated earlier, defining characteristics are what help convey both physical appearance and temperament. The large muscular frame of a bull or horse, along with the characteristic of aptitude found in humans, are what help associate the idea of power and cunning to characters such as the

Minotaur or Centaur. In an opposite extreme, goats have been historically associated with signs of the occult or mischievousness. Goats' defining characteristics are typically their horned heads and distinct facial features. A great example of merging these goat-like physical attributes with the anatomy of man is that of the Devil. They can also be seen in Satyrs, although these creatures have generally been written as light-hearted and carefree in spirit.

 Reptiles

Next on our list of animal groups are reptiles, which are broken down into four specific orders: squamata (snakes, lizards, and amphisbaenians), crocodilia (crocodiles, alligators, and caimans), chelonia (tortoises and turtles), and rhynchocephalia (representing a single member, the tuatara). They are cold-blooded animals and are characteristically known for their dry and sometimes scaly skin.

One of the most well-known mythological creatures ever created is undoubtedly Medusa. Medusa is a half woman, half serpent with snakes for hair. As the story goes, she was such an incredibly hideous and despicable creature that anyone who caught her eye would be turned immediately to stone. Interestingly enough, reptilian characteristics have long been associated with things that are ugly or detestable. In the biblical story of Adam and Eve, it was the Devil disguised as a serpent that led to their temptation, fall and expulsion from the Garden of Eden. Even now, phrases such as 'cold-hearted snake' are used to describe a loathsome or reprehensible character.

3 Amphibians

The word amphibian is the derived from Greek, meaning 'both' and 'life'. Like reptiles, they are also cold-blooded but are unique in their biology for their ability to adapt and reside on both land and water. Amphibians are divided into three groups: caudata or urodela (newts and salamanders), anura (frogs and toads), and gymnophiona or apoda (caecilians – amphibians that resemble earthworms or snakes).

One of history's most notable creatures with amphibian characteristics would have to be the frog-headed goddess Heket of Egyptian mythology. Heket was associated with matters of fertility and pregnancy and was believed by ancient Egyptians to be responsible for giving the breath of life to all unborn creatures. Interestingly, this idea was developed as a result of a frog's ability to live in two separate environments. In Egyptian history, frogs were believed to have been created from mud and water, since they would seem to appear from nowhere as a result of river floods during the rainy seasons.

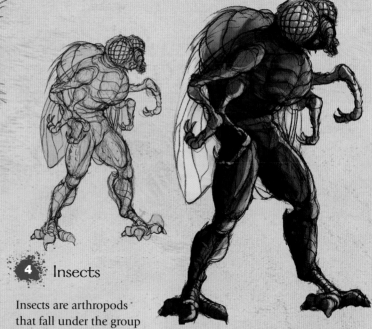

4 Insects

Insects are arthropods that fall under the group known as hexapods. The word hexapod is derived from the Greek Hexapoda, meaning 'six legs', which is also one of the most distinctive features of most insects. Other distinct features include the body, which is split into three segments – the head, thorax, and abdomen – as well as other parts such as wings or antennae.

There are also three smaller classes within the hexapod group, known as the springtails, proturans, and diplurans that lack most of these recognisable 'insect' characteristics.

It could be said that insects are similar to reptiles in the way many people react to them, which is often in disgust. With the exception of maybe the butterfly, most insects have been looked at with general distaste. This could be due to their alien-like forms or their historical association with diseases.

It's this natural aversion that has been exploited many times over to create some of most horrific creatures in popular culture. One of the most memorable examples would be the 1986 remake of the classic science fiction film The Fly, starring Jeff Goldblum, in which a scientist accidentally merges his body with that of a fly.

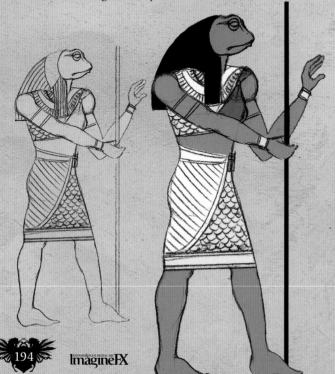

5 Birds

Like mammals, a large portion of creatures in mythology and folklore have taken on the visual characteristics of birds. Biologically, birds are similar to mammals in that they are warm-blooded vertebrates. However, they differ from most mammals in that they reproduce by laying eggs. Birds are also unique from mammals (with the exception of bats, of course) because of their ability to fly.

Characteristically, birds' most distinguishable features are their feathered wings, and mythological creatures such as the Pegasus or the Griffin shared this distinction. The Griffin is an amalgamation of a lion and an eagle.

Lions have typically been associated with strength and considered the king of all beasts. Similarly, eagles have been considered the kings of the air maintaining a unique correlation between flight and freedom. This combination is unique in that this creature is a representative of two very powerful and sought after ideals.

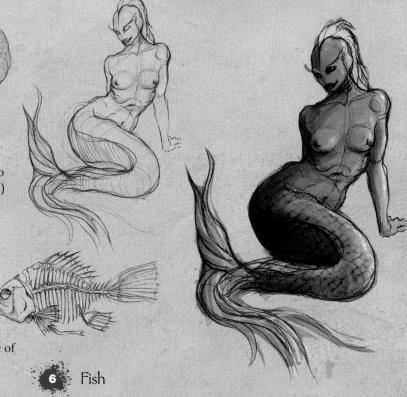

6 Fish

Fish are the largest group of backboned animals on the planet and the fact they live under water gives them unique traits.

A typical fish is characterised by its ability to breathe using gills, having a scale-covered body, and the ability to manoeuvre using fins. While the majority of fish are cold-blooded, there are some warm-blooded species.

A myriad of ocean-dwelling creatures have had a long-standing part in myth and folklore. Tales of fearsome sea monsters are legendary and can be attributed to the appearance of large sea animals such as whales or giant squids. Arguably, the most notable of all sea creatures would have to be the Mermaid. Mermaids or sea nymphs (as some people refer to them) are legendary creatures containing the head and torso of a woman and the tail of a fish. In folklore, they have been described as enchanting and beautiful creatures known for their ability to lure sailors to their deaths with beautiful singing. This dichotomy between beauty and death has added to the long-standing appeal of this fantasy creature, making mermaids most memorable.

ARTISTPROFILE
MIKE CORRIERO

COUNTRY: USA
www.mikecorriero.com

Mike is a freelance concept artist and illustrator for the video game and film industries. His work has also featured in Ballistic Publishing's Exposé 4 and 5. His clients have included Radical Ent and Fantasy Flight Games.

PHOTOSHOP

SYMMETRICAL DESIGNING

Through the process of abstract asymmetrical duplication, **MIKE CORRIERO** explains how to produce dozens of unique symmetrical thumbnail designs

humbnail designing is always a useful tool for any artist. It triples the amount of designs you can produce with much less effort and often yields a lot more effective results than a fully rendered, detailed sketch. This is a process undertaken by most artists, especially in the professional field.

When sketching, you'll need to keep in mind what shapes might end up as a head or arms. However, it's not necessary to be too precise. Keeping things abstract leaves your work open to interpretation, giving it greater flexibility. So when you're setting up these asymmetrical designs to be copied and flipped, going crazy is encouraged. The more wild and irregular the sketch, the more possibilities it opens up.

It doesn't matter if you use a pen, pencil or digital program to sketch these out because it's the shape and silhouette that matter. You should feel free to let the shapes become exaggerated, because you never know how they'll be interpreted when you work them out in 3D form.

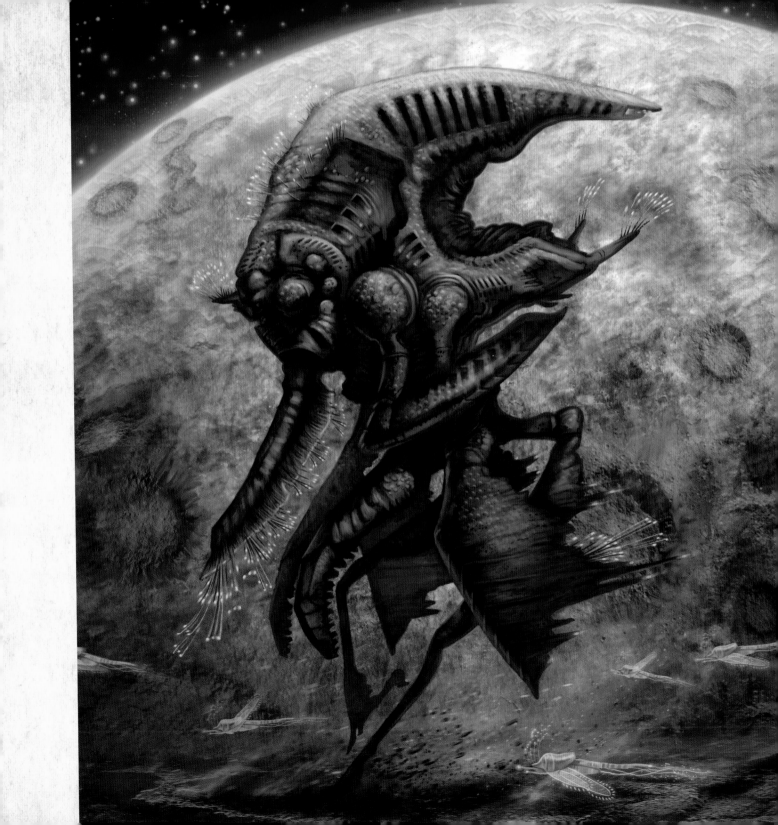

1. Asymmetrical to symmetrical

I've started these designs with a Staedtler 0.05 pigment liner pen on plain paper. Each thumbnail is approximately 1x2 inches. Start by drawing a couple of vertical lines in pencil; these will serve as your design separation points, to create symmetrical designs later on. In the thumbnail that's blown up you can see the design split down the middle. Below it are the two symmetrical designs created from the purposely asymmetrical design in order to produce two similar but unique shapes. To the right is a set of asymmetrical concepts, which you can see were each designed to be unique, with different elements, varying amounts of limbs and a mix of height and width.

2. Copy flip method

To produce double the amount of concepts in terms of symmetrical designs, I took the asymmetrical versions, selecting one half with the Rectangular Marquee tool. Then, by using the copy and paste method, I flipped the second paste of the same half horizontally. With my settings applied to View Snap, it's quick and simple to drag and align the duplicated selection to meet and snap together. Just repeating this process with the opposite side of the thumbnail will provide a second symmetrical design. This brings the original 12 thumbnails to a total of 36 designs – of which 24 will be symmetrical only – having taken one third of the amount of time it would have taken to produce 36 individual sketches.

3. Asymmetry

In our world there are examples of asymmetrical life forms – usually crustaceans and sometimes fish – but it's rare as most life consists of symmetrical biological constructions. In order to more easily read my designs and distinguish the differences, I've selected all the negative space, inverted the selection and, on a Multiply layer, filled the designs with a solid colour. It's very easy to manipulate a design via Free Transform if I decide to make it more streamlined or stretch it out. I can even mix and match various portions of one design with another by overlapping a selection and fitting it to the width or height of the other thumbnail.

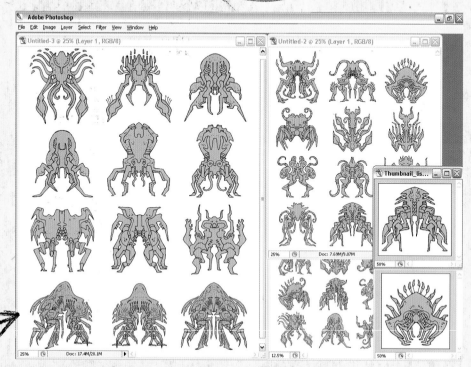

4 Digital thumbnails in silhouette

One other method I use on occasion is the silhouette technique, which is very quick and easy to produce digitally. Using the lost line technique and erasing out the details or separation of shapes is highly useful and makes it easy to produce many designs from just one shape. When working with the digital thumbnail in a silhouette manner you can manipulate the shape in hundreds of ways, erasing and working with a strong use of positive and negative values. Overlaying and warp transforming (while providing texture) and a rapid transform repeat technique makes it all so easy to go from one sketch to one hundred sketches in a matter of minutes!

SHORTCUTS
COPY/PASTE TRANSFORM
Ctrl+Alt+T (PC)
Cmd+Option+T (Mac)
Creates a duplicate of a selection and sets Free Transform.

5 Evolution of a thumbnail

Now that the thumbnail process has been completed and I've produced around 80 designs, I've chosen two that are close to what I want and have started to sketch my design using the pigment liner pens. It's easiest to start this process by reproducing the large, dominant shapes from thumbnail to final design. I'm taking an easy way out here with a semi-profile view of this life form.

6 Detail and mirroring

How much work you do here is up to whether you want to keep the sketch rough and loose or detailed and refined. Mirror your drawing by first producing the line work and shapes that dominate it then just duplicate the necessary limbs and biological elements to the other side. If you're happy with your sketch, shading in at this point can sometimes help cut down on painting later on.

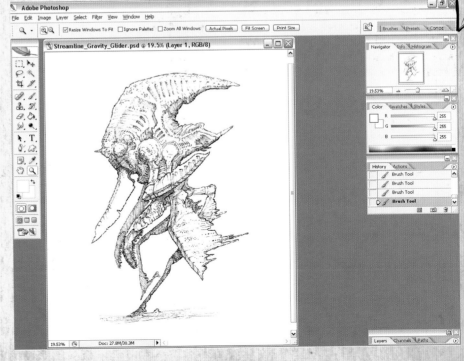

7 Sketch complete

I complete the final sketch with sensory fibres, shading and minor details. It actually takes much less time if done using a pigment liner rather than a pencil; it helps to steady your hand and produces more confident lines if you can't erase. Using small 0.05 Staedtler pens also enable you to shade and control line weight effectively. I line up some of the thumbnails that I liked the most next to the final image, to see if anything inspires me.

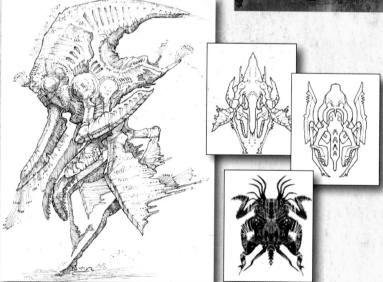

8 Base texture

Courtesy of www.mayang.com/textures, I've used a texture photo of an old worn-out wall to give my sketch some colour and a base to begin my painting. I just pasted the photo, rotated it and enlarged it to my liking.

9 Establishing a setting

With the use of additional photos from Mayang's free texture library, I've laid down a ground, which was actually a photo of a termite mound, and overlaid another texture on top of the wall photo. At this point I'm just playing with colours through the Hue and Saturation options to find anything that works, keeping in mind what I'm aiming for, which is an unearthly setting and a blue/pink colour scheme. In addition, at this point, I've gone back to the original sketch layer and selected and inverted it, filling it with a pinky base colour.

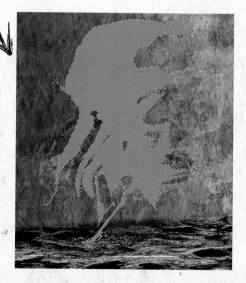

PROSECRETS

TRANSFORMING A SHAPE
Create a shape on a new layer then select it. Hold down Alt/Option+Ctrl/Cmd+T to copy/transform the shape. Then use the Transform tool to move it in any direction, shrink or enlarge it a little and rotate it a bit. Hold down Shift+Alt/Option+Ctrl/Cmd and hit T to duplicate the action as many times as you want.

⑩ Colour flow

Keeping elements on separate layers makes it much easier for me to play around with the values, the hues and colour shifts. In order to build up colour gradually, I want to use cool, muted and darker tones all from within the same colour spectrum.

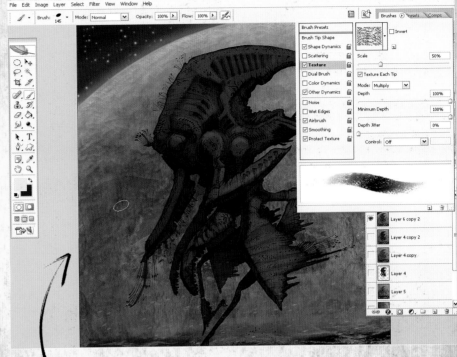

⑪ Defining the location

To complement the curved dorsal shape of the creature's cranium I've used the Circular Marquee tool to create an arch and set the beginning for my planet in the backdrop. In order to create a striking planetary lighting effect, it always helps to paint a glow produced by the atmosphere, and to continue the light around the source as it hits the sphere.

⑫ Planet surface

A quick light and dark value texture is applied with a stippled concrete pattern, inverting the texture to make the pattern more prominent. Reducing the scale of the pattern as it nears the lit edge helps create an appearance of the texture wrapping around the surface.

⑬ Gouged soil

With the use of another photo texture cropped to a circular shape and framing the planet, I can provide a contrast in colour between the foreground and the background. It's also being used to supply additional texture and quick colour variations.

14 Overlay

By setting the gouged soil photo texture to an Overlay layer on low Opacity, it will give the appearance that it's sitting on top of the planet. It will sink into the existing colour and textures while still affecting the values and the shifts in hue, appearing as different colourations in soil or varied locations and elevations. Erasing with a soft airbrush and breaking up the strength of the photo texture also helps to achieve a more natural appearance. Duplicating the layer will increase the strength of the Saturation and Opacity, which is useful if you want to light a section on one side and leave the other in shadow.

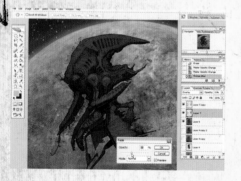

15 Atmosphere and particles

What I've found to be an effective way to knock down the strong, clear pixels of a photo in order to give it a more painted feel is to copy and paste a selection directly on top of the image. I then apply a Motion Blur on an angle in whichever direction is appropriate and set the duplicated layer on a low Opacity. This is a great and easy way to supply a misty, soft atmosphere and to help cut down on the harsh pixels that photos sometimes produce in contrast to a painting.

16 Gravity Glider edging

On a new layer above the background and above the sketch, I've started painting dark and light values – working out the forms and shapes of the streamline Gravity Glider. This character has a complex design so I'm trying to keep a good deal of it in shadow, especially since bioluminescent light will play an important part in the creature's biology. Edge control quality consists of defining the silhouette by applying reflective and local colour both from the dominant light source and colour from the background.

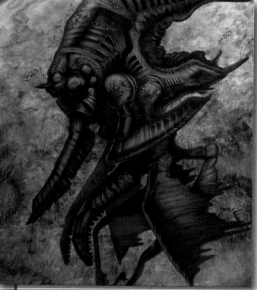

PROSECRETS

ASK WHY

Designs are limitless so long as you take into account all aspects of why something looks the way it looks. It's the question 'Why?' that comes into play, and if you can find answers to the question for the idea behind a concept, you'll find a much stronger design. Why does it have three legs, how does it eat, where does it live, is it dangerous, does it lay eggs or carry a baby in a womb? Make sure there is a reason why in answer to all questions.

17 Contrasting bioluminescent

Important parts of this life form are also important parts to the focal points and interest of the painting. The sensory fibres help this creature in many ways, from its sense of touch and vision to its mating habits and digestion. They're also a great element for the environment in which it lives, as living in space is similar to living in the deep oceans of earth.

19 Not alone

I sketched out these little guys during my thumbnail creations. I felt they would do the job of providing some sense of scale. I only painted one but by adjusting the scale, the angle and the position of the wings, among other things, the effect of many can be made with ease. Keeping with the deep sea and space theme I kept the smaller life forms completely bioluminescent to provide enough additional eye candy without being a distraction.

20 Light, value and that's a wrap

The last thing I do before finishing a painting is to take a day or a few hours away from it. When I come back I may find that it's too muted, there might be something missing or the lighting isn't right. So here I have used the Brush tool on Overlay to create a stronger sense of light on the planet and adjust the overall light value.

18 Glider's skin

Using a scratched glass bump pattern created from Mayang's texture library, I'm using the same light and dark value invert technique as in step 12 for the planet's surface. In order to get the most out of my texture, I desaturated the colour, pump up the values and make sure there are no seams so it repeats continuously. Set the Depth to its full extent, the mode to Multiply and check the box that says Texture Each Tip.

ESSENTIAL ART SKILLS

BOBBY CHIU introduces his top ten fundamentals that every digital artist should bear in mind. Forget these at your peril!

10 THINKING AHEAD

In order to start an image off on the right foot, it's important to know where it's headed. When I started this creature, for example, I lay down base tones with an idea of what its final colours would be. The musculature in the final image was present in the sketching stage. Having a solid plan for a painting ensures that my image will maintain uniformity throughout the painting process.

9 COMPOSITION

Composition begins with good lighting and spacing: the areas of prominence are usually well-lit and unobstructed to draw the viewer's attention. In this image, the viewer is drawn to the dog's head first due to its size and position in the middle of the piece. The dog's eyes as well as the boy are both pointing the viewer to the next thing I want to show, which is the man, who is, in turn, pointing at the bike. At the end of this 'tour' of my image, the viewer will retrace their steps until they piece together the story I'm telling.

8 LIGHT AND SHADOW

When applying light and shadow, focus on which sides would catch most of the light, some of the light (possibly from reflection), and none of the light. The outward sides of this girl's arms catch the most light while the leeward sides get more shadow, establishing the location of the light source. It's important to constantly remind yourself where the light is coming from as you paint.

7 SELECTIVE DRAWING

When drawing, it's important to spread your focus across the whole image rather than a few certain spots. I usually establish a framework for my sketch first, then break it down into large pieces that I can work on individually. This way, the entire image will show the same degree of polish and won't feel lopsided with one extremely well-drawn corner next to one that's oversimplified.

6 LINE QUALITY

In sketching, soft lines typically indicate light, while darker lines are used as a structure descends into shadow. Compare the quality

of the lines at the top of the woman's head, which is lit, as opposed to those on her mouth, which is shadowed by her nose. Lines also define structures. The darker and sharper a line is, the stronger your commitment to position of a structure. Build your shapes using soft, fuzzy lines to establish light and shadow and then commit to dark lines later. Starting with dark, heavy lines leaves you little margin of error.

5 SILHOUETTES

As a rule of thumb, the best 2D designs should still work even with most of the information missing. So, one way you can gauge the effectiveness of a design is to block in the image so you see only the silhouette. If I design something that isn't identifiable through just the silhouette, I will scrap the image and start over again.

4 TONALITY

Start painting by thinking about tonality. The colour tones of the girl's boots and bikini are inherently much darker than her skin tone, for example. By staying conscious of the

relationships between the tonality of structures in the image when compared to one another, you can more effectively build a good lighting and shadowing scheme.

3 LINEAR STRUCTURE

Most structures, even if they have few hard corners, have a top, a bottom and four distinct sides. So try using boxes as guides for how the structure is positioned, where the front, back, and sides are, and so on. When you lay down these 'building blocks' in the correct proportion and relative position to each other, and pointing or facing in the right directions, the figure you draw on top of them will feel more solid and sturdy – it will have a stronger feeling of cohesive structure.

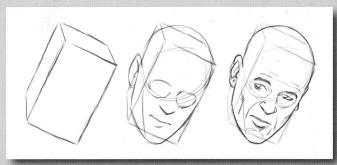

2 TENSION AND RELAXATION

Here are two images of a person yelling. As you can see, he's quite angry in both pictures, but which screaming mouth communicates that the best? Straight, stretched lines show tension while slack, curved, or squished lines are more relaxed, so when the sides of his mouth are stretched taut, he seems much angrier and more frustrated. He's yelling so loudly that his mouth cannot open any bigger.

1 BLIND CONTOURS

Blind contours are basically drawing from life without looking at what you're doing. Accuracy doesn't matter; the point is to improve your hand-eye coordination by making you concentrate on what you think your hand is drawing. Practise consistently and you'll find your hand-eye coordination and muscle control will dramatically improve, and you'll be able to translate what you see and imagine to paper more accurately.

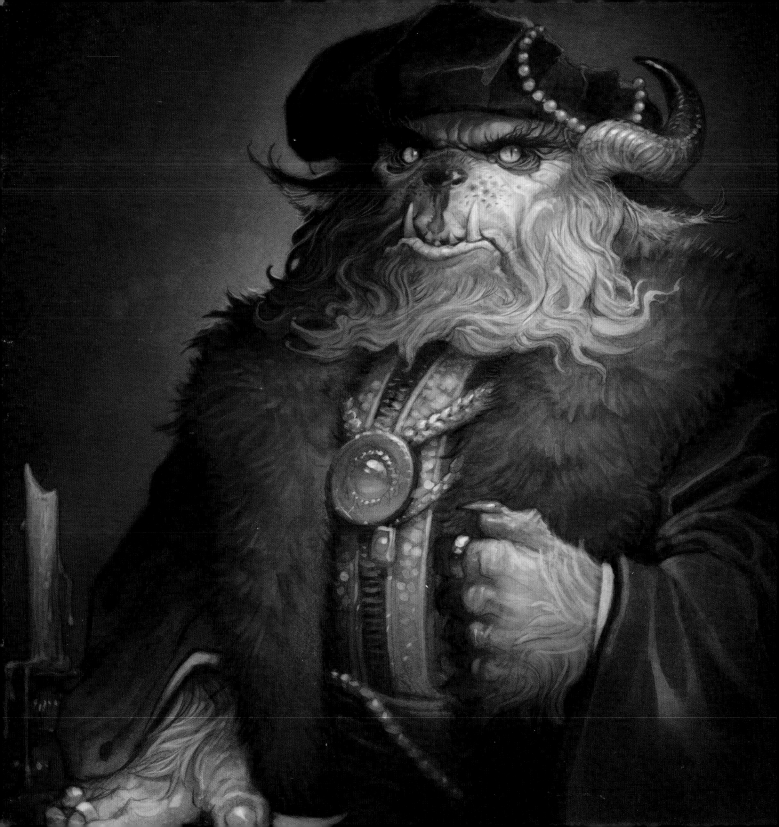